Great Victorian Engravings: A Collector's Guide

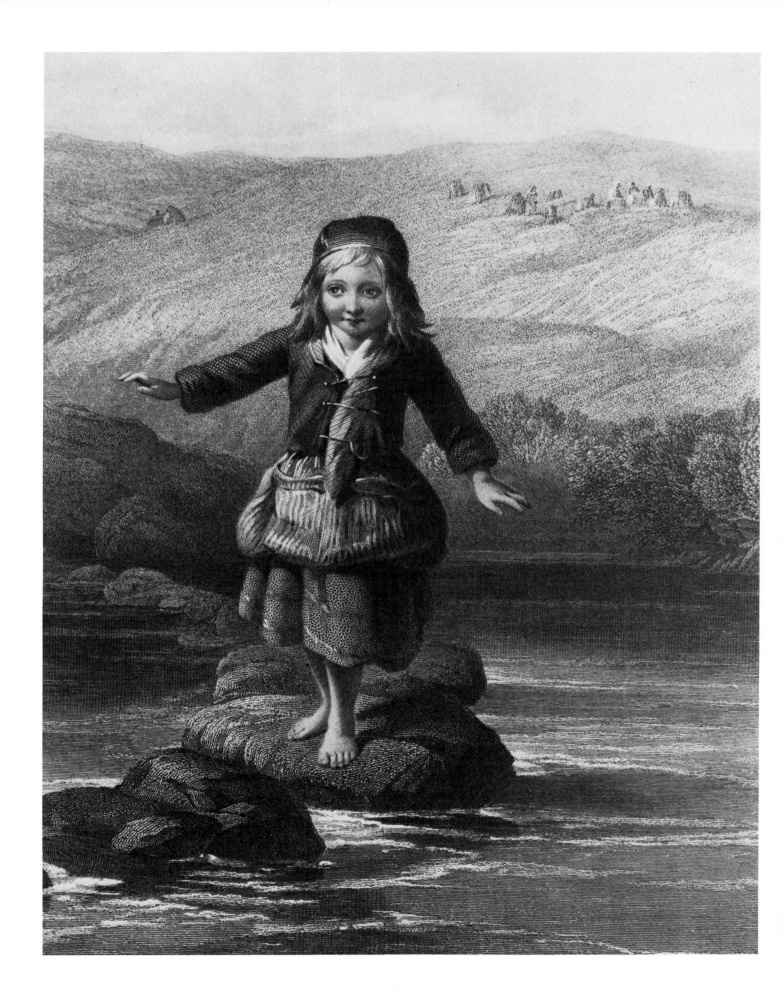

GREAT
VICTORIAN
ENGRAVINGS

A COLLECTOR'S GUIDE

HILARY GUISE

ASTRAGAL BOOKS · LONDON

For H.H.B.
who had the gift of friendship
April 1900 to April 1973

Frontispiece: Detail from Come Along *by Francis Holl*

First published in 1980 by Astragal Books/an imprint
of The Architectural Press Ltd: London

British Library Cataloguing in Publication Data

Guise, Hilary

Great Victorian engravings.
1. Engraving, English—Collectors and collecting
2. Engraving—19th century—England—Collectors and
collecting
I. Title
769′.942 NE628.3
ISBN 0-906525-10-1

Set in Century Schoolbook and printed in Great Britain by
BAS Printers Limited, Over Wallop, Hampshire

Contents

List of Illustrations

Acknowledgements

I would like to thank the Victoria and Albert Museum and the British Museum for permission to reproduce works from their print collections. (Full details and Accession Numbers are given in the notes to the illustrations.) My special thanks also to Graham Reynolds, formerly Keeper of the Department of Prints and Drawings at the Victoria and Albert Museum. I have had continuing help from Sue Lambert, Jean Hamilton, Ray Smith and many others in the Museum and the National Art Library. At the British Museum I was given much practical help by Peter Moore, and I am most grateful for the photographic facilities he made available. Rosemary Treble at the Witt Library has been most helpful, and her catalogue for the Arts Council Exhibition of 1978, *Great Victorian Pictures* is invaluable. I must also thank the librarians of the Courtauld. I am deeply indebted to Edith Pritchard for her meticulous proof-reading. Most of all I am grateful to my husband for all his help and encouragement.

Introduction

here is a cryptic but perceptive statement in Marshall McLuhan's *Understanding Media* about objects from the past: 'The more there were, the fewer there are'. Victorian reproductive engravings are not particularly scarce—though some of the best and some of the most famous ones increasingly are—but considering this was a major medium for visual mass communication before the age of photographic reproduction they are few indeed compared with their proliferation in the 19th century.

This proliferation was brought about by a number of factors, some of them social and economic, others technical. As always, these factors were interlinked: the demand, occasioned by a rapidly growing and art conscious, or at least fashion conscious, middle-class public, spurred the technical innovations that made print making on a huge scale possible.

It was not so earlier. The production of prints has a very long history, but by the end of the 18th century two processes, both of them fairly laborious, were predominant: these were the processes of line engraving and mezzotint.

The line engraver worked from light to dark on a polished copper-plate and built up the design with a network of incised lines cut with a burin. Three-dimensional form was described by a closely laid pattern of lines; tone and richness by the depth and complexity of cross-cuts. Highlights were rendered with a brilliant system of dots and dashes so that the lines, getting finer as they approached the light area, would disintegrate in a spray of fine dots. Stability in the design was achieved with long, continuous lines flowing evenly across the plate. Perspective could be registered more easily in line engraving than in other kinds of engraving by the use of strong, receding lines which suited landscape subjects and could well convey brilliant flood-lit skies which were the stock-in-trade of the Romantic landscapists at the turn of the century.

Line engravers had also excelled in the translation of classical or 'high' art. As classicism manifests itself in linear, controlled or contained form, subjects in the classical manner were ideal material for the engraver's burin, for example *The Combat*, **164***. But the new patrons, the emerging mass market of the Victorian middle and lower middle class, had neither the classical education nor the stomach for subjects so far removed from everyday life. Their interest was in more mundane events, reflections of what went on around them or how the other half lived. Pictures of great events from England's history and familiar themes from her literature; or simple story-telling pictures that expressed Victorian sentiments and moral attitudes were more popular. Victorian taste was influenced by Landseer's *The Old Shepherd's Chief Mourner*, **30** painted in the late 1830s. Apart from being itself republished many times, it established the mood for countless future and similar works. It shows a bereaved sheepdog, his breast on his master's coffin, with a soft light bathing the rough cap of a shepherd whose abandoned Bible and humble cottage suggest a life of lonely piety: a pathetic contrast is thus made between canine fidelity and human indifference.

Mezzotint was more suitable than line engraving for this kind of subject for a number of reasons. Mezzotint was carried out from dark to light. The plate was first roughened with a 'rocker' so that it would print totally black. The design was then brought out by scraping away the roughness with a 'scraper' so that less ink would adhere to its surface. As the mezzotinter worked with tones rather than lines his technique was aptly suited for translating painterly and textural effects. Mezzotint could well describe the softness of velvet, or the furriness of domestic pets, shadows of interior lighting and the modulation of a human face. It was particularly attractive to an apocalyptic painter like John Martin, though conversely it was inimical to J. M. W. Turner's radiant effects.

But quite apart from its suitability for rendering the kind of subjects that were popular with the Victorians, mezzotint had a further decisive advantage. It was a much faster method than line engraving.

William Sharpe, an eminent line engraver, in a letter addressed to Mr Charles Warren, dated 29 May 1810, described mezzotint as 'being almost as quick as drawing' and continued:

* Numbers in bold refer to illustrations.

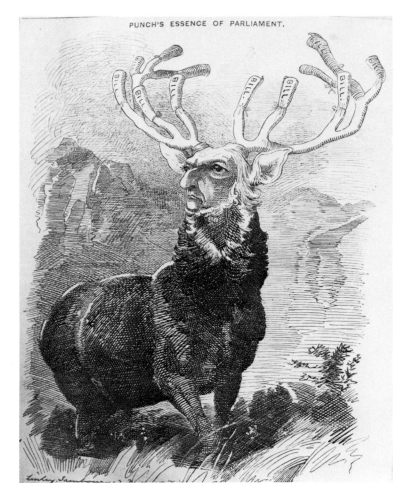

Cartoon from Punch *(1880), parodying Landseer's* Monarch of the Glen. *It shows how deeply the images from engravings were entrenched in the public mind*

Many of them can be begun and finished at the same time that one engraved plate can, in a greater proportion than twenty to one.

He calculated that ten large line engravings would employ one individual for at least 30 years, three years to each plate, whereas four mezzotint plates could easily be completed in under two years. He also noted one other important advantage of mezzotint,

On account of its rapidity it had a great advantage in a pecuniary way—particularly when any event of the day may suddenly engage the attention of the Public—it may be brought forth at the same time to ensure a sale whilst the subject is alive.[1]

The speed of mezzotint engraving, and hence its ability to meet the demand for topical subjects and provide a quick return on capital invested, brought it in line with contemporary requirements.

In spite of these advantages mezzotint could never have become the most practical and popular style of the 19th century without the introduction of steel plates. The distinctive quality of a mezzotint lay in the richness of tones which depended on the crispness of the burr. The burr on a copper-plate was flattened in the press after about 200 impressions had been taken. Steel entirely removed this drawback, though a steel plate took a great deal more preparation than a copper one.

It also had other disadvantages which from the engraver's point of view proved to be very damaging. Engraving, though a skill that required a high degree of craftmanship, was not highly regarded by other artists. In 1768 engravers were firmly cold-shouldered by the newly founded Royal Academy who were prepared to

Admit six engravers, as associates only; but without the plea of teaching, encouraging or otherwise serving engraving.[2]

It was an insult that rankled. As one of the most distinguished 18th-century engravers, Sir Robert Strange, remarked

Care was taken that the mode of admission should eventually exclude every engraver who had any of that conscious pride which the better artists always possess.[3]

This accusation was made in 1775. Half a century later nothing had changed. An original document in the National Art Library runs as follows:

London July 10th. 1826

We the undersigned being of opinion that the Royal Academy as now Constituted tends to degrade the Art of Engraving, and that

those members of the profession who become associates, by so doing, degrade themselves; do hereby give to each other a voluntary pledge never to become candidates for Election into that body of artists until it shall render to the Art of Engraving that degree of importance which is attached to it in other Countries of Europe.

(signed) John LeKeux John Burnet
 Henry LeKeux
 George Cooke
 Edward Goodall
 John Henry Robinson
 W. Finden
 John Pye
 George T. Doo

The original petition with signatures

Those engravers who did not take the pledge and became associates, James Heath and Frederick Bromley for example, were felt to have betrayed the cause.

This band of men formed a Society of Engravers under the patronage of John Sheepshanks. Ten years later they decided to put their problem before Parliament. Their petition,[4] submitted on 11 June 1836, asked for an investigation into the state and prospects of engraving in England in view of the lack of support from official institutions.

John Burnet was asked his opinion on engraving as a means of diffusing taste. He replied that in the past people had come to England to learn engraving, consequently the English style was known and copied all over Europe. Hence the galling fact that English engraving was highly regarded abroad whereas at home engravers were con-sidered no better than ingenious mechanics.

It was not the truth but it was near enough to hurt because the quality the new public looked for in engravings lay much closer to what an 'ingenious mechanic' could provide than what the engravers prided themselves on being able to produce. The engravers insisted that their talent lay in the translation of a painting into another medium, yet the public were clearly more interested in imitation: a replica, as exact as possible. Ultimately this led to the development of techniques—culminating in photogravure—that would achieve this aim. But in the first instance, if no great value was attached to engravings as works of art in their own right, then it was clearly desirable that they should be produced as rapidly and in as large editions as possible.

Steel was ideal for this purpose. It was much harder than copper and whereas only a few hundred impressions could be taken from a copper-plate, with a steel plate, or a steel faced copper-plate, the number could run into many thousands. In some respects the growth in demand created more work for engravers, but since they were paid an outright fee for a plate, the return, relative to the number of impressions run off, diminished drastically with the introduction of steel plates. Whilst editions grew, plates shrank to a fraction of their former size as did engravers' fees which were fixed by the size of the plate, not size of the edition. Furthermore because steel was harder to work than copper the range of effects the engraver could create was reduced. Only shallow, fine lines could be engraved for which no great skill was required other than the ability to lay such fine lines close together. Consequently engravers of unequal merit were brought on a par because it was hard to distinguish talented work from that of the army of ill-paid hacks who churned out small, steel engravings for the mounting tide of books, fashionable octavo publications like *The Keepsake* and the *Book of Beauty* (quasi-literary

Title page from The Keepsake *showing the fine, shallow engraving style created by the introduction of small steel plates*

3

periodicals with charming illustrations of poems and romantic stories), the *Picturesque Annuals* of grand tours for the well-travelled nobility and other printed ephemera that poured out from the 1830s onwards.

Engraving methods and media

The immense demand for reproductive engravings—and it must be remembered that before the age of photographic reproduction, this was the only medium that existed for visual mass communication—was such that techniques had to be developed which were faster and required less skill than the laborious process of pure mezzotint and line. One of these, stipple engraving or 'dotting', had been introduced as an alternative method of engraving tone by a system of irregular dots.

Sharpe relates how the multiplication of stippled prints was affected by a coincidental change in shoe fashions. Buckles with punched design went out of favour and the redundant buckle-punchers were summoned from Birmingham to London and put to work punching backgrounds for stipple portraits. By employing unskilled men an enterprising engraver could amass a considerable fortune. One engraver boasted to Sharpe that he had acquired £20,000 solely by the work of others. Mezzotinters were also able to employ unskilled workers for the heavy task of grounding the plates, so when the new hard plates were introduced the mezzotinters had all the advantage from them with little extra effort, whereas the line engravers were very much set back.

Line engravers could not exploit untrained labour but they could use machines. Charles George Lewis used an engraving machine on *A Lesson for Humanity*, **66** and Charles Mottram used one to fill in the wide Jordanian sky behind *The Scapegoat*, **120** in 1861. Machine engraving was most frequently used to fill in large background areas and is easily identified by its lifeless regularity.

Engravers found a particularly happy compromise between pure line and pure tone in the combination of line engraving and stipple. These two techniques enhanced each other and released a new kind of technical virtuosity not allowed by either single method. H. T. Ryall's plate *The Pursuit of Pleasure: a Vision of Human Life* (1859), **168** is a good example. Here the glitter of armour is expressed in rich line engraving and the softness of the female nude in stipple. The Holl brothers were exponents of this style, and William Henry Simmons's brilliant engravings after William Holman Hunt's *Light of the World*, **119** and *Claudio and Isabella*, **57** suggest that financial pressure rather than personal inclination was responsible for him having to devote most of his time to mixed mezzotint instead of line and stipple.

Another partnership of line and tone used aquatint. This was a much faster way of applying tone than stipple as the plate was pitted by acid and not manually. It had a big advantage over mezzotint in that the resin ground could be 'blocked out' so that only selected areas of the plate were exposed to the acid. Smooth polished areas remained which provided a brilliant white background for the incised lines. Mezzotint always covered the entire plate with tone and although white areas could be created by laboriously burnishing away the surface texture, these areas would be receding and ill-defined. Lines engraved in these valleys would not print well. The use of aquatint satisfied the market's demand for a more painterly effect without hampering the line engraver too much. Thomas Lewis Atkinson demonstrated the technical possibilities of line engraving and aquatint in his plate *The Black Brunswicker* (1864), **59** after Sir John Everett Millais.

Finally mixed mezzotint emerged as the style most characteristic of 19th century engraving. It was a style without rules; any combination of tonal and linear techniques could be used in any order on a mezzotint ground. The engraver would establish the tonal pattern of his design on a mezzotint plate and then clarify the drawing with engraving, stipple engraving or etching, and frequently all three. This evolved from the fact that mezzotint on steel tended to print grey and contrast could only be achieved through further work on the plate.

This compromise destroyed traditional mezzotint and line engraving by reversing their most fundamental elements. The dazzling effect of a good line engraving came from the smoothness of the polished plate which provided a stark white background. Now lines were being incised into a roughened plate and appeared against a grey background. Mezzotint drew its richness from the varying surface textures of the plate. Now these textures were being scored across with lines.

Etching which registers every impulse and innuendo of the hand relies for its effect on unhampered spontaneity and freshness. The fluidity of etching vanished in the confusion of textures of the mixed mezzotint. Furthermore, free lines bitten in by acid set up an uncomfortable discord next to the controlled incised lines of engraving. It was a style in which panache played no part. It consisted chiefly of timorous, flickering lines which conscientiously followed the pre-ordained design. The darker areas, rendered by an orderly arrangement of lines, produced a quasi-imitation of line engraving. This style was apparently not distasteful to contemporary eyes. Holman Hunt's *The Shadow of Death*, **130** was reproduced in mezzotint and etching by Frederick Stacpoole and published in 1877 with huge success. *Les Adieux* (1873), **60** by J. J. Ballin after James Tissot, *The Spanish Wife's Last Appeal* (1841), **75** by C. G. Lewis after J. F. Lewis and *The Alarm Bell* (1849), **162** by Frederick Bromley after J. R. Herbert are other examples.

Some engravers tried a combination of mezzotint and stipple, for example W. H. Simmons's *The Mother's Dream* (1853), **6**, H. T. Ryall's *The Scoffers* (1853), **136** and James Chant's *Remembrance* (1869), **17**. Others threw discretion to the wind and used every kind of technique on the same plate. As mixed mezzotint could be applied to almost any kind of subject and as the public were only interested in subject matter and indifferent to technique, it is not

surprising that the vast majority of Victorian engravings were carried out in this haphazard fashion.

Well-known examples of these mixed medium engravings, turned out in huge numbers, include historical subjects such as *Prince Charles Edward in Hiding after the Battle of Culloden*, **83** engraved by F. Bacon and later by H. T. Ryall and *The Last Sleep of Argyll before his Execution* A.D. *1685* (1861), **99** by William Turner Davey; contemporary realities like *Eastward Ho!—August 1857* and *Home Again* also by W. T. Davey, **70a** and **b** which were published in 1860 and 1861 and depicted the departure and return of troops to and from the Indian Mutiny: stirring appeals to patriotism like *The Champion of England*, **69** and the mixed mezzotint by H. T. Ryall after Richard Ansdell, *Fight for the Standard*, **71** published in 1861 but based on an episode from the Battle of Waterloo; prints which gave shape to heroes and heroines from English literature, such as the *Trial of Effie Deans* (1854), **134** by Frederick Bromley after R. Scott Lauder; biblical subjects, of which the numerous engravings from Holman Hunt are the best known today and Shakespearian characters like *Rosalind and Celia*, **172** by W. H. Simmons after Millais; and, as the century wore on, an increasing number of engravings that, like *Waiting for the Verdict* and *The Acquittal*, **148a** and **b** by W. H. Simmons after Abraham Solomon, reflected a developing public-spirited interest in social matters.

Under pressure from the demands of the publishers, many technical innovations were tried. Even the actual shape of prints underwent change. Early prints such as those after Webster's *Foot Ball*, **14** sometimes had rounded upper corners. Later a more pronounced arch became fashionable as seen in *The Mother's Dream*, **6**, *'Home!' Return from the Crimea*, **67** by H. T. Ryall and *Mors Janua Vitae*, **125** by W. H. Simmons. A tall rectangular shape with a semi-circular top emerged for single figure subjects like *The Light of the World*, **119** and when this arch became steeper and slightly pointed as in *L'Allegro* and *Il Penseroso*, **170a** and **b** by Francis Holl, it reflected the fashion for Victorian Gothic. (This interest in Gothic can, incidentally, also be detected in the engravings themselves; *The Eve of St. Agnes*, **173** is a good example of Gothic architecture featured in an engraving.)

The vertical oval, which had long been a favourite shape for vignettes and portraits, was thought to enhance the femininity of larger works such as *The Bouquet of Beauty* after Charles Baxter. Prints were available in every conceivable size and shape from the tiny octavo steel engravings to very large prints like *The Railway Station* (64.5 × 122 cm), **149** and Mottram's mezzotints after John Martin's *Judgement* pictures, **116** which were a yard wide and two foot six inches high.

In this, as in every other aspect of the print business, there was a search for novelty, a great courtship of the consumer society. The public could hardly be expected to exercise discernment, so bewildering was the variety of styles, shapes and subjects offered for their delectation.

Technical innovations

Even more damaging to the interests of the craftsman engravers than the development of new techniques that enabled the publishers to meet the demand for quantity at the expense of quality were new methods of reproducing the work itself. Copper-plate engraving had traditionally been a specialised affair, the finer points of which were matters for keen discussion among connoisseurs, and which were preceded by years of effort by the engraver.

A line engraver might produce no more than ten engravings in the course of a working life and though mezzotint was a faster process it was still not fast enough. This was therefore an obvious challenge for the inventive 1830s. Could not engravings be cut on to something harder than copper? Could they be cut by machine? Could something be done with that exciting new discovery, electricity? Why not try and find a way of doubling the number of prints by duplicating the plate itself?

Inventors were eager to find answers to all these questions and by 1859 the lithographic printer J. W. Stannard was able to list no less than 156 different reproductive techniques in his book *Art Exemplar*.[5] From this multiplicity certain common objectives can be discerned in which practical aspects of traditional crafts were borrowed and adapted or combined to meet the objectives of speed, cheapness and the production of exact copies in large numbers. Thus the principle of relief was borrowed from woodcut since a relief block could be set alongside type in a platen press. The application of acid, which eliminated the need for incising metal by hand, was taken from etching. As for lithography, this process dispensed with the need for the engraver altogether, because the image could be drawn directly on to a stone surface and reproduced via the antipathy between the wax and water (see the glossary for a fuller explanation of this and other techniques). Ultimately lithography was to emerge as the dominant mode but before this happened, there were all kinds of experiments involving the use of metal relief plates. An outcome of this innovatory fever was the discovery of stereotyping—a way of duplicating the plate itself by working with positive and negative plates.

E. M. Harris notes that the first stereotyping process, called Siderography,[6] was invented by an American named Jacob Perkins and patented in England as early as 1810. This led to the discovery that metal stereotypes could be made from relief wood-blocks. The way was now open for the publication of illustrated books and journals in different parts of the world simultaneously, and consequent speeding up of communications. *The Penny Magazine*, for example, was published in England and in Europe simultaneously by the Society for the Diffusion of Useful Knowledge. A dissertation on the African rhinoceros was clearly more instructive if accompanied by a picture of the beast in question.

Needless to say, the temptation to use stereotypes proved irresistible and the Art-Union of London—their role is discussed on pages 12–15—came under fire for

distributing prints from stereotypes to trusting members who had paid good money for prints from the engraver's original plate.[7]

Although the metal relief processes were all fairly similar, their inventors gave them fine technological names of which a few may be mentioned: *Gypsography*, invented by Godfrey Woone in 1837; *Branston's Process*, invented in 1838; *Acrography* invented by Louis Schoenberg about 1838 and *Glyphography* developed by Edward Palmer in 1842. Many processes used electricity and these were known as 'electrography' and 'galvanography'.

Electro-etching, invented in 1839, was not really etching as the plate was not bitten in. By using an electric battery and connecting the plate to a negative pole instead of a positive one, copper was deposited on the exposed lines instead of being removed and a relief plate could be built up. *Electrotint*, a sort of aquatint in relief, was invented two years later and consisted of a similar electrolytic process to produce tones rather than lines. *The Journal of the Society of Arts* gave space to a German process called *electromagnetic engraving* in 1854, but by this time the interest in novel inventions was beginning to pall as many of them had failed to live up to expectations.

But nevertheless the cumulative effect of the distribution of multiple copies on a large scale was to depress prices. T. H. Fielding, writing on *The Art of Engraving* in 1844, lamented the fact that beautiful engravings were being flung before the public at prices for which they ought never to have been sold. The engravers paid for this public bounty in terms of reduced income. Far from the extravagant gains they may have anticipated from this boom, their income sank from fair remuneration to insufficiency.

The development of steel as the material for printing plates, the discovery of electrolysis and the invention of stereotypes revolutionised the print business. Small printsellers became international tycoons and carried the fame of British artists like Millais, Frith, Holman Hunt and Leighton round the world; but the engravers benefited neither from the artists' fame, nor from the printsellers' fortune.

After the middle of the century there was yet another technological breakthrough in reproductive techniques and this one was finally to hammer a nail in the coffin of engraving from the commercial point of view.

This was the invention of photolithography and the subsequent development of photogravure. Almost 20 years elapsed before Daguerre's invention of 1838 was adapted for printing purposes. A. S. Kenyon describes[8] how James W. Osborne, an Irishman working in Melbourne, Victoria, hit upon the idea of transferring an actual photographic image on to stone, and how he produced his first lithograph by this method on 19 August 1859. He used a paper coated with a mixture of albumen and gelatine sensitized with potash chromate. After exposure to the negative, the paper was floated on hot water; the albumen swelled where it was not fixed by the action of light on the potash chromate and the greasy lithographic ink on those parts

was wiped off so that ink only adhered to the fixed lines. The paper was then pressed on to the stone and gave an accurate printing surface. James Osborne only patented his idea in Victoria, and when he returned to Europe in 1862 in order to exploit the new process he found it already patented and in use. He moved on to America where he eventually set up his own photolithographic company in Washington.

The process of photogravure differed from photolithography in that the exposed sheet of fine tissue and light sensitive gelatine was pressed on to a polished metal plate previously prepared with an aquatint ground. The exposed gelatine and tissue were washed off leaving a fine gelatine relief on the plate which was the negative of the original image. Thus by a sophisticated version of the traditional aquatint process, the half-tone plate was created by only one immersion in acid. A faithful copy registering every tone of the original photograph of the painting could be produced in this way.

William Powell Frith expressed his views on photogravure in the 1880s

In photogravure, so popular now, the place of the second mind is supplied by a machine, which often does its best to destroy or mutilate the efforts of the first; but sometimes, I admit, reproduces the effect of a picture with extraordinary accuracy. But accuracy, in my opinion, is not enough; I want at the same time the taste and skill, which amount almost to genius, with which the great engraver changes into black and white the colours of the picture before him.[9]

The engravers
An engraver's lot was not glamorous. Its circumstances were vividly evoked by Algernon Graves when he wrote

... they earned their money by great manual toil and very slowly, and consequently they knew the value of money and lived well within their means. I do not often remember meeting another engraver at the house of any that I visited, neither do I remember that any of them were given to entertaining; their whole souls were in their work, and many an evening when I have visited them [I] have found them hard at work with their burin or scraper by gas light.[10]

This describes a solitary dedicated way of life demanding sustained application. Graves recalled three plates engraved for his father Henry which each took 15 years to complete. This throws some light on the Victorians' feverish search for quicker ways of producing plates, for it is hard to see how a publisher could afford to wait so long for a reproduction of what might be no longer a topical picture. An equally pertinent question is to ask what kind of man would want to spend so long copying one single work of another? Possibly a skilled and dedicated craftsman, but certainly not someone with any original creative drive. Skilled craftsmen were not, in general, highly rewarded in the 19th century and this was certainly true of the engravers. Since they were neither entre-

preneurs, nor producers, they were in a weak position economically. A good plate merely spread the fame of the painter. Algernon Graves remembers[11] that in the 1860s no one seemed to care who had engraved a plate as long as it was well done.

Possibly for this reason not a great deal is known about the lives and personalities of the engravers. One exception, however, was Thomas Landseer, brother of Sir Edwin Landseer and known to his friends as 'dear old Tom'. He was, according to W. P. Frith, always bubbling over with smiles and good humour. Although he became totally deaf many years before his death, he never suffered from the irritable suspicion which sometimes afflicts the deaf. 'He could hear nothing, but sat and smiled in lifelong silence, quite regardless of what might be said of him or his doings.'[12] He was in the habit of visiting the Frith household in the company of a friend who was quite blind, and there this odd couple would suffer the strenuous attentions of the Frith children. He was sometimes forearmed with a pocketful of half-melted sweets in the form of fishes, or 'fishes in a perspiration' as he called them.

Tom Landseer was born in 1795 in London, the son of the distinguished engraver John Landseer from whom he learnt his skill. The life-long partnership with his brother Edwin began when at the age of 16 he made his first etchings after the nine year old Edwin's drawings. He became an engraver of considerable power and translated many of Sir Edwin's most famous works and so contributed to his brother's renown, whilst he himself remained in the wings. An indication of his regard for his brother and

possibly of how engravers regarded painters is apparent in the plate *Vanquished Lion* which has Sir Edwin's name on it but is thought to have been painted as well as engraved by Tom.[13]

He engraved the well-known *Monarch of the Glen*, **35** in 1852, closely watched by Sir Edwin who amused himself by engraving the nose of the deer.[14] His other works include *A Distinguished Member of the Humane Society* (1839), *Dignity and Impudence* (1841), *Not Caught Yet* (1845), *The Stag at Bay* (1848), **39** and *Laying down the Law* (1843), **32** which was a portrait of Count d'Orsay's French poodle. Sir Edwin always championed his brother — 'If anyone has the right to the benefit of my signature, it is my brother, the engraver'.[15]

When a small printing press was set up in Buckingham Palace in 1841 so that Sir Edwin could teach the Queen and Prince Consort to etch, Tom was there supervising the acid baths and the biting-in. Tom was always included in Sir Edwin's social and business activities, hence the frequent strong letters sent to Henry Graves & Co insisting on commissions for him. Tom Landseer's work began to fall off after the death of Sir Edwin in 1873. It was partly old age and partly the loss of his closest friend and adviser. There was talk of making him a full academician as a compliment during his last illness, but he did not live to receive it. He kept his sense of fun. As an old man it amused him to sign his proofs for the small fee of one cigar per signature.

Charles George Lewis (1808–80) was a rather more taciturn engraver. He was the brother of the exotic painter and water-colourist John Frederick Lewis and second son

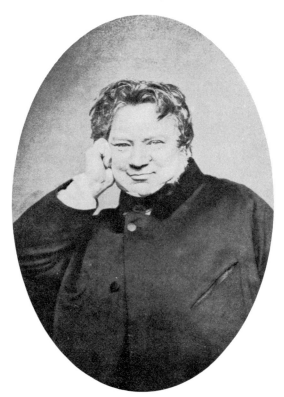

Tom Landseer

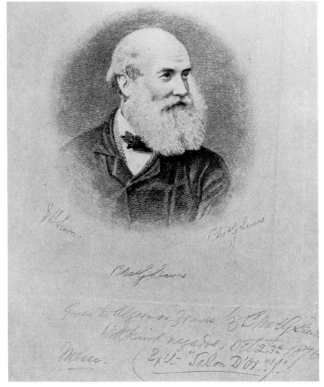

Charles Lewis

of the engraver Frederick Christian Lewis. He was trained entirely by his father and became a prolific engraver. He produced over 80 plates, most of which combined etching and mezzotint with engraving and stipple. His best work was executed in his early and middle period and according to Algernon Graves his finest plates after Landseer ceased in 1853. Sir Edwin's relationship with Charles Lewis was very different from that with his brother Tom. In spite of the large number of successful plates engraved by Lewis after Landseer's paintings, the engraver suffered that painter's fiery displeasure. The break occurred in 1849 when Lewis failed to produce an engraving in the specified time and also refused to hand back the painting which he had had in hand for six years. The owner, a Mr Blakemore, tried to wrest the painting from him at gun point. The ensuing lawsuit resulted in a life-long coolness between Messrs Graves and Lewis. Up to that time his record had been excellent. He had engraved *Shoeing the Horse*, **33** in 1848, *The Otter Hunt* in 1847, *The Cat's Paw* in 1846 and *Hawking in the Olden Time* in 1842.

Two days before the fire which destroyed Graves's galleries in 1867, Landseer was there signing some proofs of a set of plates by Lewis. He was handed some of the engraver's own proofs, whereupon he flew into a rage, threw the proofs across the room and brought another lawsuit against Lewis. He wrote 'I immediately pulled up C. Lewis. It cost him six or seven hundred pounds'.[16] It is not known exactly what infringement of professional etiquette led to this disaster for the engraver.

Other painters and publishers were glad to employ Lewis. He engraved the two well-known plates after Thomas Jones Barker, *The Meeting of Wellington and Blucher*, **87** and *A Lesson for Humanity*, **66** in 1851 and 52. In 1864 he engraved *The Hunted Slaves*, **146**, one of several plates after Richard Ansdell. Three years later, when he was 68 years old, he completed his last large plate after W. P. Frith's *Salon d'Or, Homburg*, **154**. The next year, 1877, he retired from engraving and left London to live near Bognor. On the 16 June 1880 he heard a band playing in the street and went to the window to give them alms. He was overcome by an apoplectic fit and fell back dead.[17]

The brothers William and Francis Holl (1807–71 and 1815–84) also learnt their craft from their father, the stipple engraver William Holl the elder. The family included two other brothers, Benjamin and Charles, who also practised engraving. William frequently combined line engraving with the stipple technique learnt from his father. His two plates commissioned by the Art-Union of London, *An English Merry-making in the Olden Time* (1852), **34** and *Rebekah* (1871), **128** after Frith and Goodall, were engraved in this way. The publication of *Rebekah* was delayed by his long illness. It was finally completed after his death by his brother Charles.[18]

Francis Holl appears to have led a rather more colourful life than most engravers. He was a keen amateur actor and member of a company called 'The Histrionics' who performed in St James's theatre. He knew George Cruik-

shank with whom he played for the benefit of the Artists' General Benevolent Fund. He seemed to have a natural penchant for comic acting. He also found time between engraving and acting for both cello playing and singing. Two of his large and best known plates were *Coming of Age in the Olden Time* after Frith, published by the Art-Union of Glasgow in 1854, and *The Railway Station*, **149**, also after Frith, published in 1866. He also engraved a large number of portraits. He exhibited at the Royal Academy between 1856 and 1879 and was made an Associate in 1883 one year before his death. His son, the painter Frank Holl, RA became an Associate before his father.

So often the professions of painting and engraving ran in families, for example the Landseers, the Holls and the Goodalls. One family at the centre of the print business whose influence spanned more than a century, was the Graves family. Two generations of printsellers preceded Henry Graves the publisher and his elder brother Robert the engraver. Robert Graves was born in Tottenham Court Road, London on 7 May 1798 and he was one of the last pure line engravers. He produced many plates for the popular annuals and he illustrated the Waverley novels. His first large plate was *The Highland Whisky Still* (1842) after Landseer and at his death it was still considered to be his best work. This was followed by *First Reading of the Bible in the Crypt of Old St. Paul's*, **80** (1846). His last large plate was *The Slide* after Webster published in 1861. He occupied his last year engraving a series of small plates after Gainsborough portraits. He was elected an Associate of the Royal Academy in 1836 unanimously without a ballot which indicates the esteem in which he was held by all who knew him.[19] Disaster struck his engraving of the *Blue Boy*. After much work and many alterations the first finished proof was presented at his brother's gallery and after being admired by all it was destroyed in the fire which gutted the gallery that night.[20] Graves died in Kentish Town in February 1873 after being struck with paralysis, and was buried in the family vault at Highgate cemetery.

Edward Goodall was born at Leeds in 1795 and was entirely self-taught. He practised painting as well as engraving as a young man. Turner noticed his talent at a Royal Academy exhibition and offered him as many plates as he would undertake. This decided his career as a landscape engraver. His three sons all became painters. Frederick Goodall became a Royal Academician and A. Goodall and Walter Goodall were members of the Royal Society of Painters in Water-Colours. In his later years Edward Goodall engraved a number of figure subjects after his son Frederick. These he carried out in mixed mezzotint as landscape engraving was no longer fashionable. *The Angel's Whisper*, *The Soldier's Dream of Home* and *Cranmer Landing at the Traitor's Gate*, **95** are examples of his work after his son. He died at Hampstead in 1870.

Little is known of the private life of William Henry Simmons although he was one of the finest Victorian engravers in the mixed style and produced a vast body of

work. He studied under William Finden, the line engraver but he later abandoned line engraving for mixed mezzotint and became one of the foremost exponents of this style. He worked for all the leading publishers including Alexander Hill in Edinburgh for whom he produced three fine plates after Sir Joseph Noel Paton, *In Memoriam*, **72**, *Hesperus*, **58** and *Mors Janua Vitae*, **125** in the 1860s. His famous plate, *The Light of the World* (1858), **119** and the equally fine *Claudio and Isabella* (1856), **57** after Holman Hunt were carried out in line and stipple. He engraved plates after many of the leading painters. His mezzotints after Thomas Faed include *The Poor: The Poor Man's Friend* (1871), **151**, *His Only Pair* (1862), **11**, *The Last of the Clan* (1868), **150**, *Baith Faither and Mither* (1874), **22** and *Sunday in the Backwoods* (1863), **144**. After Millais he engraved *The Proscribed Royalist* (1858), **53** and *Rosalind and Celia* (1870), **172**. He engraved four of Abraham Solomon's best known works, *Waiting for the Verdict* (1866), **148**, *The Departure—Second Class*, **137** and its companion. Philip Calderon's *Broken Vows* was another on his list. Simmons emerges as one of the most sought-after engravers of the high Victorian period. He produced money spinners after Landseer and he also engraved Frith's official painting of *The Marriage of T.R.H. the Prince and Princess of Wales*. He lived and worked in London. Though he exhibited at the Royal Academy between 1857 and 1882 he never received any honours. He died after a short illness in Hampstead on the 10 June 1882 and is buried in Highgate cemetery.

Samuel Cousins, RA (1801–87) discovered his talents early in life. At the age of ten he was awarded the silver palette of the Society of Arts for a drawing and the next year he received the Isis medal for another drawing. S. W. Reynolds, the mezzotinter, saw his work and took him on as an apprentice without accepting the usual fee of £300. Cousins subsequently became one of the most distinguished mezzotinters of the 19th century. He concentrated on portraiture yet he also produced a number of figure subjects, for example his plates after Thomas Faed, *The Mitherless Bairn* and *From Dawn to Sunset*, **145**. He was a fast worker. He undertook to complete a plate after Landseer's *The Connoisseurs* in one year and delivered it in three months. Another successful plate after Landseer was *Bolton Abbey in the Olden Time*, **29**. His beautiful mezzotint, *The Order of Release*, **51** was the first of many plates after Millais. His technique was particularly well suited for translating Millais's studies of children, of which *Pomona*, **27** is a good example.

In 1868 Cousins told Henry Graves that he meant to retire and this he did. But his retirement was short-lived as five years later Thomas Agnew induced him to start again, and there followed a long series of plates after Millais, Reynolds and Leighton which only ended with his death in 1887.

The business of engraving had its lighter moments. As an old man, Samuel Cousins was pleased to point out a small alteration on the plate *Bolton Abbey*—the date had been changed from 1 May to 9 May in honour of his birthday.[21] This engraving was special for another reason in that it was his first work to be exhibited at the Royal Academy in the year 1837. Another anecdote tells of the disastrous day when Samuel Cousins lingered at his printer, having sent a completed but unprinted plate home ahead of him by messenger. He then set off in the direction of Camden Square himself. 'Imagine my astonishment and rage, when I overtook the boy in Harrington Square, with the plate face downwards on the wet pavement, playing pitch-and-toss, with a companion, on the top of it!'[22]

Painters, publishers and copyright

The engravings boom of the 19th century can be well illustrated by some simple statistics. In 1842 there were approximately 20 printsellers in London[23] (discussed by Jeremy Maas in *Gambart*, 1975). By the 1890s 126 printsellers had registered with the Printsellers Association. The number of plates declared through that association between 1847 and 1894 totalled 4823, excluding those which were printed privately and as each plate produced thousands of impressions the total number of prints must have run into millions. The painters held the whip hand because, under the curious copyright arrangement which existed before the whole copyright system was regularised by various commissions and conventions in the latter half of the century, they stood to gain from their work twice over. Until the Copyright Commission of 1897 ruled that ownership of a work of art also conferred copyright, this was vested in the originator of the picture, not in its owner, so painters were able to dispose of the right to produce and sell engravings quite apart from the sale of the work itself. Successful Victorian painters earned vast sums from the sale of copyrights alone. The well-known Victorian art dealer, Ernest Gambart, who had begun life on the bottom rung, colouring prints for Thomas McLean in London, bought the engraving rights for Frith's *Derby Day*, **139** in 1859 for £1500 and the following year was able to afford no less than £5500 for Holman Hunt's *Christ in the Temple*, **124**.

Gambart lived in great style, owning opulent establishments in St John's Wood, Belgium and the Riviera.[24] Other printsellers were almost equally affluent and their average income in the 1840s was calculated to be in the region of £16,000. Messrs Graves & Co, for instance, reached an income of £22,000 in 1844. This was a huge sum of money by today's standards for even in the 1860s an annual income of £250 would support a family with three children and a maidservant,[25] and living up to standards of 'good society' required between £800–£1000. Thus mid-19th century prices can be multiplied at least 15 times to reach today's equivalent.

Competition between publishers was keen and they fell over each other in pursuit of successful painters whom they wooed with ever larger sums of money. A letter from Count d'Orsay to his friend Landseer sets the scene,

An original letter from the engraver A. Rainbach to his publisher R. Hodgson about the purchase of the copyright of David Wilkie's The Spanish Mother *for 200 guineas*

I saw Gambart today—he told me that he saw our friend Bell to whom he explained what he would do for you, without having the appearance of spoiling the market for speculators like MacLean and others, who will put in their pockets what ought to go in yours in a very short time. Gambart and all the publishers had a dinner yesterday at Blackwalk, where Moon and Graves met after fourteen years of coolness. The details of the whole affair made me die of laughter. Be sure that Gambart will show you on paper that by the present picture and the two others that you have in hand, you will make £10,000 by the engraving alone in three years.[26]

Jacob Bell, Landseer's business manager, knew that he held an ace. He could play off one printseller against another, and it was his policy 'never to appear at all anxious to dispose of the copyright'. His letters to Landseer describe guineas pouring in from all directions: 'Moon has called on me to pay 200 gns'; 'I shall also call on MacLean in a day or two for his 230 gns'; 'I shall draw up an agreement with Graves for 500 gns' and many more.[27]

The unfortunate engravers saw remarkably little of these rich spoils. David Lucas, for instance, who had produced some fine mezzotints after Constable and others, died destitute in a Fulham workhouse in 1881. That there were huge disparities between the kind of deals offered to engravers and those offered to painters can be shown by comparing two contracts. In the first the engraver, Samuel Cousins, offered to sell the publisher Moon, Boys & Graves the mezzotint plate of Sir Thomas Lawrence's *Miss Peel*, together with all the rights for the sum of 210 guineas.[28] The second contract offered to the painter, Frith, by Gambart is included in Frith's autobiography[29] 'for the benefit of sceptical readers'. It guaranteed the sum of £10,000 payable in instalments in advance and required only that three paintings be produced entitled *The Streets of London*. It is clear from this contract that what Gambart was really interested in was the copyright rather than the paintings themselves.

As so often happened with economically depressed sectors of the workforce, engravers were bullied and often shabbily treated by those who provided their slender income.

Some original letters survive in the National Art Library written from engravers to publishers and painters. The painful politeness with which engravers responded to harassment from publishers is a give-away of their true position. The letters also suggest that publishers did not always hasten to meet their debts where engravers were concerned. Sometimes engravers had to cringe and beg in order to get money rightfully owing to them. Sometimes they were patronised by kindly painters. A letter from W. B. Cooke to William Collins overflows with gratitude for a small piece of household furniture, and conjures the image of a big, impoverished family receiving largesse from a successful painter.

Engravers could not augment their income by holding back some of their own proofs for the purpose of speculation. George Doo wrote to a Mr Linnecar, printseller of Liverpool, in 1840 explaining that he could not send any signed proofs to Liverpool as he had none. He had in fact been trying to get hold of some for particular friends and had had to offer half a guinea *more* than the full price for them.[30]

Publishers sometimes showed little respect for engravers. Samuel Reynolds responded vehemently to the unprofessional conduct of a publisher in this hitherto unpublished letter,

My dear Sir,
I have not completed the plate and I think it most unjust for the printer to have taken one [impression] off the plate in its present state; indeed the thorough want of courtesy shown to me by your printer has been shameful. When I saw him at your house he promised to send me an impression to see how he brought it. I heard nothing from him until about ten days ago when two impressions were brought me, for what purpose I know not except to insult me, as they were extremely bad . . . The next I hear is from you, sending me the plate spoilt.

I have had three thousand taken off my plates and yet in a better state than the 'Gypsy' is. I have fortunately half a dozen taken off by my printer, to protect myself in a slight degree. I feel confident he would have taken off a thousand and the plate remained in a better state than it now is.

I should have had an impression sent one every fifty if common justice had been used towards me.

> I am, My dear Sir,
> Yours faithfully
> Saml. Reynolds.

Extract from the original of Samuel Reynolds' letter

The last sentence refers to the practice of checking every fiftieth print during the printing of an edition.

This letter also illustrates another aspect of professional maltreatment which must have been painful to craftsmen who took pride in their work. Once the plate had been handed over to the publisher, the engraver had no control over its future. A printseller having successfully published an edition could then sell the plate to another publisher who might repeat the success. For example William Holl's plate after Frith's *Village Pastor*, **135** first published by Lloyd Bros in 1849, later appeared in the catalogue of H. Graves & Co. Printsellers could squeeze further gain from a successful print by having it engraved more than once in different sizes; thus a diminished *Village Pastor* appeared in 1856 also published by Lloyd Bros and re-engraved by Holl. Jacob Bell writing to Landseer outlined a plan put forward by Thos Boys to extract two further plates from the large *Bolton Abbey in the Olden Time*, **29**. He suggested that Cousins should re-engrave the girl with the fish and the boy with the herons.

The only consolation the engravers might have had was in watching the cut-throat antics of the publishers, among whom quarrelling and jealousy were proverbial. Trouble usually arose when publishers vied for a particularly saleable subject. In 1839 the Duke of Wellington was at the height of his popularity and Messrs Ackermann published a print entitled *The Army and Navy. Representing the only interview between those great commanders, Wellington and Nelson.* Within a couple of weeks Mr Moon announced the issue of his plate entitled *The United Services. Representing the only interview of the heroes Nelson and Wellington.* Mr Moon then sent around a circular couched in the strongest terms declaring that the exclusive privilege bestowed on his engraver by the Duke himself had not prevented certain unscrupulous persons from pirating the subject.

As Messrs Ackermann's plate had been published first, how could they be accused of piracy? Further investigation revealed that this broadside was actually aimed at Messrs Graves for their plate depicting guests assembling for *The Waterloo Banquet*. Mr Moon feared for the success of his plate which was to depict the gentlemen one hour later seated at the banquet. The confusion deepened as two other plates of the Duke were announced which meant that Mr Moon was in trouble with Thos Boys as well. The periodical press watched with glee to see who would sue whom and what the outcome would be. Cloak and dagger activities in the publishing world were always carried on in the grandest, most pompous language.

The prime cause of all this acrimony was the lack of legal protection for copyright at that time. Print piracy was rife in spite of an Act passed in 1735 in the reign of George II for the protection of etchings and engravings. This had been largely inspired by Hogarth, whose work had been a favourite target for print pirates. However this 18th-century Act became increasingly ineffective because it did not extend to the many new reproductive methods which began to emerge in the 1830s.

John Martin, giving evidence at a Parliamentary inquiry into copyright in 1835, described the illegal exploitation of his works. He explained how sub-standard copies of his works were being made in France and then brought over to flood the English market; how various shops in Windsor were selling lithographed copies of his work at very low prices; how an unscrupulous person had exhibited a forgery of his *Belshazzar's Feast* in a sort of diorama in Oxford Street and informed the public that it was painted by Martin himself. He described how plagiarists were not only safe from prosecution, as the cost of an action far outweighed the benefits derived from the verdict, but how they came into the market having all the advantages of advertising and publicity launched by Martin at his own expense.

Damages were theoretically recoverable at the not inconsiderable sum of 5s a copy, but it was quite impossible

to prove how many copies had been printed, though in Martin's case the numbers must have run into thousands.

It was not until 1852 that active measures against piracy were taken. In that year Queen Victoria ratified an Act which extended to new reproductive methods the protection given in the 18th century to etchings and engravings and a decade later paintings, drawings and photographs were also made subject to copyright.

The international nature of the market in engravings soon made it evident that protection across borders as well as within individual countries was required. Thus in 1852 an international convention on copyright was concluded between England and France and in 1879 a similar bilateral arrangement was initiated in America with the passing of an Act of Congress requiring the registration of copyright with the Library of Congress in Washington. This led to a good deal of collaboration between British and American dealers. New York firms like William Schaus and M. Knoedler registered copyright on behalf of their British associates, Messrs Graves, Thomas Agnew and Arthur Tooth. Some British firms also followed the example of Frost and Reed in Bristol who registered prints in America themselves. Ultimately there was an international network of print publishers, people like Carl Gluck and Stiefbold & Co in Berlin, François Delarue in Paris and Arthur Tooth in London, who organised the production and distribution of prints world-wide and on a huge scale. Indeed as print publishing became increasingly costly and complex, collaboration on big projects became a necessity.

In view of the generally tense and competitive atmosphere, the complexity of publishing and the very high sums involved even in the 1850s, it is astonishing to find a woman in the field. Mary Parkes operated from her establishment at 22 Golden Square, London, in the 1840s and 50s. *The Sacking of Basing House*, *The Death of Douglas* and *Flora MacDonald's Introduction to Prince Charles Edward*, **84** are some of her publications. She also made a determined effort to crash the art lottery game and managed to raise subscriptions of at least 1820 guineas[31] but it is not known if her lottery ever succeeded.

The Art-Unions
Distribution to a large and diffuse public is a problem in any publishing operation particularly if, as was the case with Victorian printsellers, there is no national or international network of retail outlets. An ingenious solution was found in the establishment of the Art-Unions, the British example of which, the Art-Union of London, was set up in 1837 'to aid in extending the love of the Arts of Design, throughout the United Kingdom, and to give encouragement to artists beyond that afforded by the patronage of individuals'.[32] These characteristically high-flown Victorian sentiments were no doubt sincerely meant but, apart from that, Art-Unions were also an excellent marketing device combining the attraction of a book club

Title page from an Art-Union of London almanack dated 1842

with that of a lottery. The Art-Union of London was composed of members who subscribed one guinea or more annually. Prize money was allocated by lottery and the winner could choose works of art from current exhibitions at the Royal Academy, The British Institute and either of the Societies of Painters in Water-Colours. The selected paintings were exhibited by the Art Review Committee for the benefit of all members, after which they became the property of the prize winner. The Committee also commissioned an engraving, usually after one of the winner's choices, and prints were distributed to subscribers.

The idea of organising the art market on the lines of a lottery did not originate in England. Art-Unions had been started in Germany in 1825 and were flourishing in Berlin,[33] Dresden and Düsseldorf before the London Union got under way. In fact the German Art-Unions opened an office in London to capture British members; a step which was rapturously greeted by the monthly journal *The Art-Union* with the words that this would 'cause a considerable circulation of German engravings among us, whence can result nothing save improvement'.[34]

The Royal Dukes of Sussex and Cambridge were enlisted as patrons of the German Art-Unions in London,[35] possibly with a little prompting from Prince Albert who himself became the first president of the Art-Union of London.

Once established, the Art-Union concept spread quickly and within Britain the Art-Unions proliferated. By 1840 they were to be found in Liverpool, Birmingham, Manchester, Leeds, Norwich, Bath and Bristol. The existence of this curious form of public patronage did much for the

sale of paintings in Britain and America, though the sort of works that it encouraged were often criticised as being parochial and mediocre. The Society for the Promotion of the Fine Arts in Scotland was criticised in 1842 for exclusiveness in its operations which were limited to Scottish artists only, unsteadiness and fickleness and too great a striving to bring to notice the immature efforts of young artists.[36] In spite of this the Scottish unions had collected almost double the sum of the Art-Union of London in 1840. The *Annual Report* of the latter made peevish comment on this which they attributed to good relations with the Royal Scottish Academy, an advantage not enjoyed by the London Art-Union with the Royal Academy.[37]

The Royal Irish Art-Union was founded in 1839. The first engraving commissioned by them was undertaken by an English engraver, Henry Thomas Ryall, after a water-colour drawing by Sir Frederick Burton entitled *Blind Girl at the Holy Well*, **107**. This was a piece of luck for the publishers as its unhappy sentiment proved wildly popular with the Irish and subscriptions doubled to £3500 as a result. The committee resisted the temptation to squeeze more than the agreed 1300 prints from the steel-faced plate and destroyed it in 1842.

The Irish Art-Union should have stimulated the development of Irish painters, but sadly failed to make much impact in this direction largely because of the somnolence of the Royal Hibernian Academy which was notorious for doing nothing to promote the arts in Ireland, in spite of it being the only body of its kind to receive a grant from Westminster.

In spite of the precaution which stipulated that prizes should only be chosen from the reputable exhibitions mentioned above, officials of the London Art-Union very soon discovered evidence of lamentable taste among their prizewinners. In 1842 there was a move afoot to change one of the principal features of the Art-Union, namely the right of the public to select their own prizes.[38] 'Your committee' felt it would be desirable if prizes were selected only with their best advice, but after some high-principled sparring in the columns of *The Art-Union* this idea was quashed. If this plan had been adopted it would have put British art-unions in line with practices in Germany.

Because private individuals with little artistic judgement selected the prizes, some artists painted in a way designed to cater for these new patrons. Thackeray thoroughly disapproved of this attitude.

As one looks round the rooms of the Royal Academy one cannot but deplore the fate of the poor fellows who have been speculating upon the Art-Unions; and yet in the act of grief there is a lurking satisfaction. The poor fellows can't sell their pictures; that is a pity. But why did the poor fellows paint such fiddle-faddle pictures? They catered for the *bourgeois*, the sly rogues!... they are flinging themselves under the wheels of that great golden Juggernaut of an Art-Union. Alas! it is not for art they paint, but for the Art-Union![39]

As the Art-Unions' influence grew it was not surprising that doubts and complaints about their conduct grew too. Why had members received such poor impressions of the plate *The Tired Huntsman*? Would it not be a good idea to distribute engravings in the order in which subscriptions were paid in, so that early subscribers received the best impressions? The problems lay in the very success of the Union, for by 1840, when *The Tired Huntsman* was produced, there were 1959 members and a copper-plate could not produce that many prints. Two years later the membership was nearly 12,000 and the committee found their way out of the difficulty. In future copper-plates would be steel faced by means of electrolysis. The electrotyping was undertaken by Mr George Barclay of Gerrard Street, Soho, and Mr Palmer of the Polytechnic Institution.[40]

Not long after this, though, in 1844 there was a sudden move to suppress the art-unions. In America where the concept of a lottery was challenged in the Supreme Courts they lost their case and rapidly went under. In Britain they battled through, though a good deal of embarrassment was caused when it turned out that the list of subscribers and promoters included members of the Royal Family and even the Lord Chancellor himself.

Petitions flooded in from all parts of the country, meetings were held, guarantees were sought, and Thackeray gleefully took up his pen again.

The long-haired ones are tearing their lanky locks; the velvet-coated sons of genius are plunged into despair; the law has ordered the suppression of the Art-Unions, and the Wheel of Fortune has suddenly and cruelly been made to stand still.[41]

The attack on the art-unions came as a shock because the House of Commons had expressed itself in favour of them in a Report of 1836. However, eventually Parliament had a change of heart and, waiving objections, passed 'A Bill entitled an act for legalising Art-Unions'[42] which enabled them to go on operating into the 1890s.

Between 1838 and 1887 the Art-Union of London published 50 large plates and a number of folios of wood engravings and 'outlines'. By 1860, that is in 23 years, this Union had raised and distributed £254,143 of which £64,623 had gone to engravers and towards the cost of supplying impressions to subscribers.[43] Many engravers benefited, of whom David Lucas was the first as he engraved their first plate, *A River Scene in Devonshire* (1839). H. C. Shenton engraved the contentious plate, *The Tired Huntsman*. George Thomas Doo produced the fine line engraving, *The Convalescent from Waterloo* (1845), **65** and Peter Lightfoot received two commissions, for *Jephthah's Daughter* (1846), **109** and *Sabrina* (1849), **163**. Both the Holl brothers worked for the Art-Union, and William Sharpe produced the famous *Life at the Sea-side* (or *Ramsgate Sands*) (1859), **138**, *Raising the May Pole* (1862), **142** and *The Death of Nelson* (1876), **24** (detail). Lumb Stocks was also frequently employed, and his plates

include *Claude Duval* (1865), **103** and *Wellington and Blucher after the Battle of Waterloo* (1875).

The market for English engravings distributed in the United States from the fifties onwards in increasing numbers was no doubt opened up by the activities of the American Art-Union in the late thirties and forties. This organisation was based on the European models and run in the same way with subscriptions, annual hand-outs of prints and a lottery with paintings as prizes. The motivation, to influence, elevate and purify public taste along nationalistic lines, mirrored that of the Art-Union of London. As the American public, like the British, showed an irreversible preference for genre subjects, there was a flowering of American genre painting which no doubt paved the way for the successful American publication of such English engravings as *Baith Faither and Mither*, **22**, *Looking Out for a Safe Investment*, **25**, and *Steady, Johnnie, Steady!* Some of the most charming and successful promotions of the American Art-Union were *The Jolly Flat Boat Men* by George Caleb Bingham, engraved by Thomas Doney in 1847, a print of which was for sale for $2000 in New York City in 1878, *Mexican News* by Richard Caton Woodville, engraved by Alfred Jones in 1851 and *Farmers Nooning*, a delightful pastoral scene by William Sydney Mount, engraved by Alfred Jones in 1843. However, several of the engravings published by the American Art-Union show how closely American artists of this period followed the style and subject matter of British artists: *The Signing of the Death Warrant of Lady Jane Gray*, for example, shows how Daniel Huntingdon copied the work of Daniel Maclise, *The Capture of Major André* by Asher B. Durand is rather in the manner of Frederick Bromley, *The Voyage of Life — Youth*, by Thomas Cole, has a strong Martinesque flavour and *The New Scholar*, by Francis William Edmonds, is in the George Harvey/ Thomas Webster tradition.

The American Art-Union got off to a slow start as the Apollo Association for the Promotion of the Fine Arts in the United States in 1839, but ten years later, its annual exhibitions were attracting crowds of 250,000, when the population of New York City averaged about 400,000. A vast interest and demand had been stimulated and it is hard to avoid the conclusion that when the activities of this Art-Union ceased abruptly in 1851, bedevilled by the same question of legality that closed the Art-Union of London at about the same time, this demand was left largely unsatisfied. From the fifties onwards, we find English engravings being copyrighted and marketed in the United States in increasing numbers.

Examples of English engravings that found a market in America during the last half of the 19th century abound. Williams, Stevens, Williams & Co, Broadway, New York, marketed *Prince Charles Edward in Hiding after the Battle of Culloden*, **83**, by H. T. Ryall after Thomas Duncan, RSA, ARA, in about 1850 and *Beaming Eyes* by Henry Cousins after Charles Baxter in 1856. William Schaus in New York distributed engravings for Moore, McQueen & Co, for

example *Contemplation (Evangeline)* by James Faed after Thomas Faed, RA, RSA, in June 1863, and handled the famous Holman Hunt, *The Shadow of Death*, **130**, engraved by Frederick Stacpoole for Thomas Agnew & Sons, published 30 May 1878. The London publishers Pilgeram & Lefèvre also used William Schaus for the American distribution of their genre subjects after Faed, for example, *A Wee Bit Fractious*, **20**, engraved by William Henry Simmons, published in 1872; and those after Erskine Nicol, ARA, RSA, for example, *Looking Out for a Safe Investment*, **25**, also engraved by Simmons and published in 1878, and probably *Steady Johnnie, Steady!* by Simmons, published in 1874. *Absorbed in Robinson Crusoe*, **21**, by Frederick Stacpoole after Robert Collinson, was another engraving published jointly by William Schaus and Pilgeram & Lefèvre in 1873. In the same year the copyright of *Les Adieux*, **60**, by J. Ballin after J. J. Tissot, was registered in the office of the Librarian of Congress at Washington. This became a common practice in the last third of the century. Another print, registered in Washington, which captured American interest was *Young Puritans*, **106**, by J. J. Chant after a painting entitled *Early Puritans of New England Going to Worship*, by G. H. Boughton, ARA, published by Henry Graves & Co in 1874. Twenty years earlier Graves & Co published the popular *Landing of the Pilgrim Fathers*, **86**, by W. H. Simmons after Charles Lucy.

In the eighties, Arthur Tooth & Sons and Thomas Agnew & Sons were the leading London publishers operating on an international scale through distributors in Paris, Berlin and New York. M. Knoedler & Co in New York acted for Agnew in the case of *Tell — The Champion St. Bernard*, **45**, by W. H. Simmons after Samuel John Carter, published on 1 January 1881 and Millais's *The Bride of Lammermoor*, **62**, engraved by Thomas Oldham Barlow, published on 10 January 1882. *Effie Deans*, **61**, also by Barlow after Millais, was copyrighted in Washington. *Pomona*, **27**, another famous work by Millais, beautifully translated into mezzotint by Samuel Cousins, RA, was similarly registered, but published in London by Arthur Tooth, who also handled works after Lord Leighton such as *Bianca*, published in London and New York in 1897. Arthur Tooth marketed landscape etchings by T. N. Chauvel after Benjamin William Leader, RA, *February Fill Dyke*, **46**, and *In a Welsh Valley*, **47** in America in 1884 and 1902.

An association called the British Art Publishers' Union was in existence in America in the 1890s. It was through this organization that Arthur Tooth published *The Garden of the Hesperides*, **175**, in America in 1893, and Stephen T. Gooden published *He Loves Me — He Loves Me Not!*, **176**, in the same year. The first is a circular photogravure after Lord Leighton, PRA, and the second an etching with remarque after Sir Lawrence Alma-Tadema, RA. Two mezzotints of female upper-class elegance published by Arthur Tooth on the American market were *Invocation*, **177**, by J. D. Miller after Lord Leighton, PRA, and *A*

Welcome Footstep, **63** by E. G. Hester after Marcus Stone, in 1893 and 1899 respectively. Many photogravures went to America towards the turn of the century. *The Greek Dance*, **180**, after Sir Edward John Poynter, published by Arthur Tooth in 1900, is a typical example. Other popular painters were Edward Blair Leighton and Walter Dendy Sadler whose depictions of suburban comfort, often in Regency dress, were sold in America. Such were *Sweets to the Sweet* by Blair Leighton and *After Dinner Rest Awhile*, **159** by Dendy Sadler, sold by Arthur Tooth and Raphael Tuck & Sons.

The means by which these engravings were distributed and new subscribers were recruited was in the hands of a large number of honorary secretaries appointed by the Unions. These zealous men penetrated every corner of the world garnering funds which were then forwarded to the central body. There was no excuse for anyone, be he Indian, Chinese, Turkish, American or Egyptian, to plead ignorance of Fine Art—and that meant British art. In Constantinople you could apply to Mr James Robertson, in Mauritius there was Mr Henry Nagle, in Calcutta Messrs Thacker and in Shanghai, Messrs Hall & Holtz.[44] There were agents in Barbados and Bermuda, Quebec, Cape Town, Barcelona and Berlin. There were 73 agents in New Zealand and Australia in 1885, whereas there was only one in the whole of Italy for self-explanatory reasons. There were numerous agents in the Americas and only two in France neither of whom were in Paris. With the exception of Mr M. S. Boyle in Sierra Leone, 'our agents in Africa' were all in South Africa and numbered six.

At home there were agents everywhere from Stratford-upon-Avon to Stoke Newington and the Art-Union was justified in its claim that

It sent some hundreds of engravings over the world,—to the gold-diggers of Australia, the back-woodsmen of Canada, to New Zealand, China, the Indies, Egypt, the United States; in fact, to nearly every corner of the globe where there is an English settlement, as well as to every city, town, and village of the United Kingdom.[45]

The mass medium

Wherever the Union Jack went, Victorian engravings followed. Illiteracy and language barriers were swept aside by these pictorial dramas. The Victorian message was so powerfully distilled in them that it overcame any ignorance of the exact literary or historical references. One need not have read Longfellow to understand the meaning of the print, *The Hunted Slaves*, **146**. A plate such as *Guilt and Innocence* revealed only too plainly the heavenly displeasure meted out to pretty, wayward girls, and the alternative grace bestowed on plain piety. *Charity*, **12** spoke for itself. *Fight for the Standard*, **71** proclaimed the supremacy of England. *The Secret of England's Greatness*, **122** was undoubtedly her Christian faith and her willingness to impart it to the unenlightened black masses. Here the Queen graciously presents the Word of

God to a Zulu king—there is no indication that her Parliament might later annex his land.

The stories behind the engravings in this book are told in the notes to the plates. Recurring themes such as poverty, death, homelessness, imprisonment, emigration and war seem morbid subjects for decorating a home, yet they were the stuff of life to the mid-Victorian print buyer. Loaded emotional content often obscured the lack of aesthetic quality. The lack of sophistication, the absence of satire and the transparent motives which characterise these engravings often appear obtuse to our eyes. Yet, as Boase says, 'their sentimentality was a stage in the growth of social responsibility'.[46]

Evangelists, emancipators, and all those with a moral cause, exploited the medium, although the advertising potential in the industry was never developed for financial gain. Engravings were used to propagate current attitudes and thus bring about the conformity of public opinion which has now reached international proportions in the term 'world opinion'.

As this medium took hold of the public imagination and gained momentum, it gave rise to the vexed question of public taste. This delicate question, loaded with class awareness, was a source of constant fascination to those who set themselves up as the arbiters of taste. The periodical press rang with high-toned comment and censorious attitude. The great machine was getting out of hand, it should be directed aright for public improvement. Print publishers who gave the public what it wanted were regarded as unprincipled bounders by those who were not print publishers and had nothing to lose by criticism.

The Victorians were frustrated by the belief that somehow everyone should share the same tastes and those had to be the 'elevated' tastes of the minority. What is more, the minority had a moral obligation to subsidise and support this process. A hundred years elapsed before this false premise was understood and the profitable business of catering for the majority could be used to generate resources to feed minority taste as well.

This medium was in many ways a more subtle and insidious tool than today's television documentary. First, because the incident portrayed was always a re-arrangement of reality through the bias of the painter. A documentary photograph, on the other hand, is a pictorial fact. Secondly, the real punch was often concealed behind some palatable fable or anecdote and thus caught people unawares or affected them subconsciously.

The timing of the publication of *The Hunted Slaves*, **146** suggests that it was calculated to play on political as well as humanitarian feelings. The emancipation of the slaves had been achieved in 1833 when Britain raised £20,000,000 to compensate slave-owners in her dominions. The print sold on the emotive question of slavery, yet it also aimed concealed barbs at the Americans. This may explain why it was actually published in 1860, 30 years after the question of slavery had been settled but at a time when America was the burning issue.

The double entendres in Victorian engravings make a fascinating study in their own right. It was quite possible for someone to buy a pictorial tirade on the evils of lust, and by doing so hang on his wall an alluring and shameless nude—a most enjoyable piece of chastisement and no offence to propriety. Such a print is *The Pursuit of Pleasure: a Vision of Human Life*, **168**.

Victoria's presence on the throne dispelled the Byronic glamour of the Napoleonic era and brought a new sense of sobriety and properness. Painters tackled the earnest question of real life. But as the century drew to a close and the responsibilities of the Empire reached a peak there was a general retreat from reality into opulent fantasies of ancient Rome or the pseudo-simplicity of Medievalism. Photogravure and etching were the commonest kinds of reproductive print at this time, see *The Legend of the Briar Rose* (1892), **174a**, **b**, **c** and **d** after Burne-Jones and *He Loves Me—He Loves Me Not!* (1893), **176** after Alma-Tadema; though pure mezzotint was still used for prestigious prints after painters like Lord Leighton and Albert Moore, for example *Invocation* (1893), **177** and *Dreamers* (1898), **179**.

The fashion for reproductive etching, instead of engraving, was an indirect outcome of the Paris Commune of 1870 which caused French etchers to flee to England. The general adoption of photogravure for mass-produced prints liberated the graphic arts, hence the revival of lithography and etching as spontaneous, original graphic techniques. However, there was no re-birth of engraving.

In these late prints, full of effete sophistication and contrived aestheticism, the simple intensity of the mid-Victorian engravings can no longer be found. The languid poses and faintly festering lilies spell out decay. The print industry no longer exported a moral code, it simply supplied decoration.

If we can say, therefore, that pictorial images represent history in its most truthful form, then these engravings unlock the history of Victorian England. They describe a nation united by the self-confidence which springs from absolute certainty; not only that they were the natural missionaries and masters of the earth but that the stability of their homeland, embodied in the Crown, was unquestionable and permanent.

Notes

[1] H. C. Levis, *Descriptive Bibliography of the Most Important Books in the English Language Relating to the Art and History of Engraving and the Collecting of Prints*, London 1912, p 97.

[2] *Brief Account of the Connexion of Engraving with the Royal Academy of Arts*. Prefixed to a reprint of *Evidence Relating to the Art of Engraving*, London 1836.

[3] Sir R. Strange, *The Rise and Establishment of the Royal Academy*, London 1775.

[4] *Petition to the Honourable Members of the House of Commons of the United Kingdom of Great Britain and Ireland in Parliament Assembled*, 11 June 1836. *Report of the Select Committee of the House of Commons on the British Museum*, 14 July 1836.

[5] Published in an edition of six, each copy uniquely illustrated.

[6] W. J. Stannard, *Art Exemplar*, 1859, pp 47, 48. Illus. E. M. Harris, MS Reading 1965, pp 58–68, 203.

[7] *The Art-Union*, April 1849, p 89.

[8] A. S. Kenyon, 'Photolithography: A Victorian Invention', read before The Royal Society, 1 March 1826.

[9] W. P. Frith, *My Autobiography and Reminiscences*, London 1888, III p 159.

[10] Algernon Graves in *The Printseller*, 1903, p 38.

[11] ibid, p 37.

[12] W. P. Frith, op cit, III p 160.

[13] A. Graves, *Catalogue of the Works of the Late Sir Edwin Landseer*, London 1874, no 102.

[14] A. Graves, 'Thomas Landseer' in *The Printseller*, 1903, p 107.

[15] ibid, p 105.

[16] A. Graves, 'Charles George Lewis' in *The Printseller*, 1903, p 204.

[17] ibid, p 207.

[18] *The Art Journal*, 1871, p 103.

[19] A. Graves, 'Robert Graves' in *The Printseller*, 1903, p 381.

[20] ibid, p 381.

[21] A. Graves, 'Samuel Cousins' in *The Printseller*, 1903, p 37.

[22] ibid.

[23] John Pye, Patronage of British Art, London 1845, facsimile reprint 1970, p 210.

[24] ibid, II p 116.

[25] *Early Victorian England*, 1830–65, edited by G. B. Young, London 1934, II p 103.

[26] Original letter from Count d'Orsay to Landseer, 1837.

[27] Original letter from Jacob Bell to Landseer, 1 September 1842.

[28] Contract published in *The Printseller*, 1903, p 240.

[29] W. P. Frith, op cit, I pp 338, 339.

[30] *The Art Journal*, 1856, p 92.

[31] *The Printseller*, 1903, p 240.

[32] 'Plan of the Art-Union of London', from the *Annual Report*, 1840.

[33] Article on the German Art-Unions in *The Art-Union*, 1842.

[34] *The Art-Union*, June 1842.

[35] ibid, 1 July 1842.

[36] 'The Scottish Art-Union' in *The Art-Union*, 1842, p 168.

[37] *Annual Report of the Art-Union of London*, 1840.

[38] Letter to *The Art-Union*, March 1842, p 42.

[39] W. M. Thackeray, *Critical Papers on Art*, London 1904, p 208.

[40] *7th Annual Report of the Art-Union of London*, 1843, p 6.

[41] W. M. Thackeray, *Critical Papers on Art*, London 1904, p 208.

[42] 'The Legalisation of Art-Unions' in *The Art-Union*, 1844, p 284.

[43] *24th Annual Report of the Art-Union of London*, 1860.

[44] *The Art-Union of London Almanack*, 1885, p 91.

[45] *24th Annual Report of the Art-Union of London*, 1860.

[46] T. S. R. Boase, *English Art 1800–70*, Oxford 1959, p 319.

Children

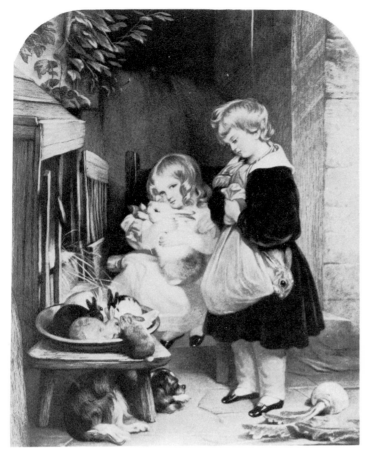

1 Children and Rabbits

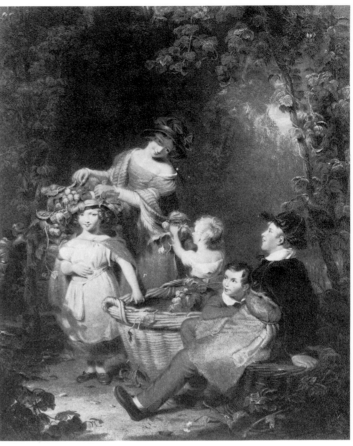

2 The Youthful Queen of the Hop Garden

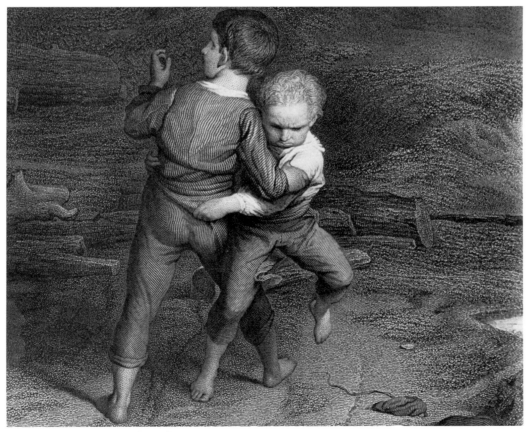

3 The Convalescent from Waterloo (detail)

20

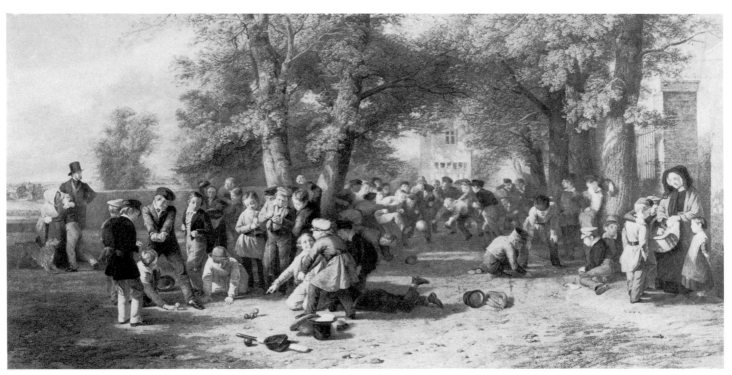

4　The Play-ground

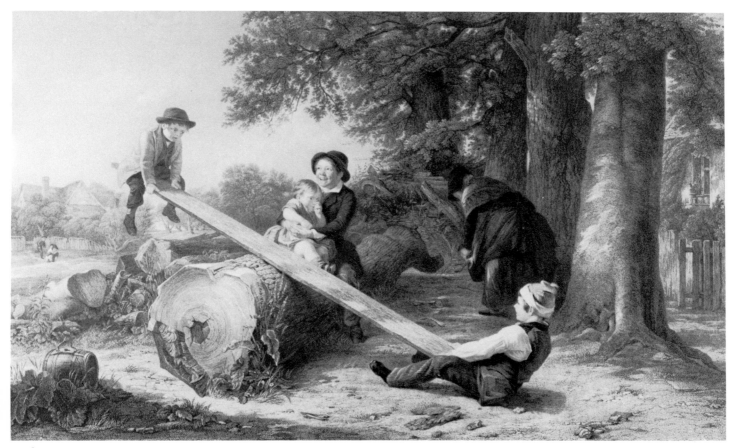

5　See-saw

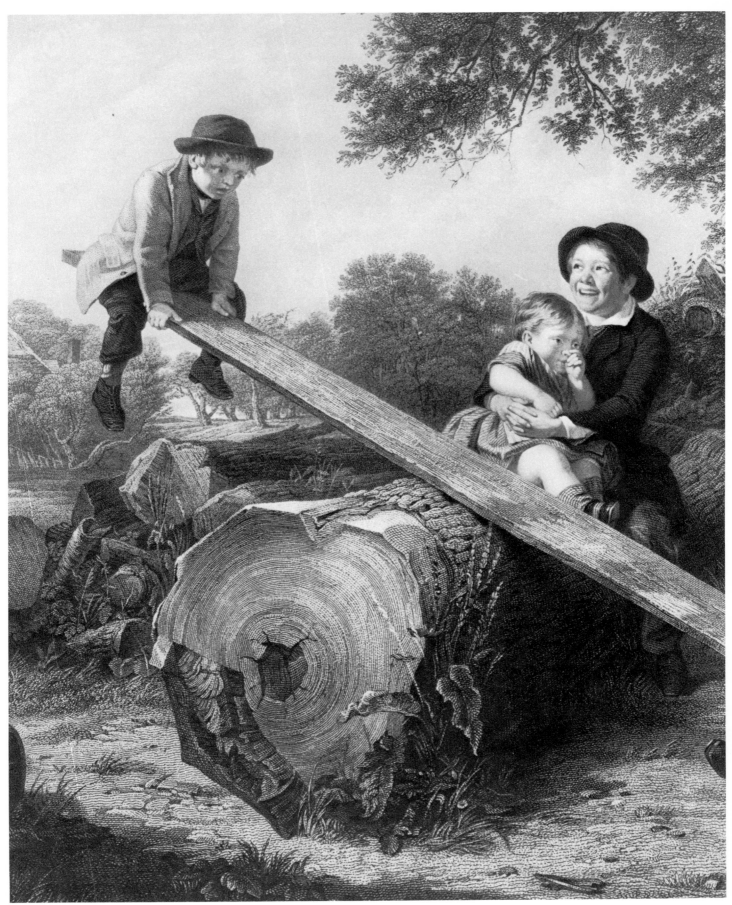

Detail of See-saw

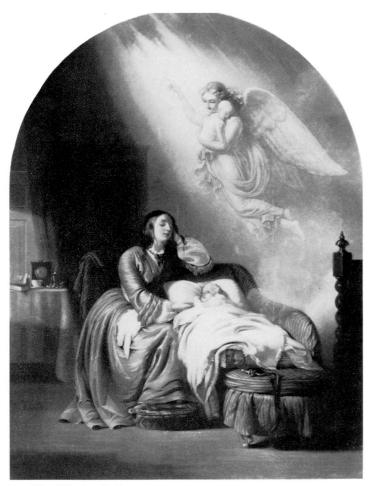

6 The Mother's Dream

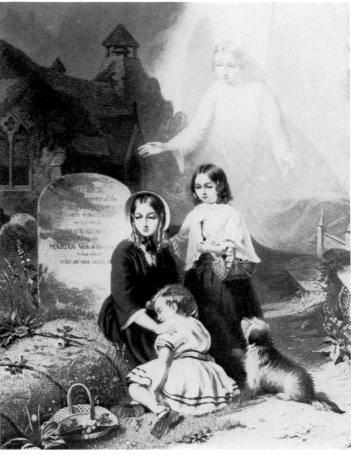

7 The Orphans

23

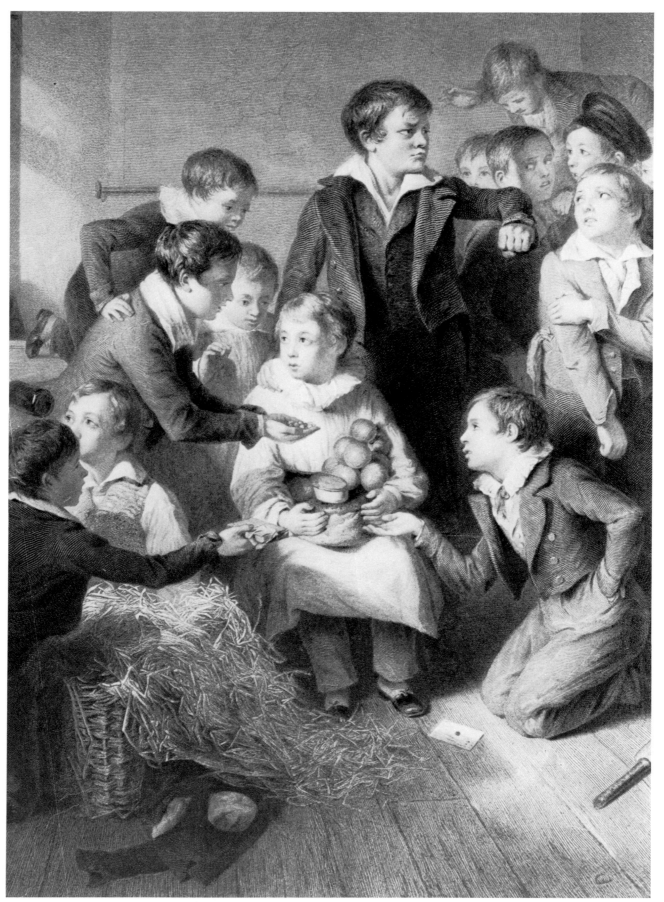

8 **The Boy with Many Friends** (detail)

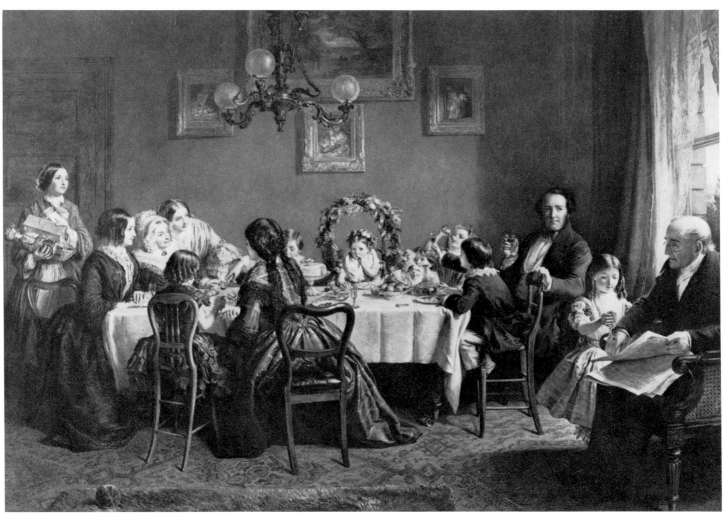

9 Many Happy Returns of the Day

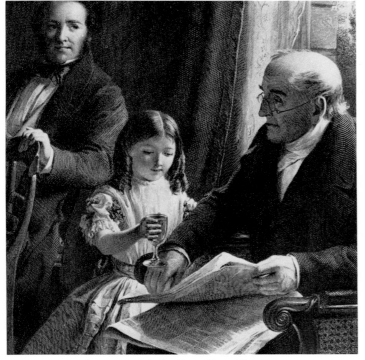

Many Happy Returns of the Day (detail)

10 Come Along (detail)

11 His Only Pair

12 Charity (detail)

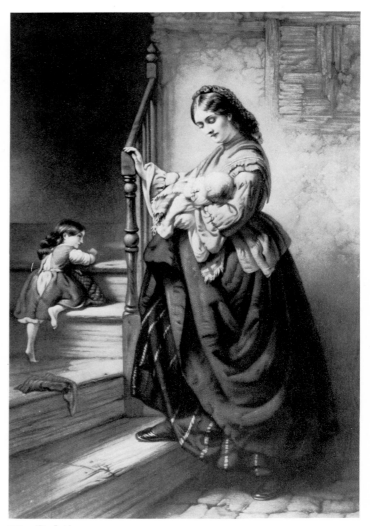

13 Bed-time

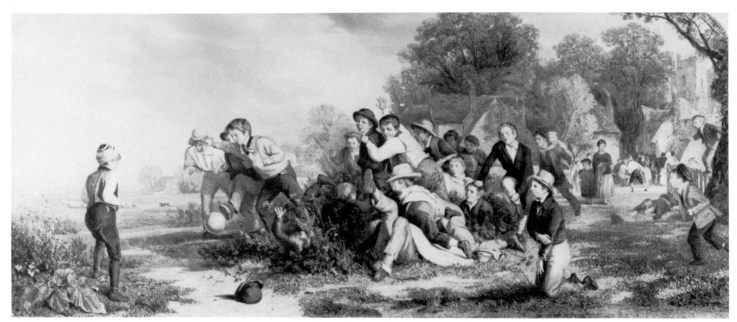

14 Foot Ball

15 My First Sermon

16 Awake (detail)

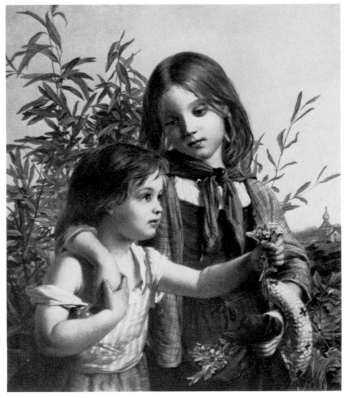

17 Remembrance

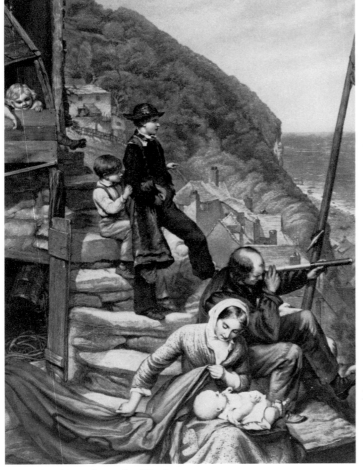

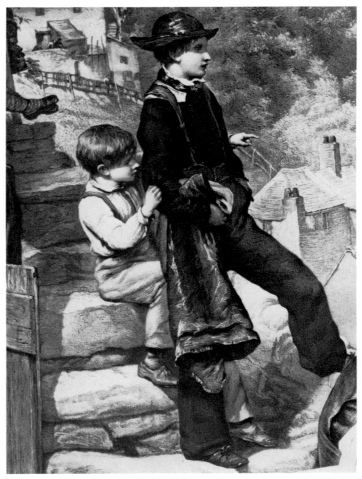

18 The Signal on the Horizon Detail

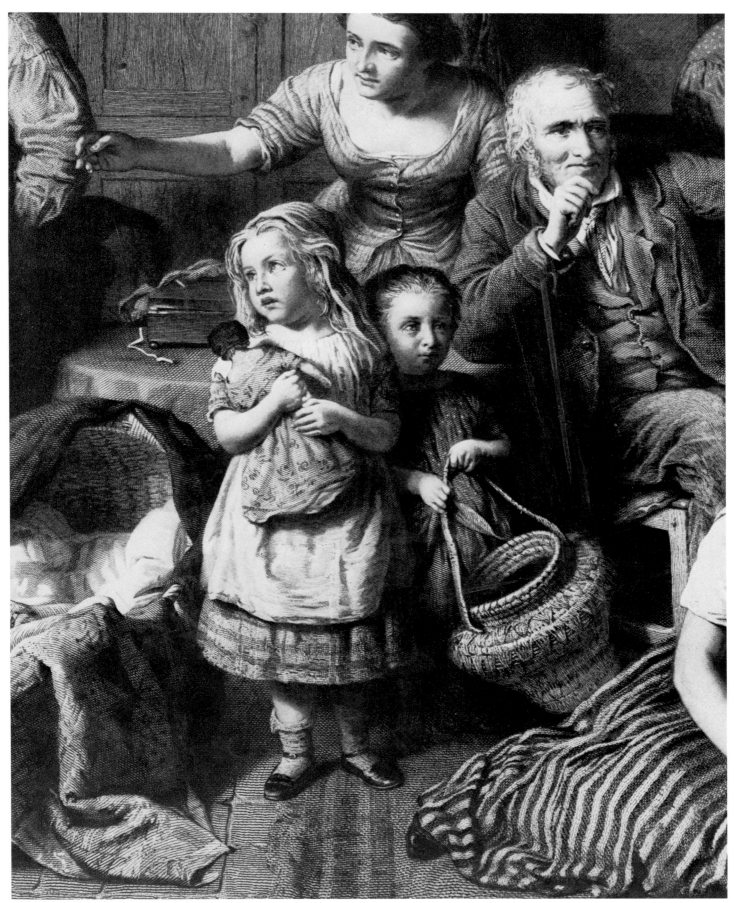

19 Light and Darkness (detail)

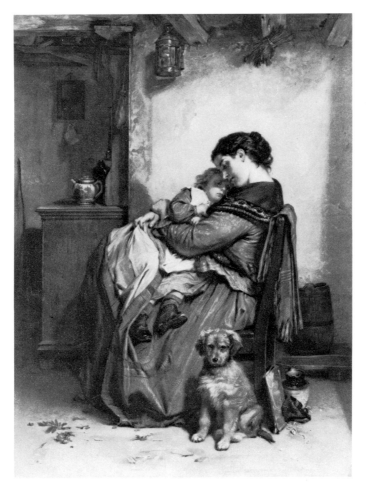

20 A Wee Bit Fractious

21 Absorbed in Robinson Crusoe

22 Baith Faither and Mither

Detail

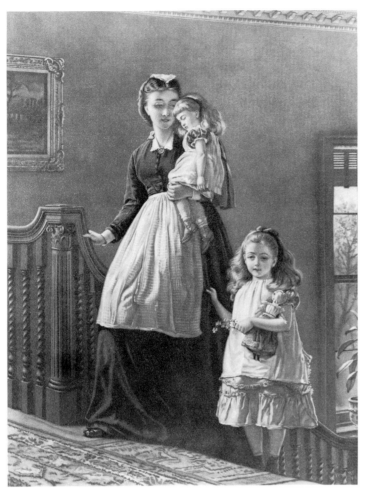

23 (a) Seven p.m.

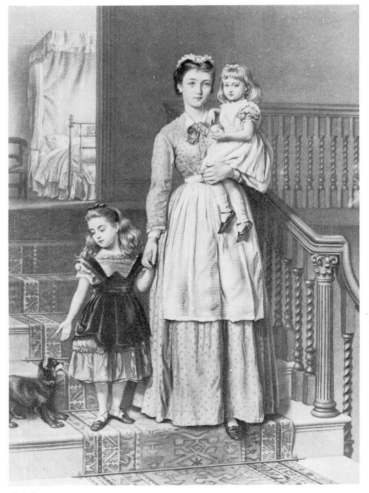

(b) Seven a.m.

24 Death of Nelson (detail)

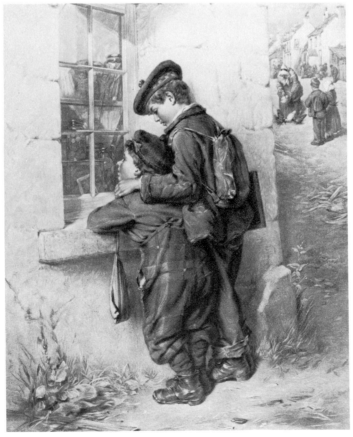

25 Looking Out for a Safe Investment

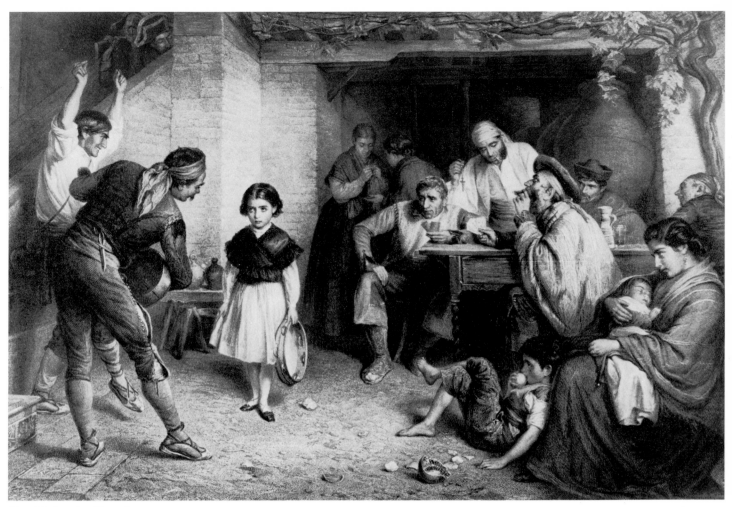

26 Stolen by Gypsies

27 Pomona

34

Animals and Rural Life

28 **The Young Bird**

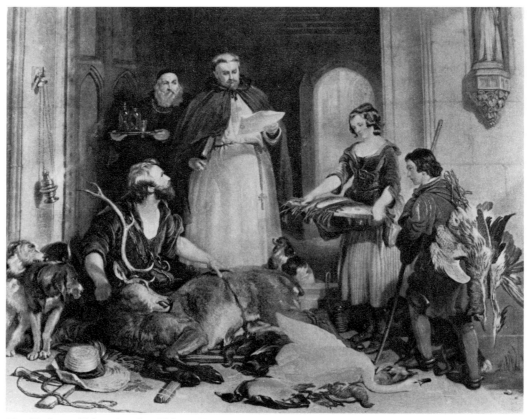

29 **Bolton Abbey in the Olden Time**

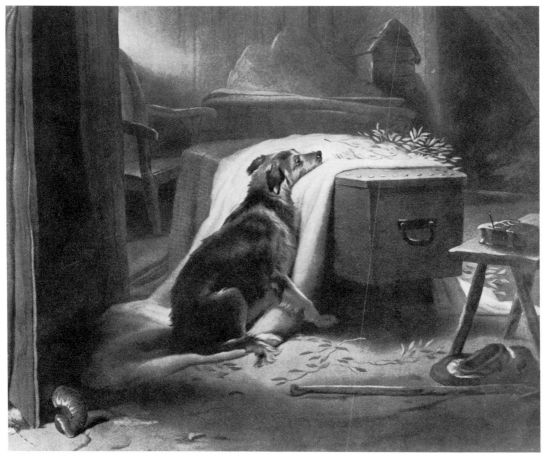

30 The Old Shepherd's Chief Mourner

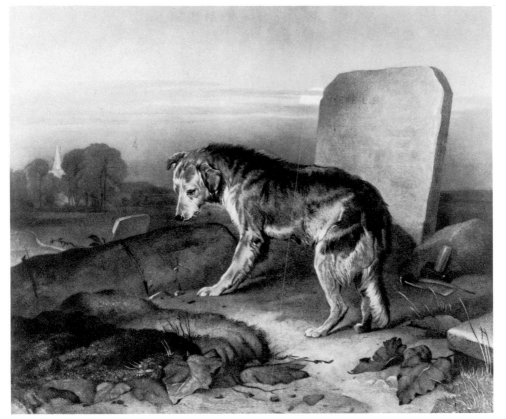

31 The Shepherd's Grave

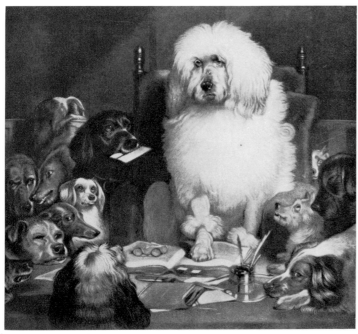

32 Laying down the Law

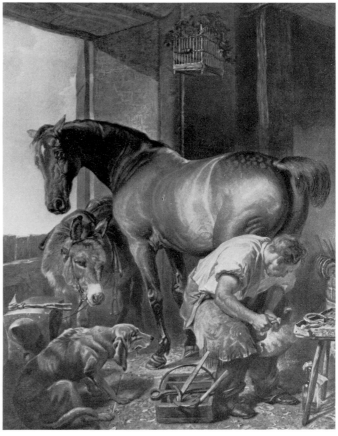

33 Shoeing the Horse

34 An English Merry-making in the Olden Time (detail)

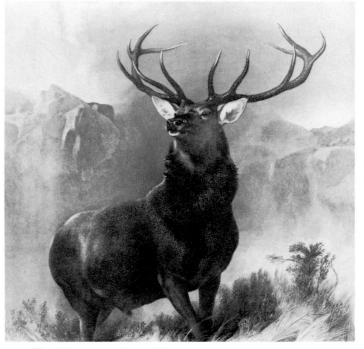

35 The Monarch of the Glen

36 The English Gamekeeper

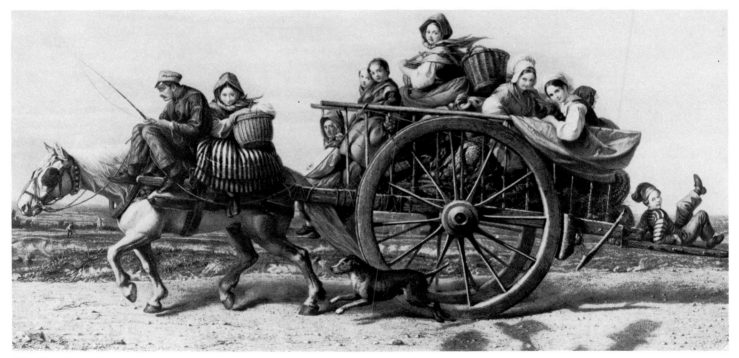

37 Bonjour Messieurs

38 The Forester's Daughter

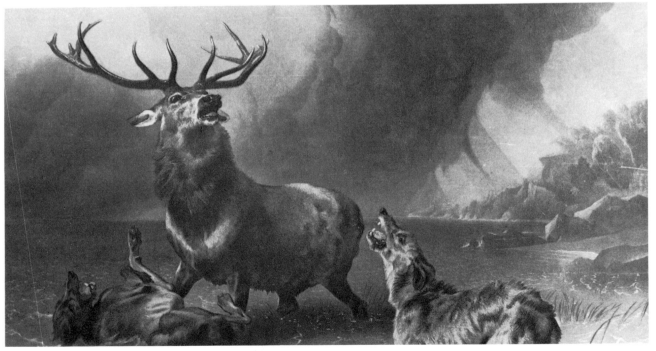

39 The Stag at Bay

40 (a) Labour

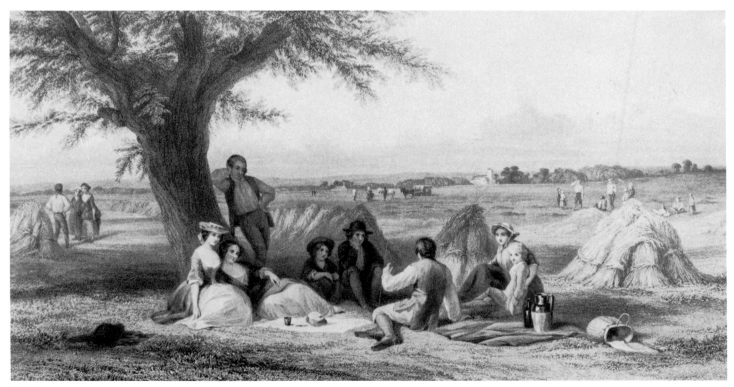

(b) Rest

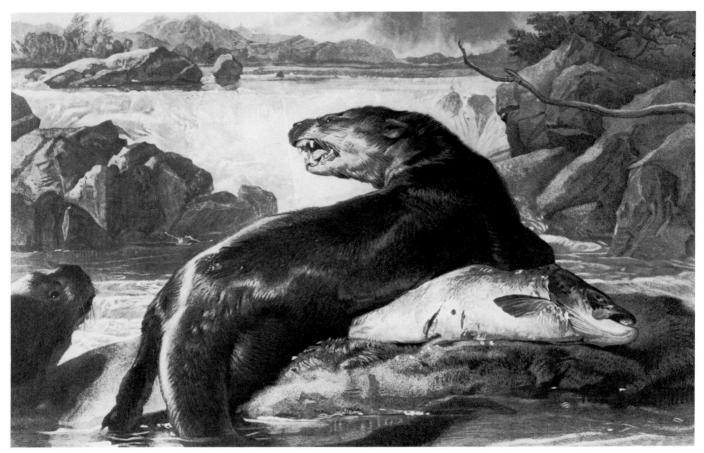

41 Otters and Salmon

42 Just Caught

Detail

43 Dominion

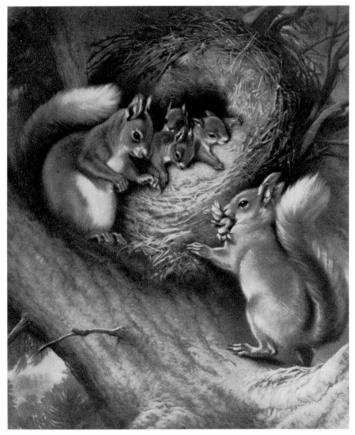

44 A Little Freehold

44

45 Tell—The Champion St. Bernard

46 February Fill Dyke

47 In a Welsh Valley

Romantic Love

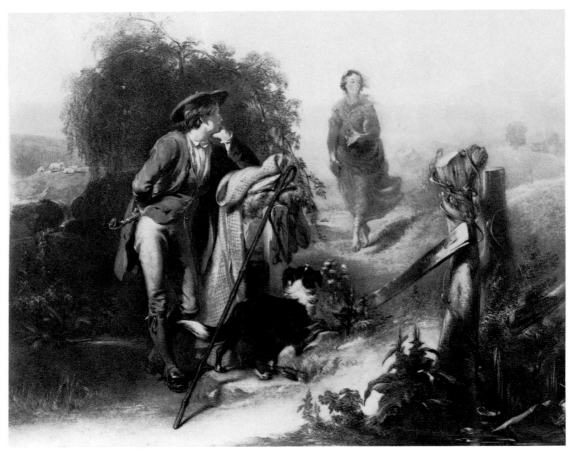

48 The Gentle Shepherd

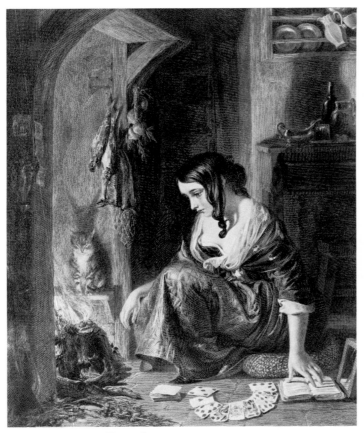

49 A Peep into Futurity

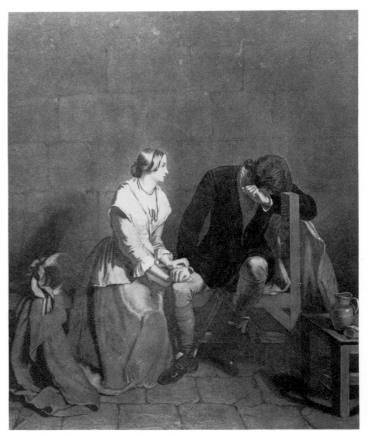

50 The Momentous Question

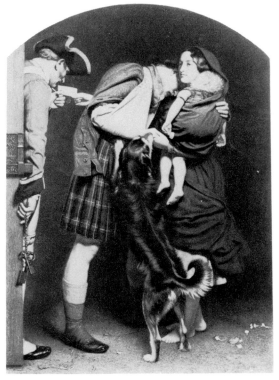

51 The Order of Release

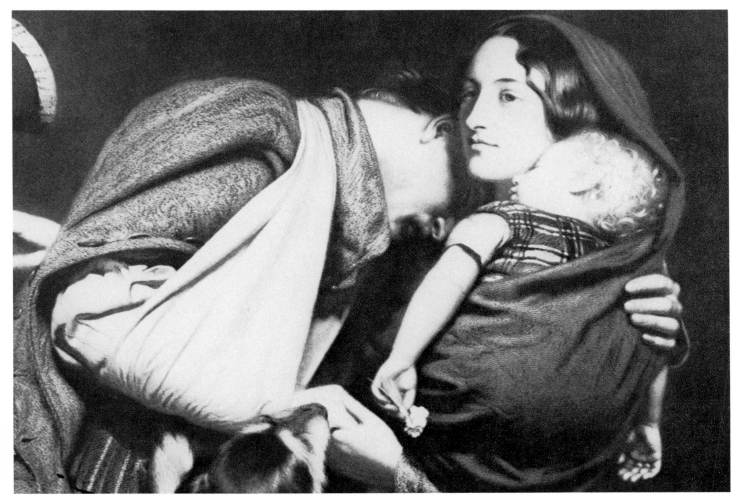

Detail

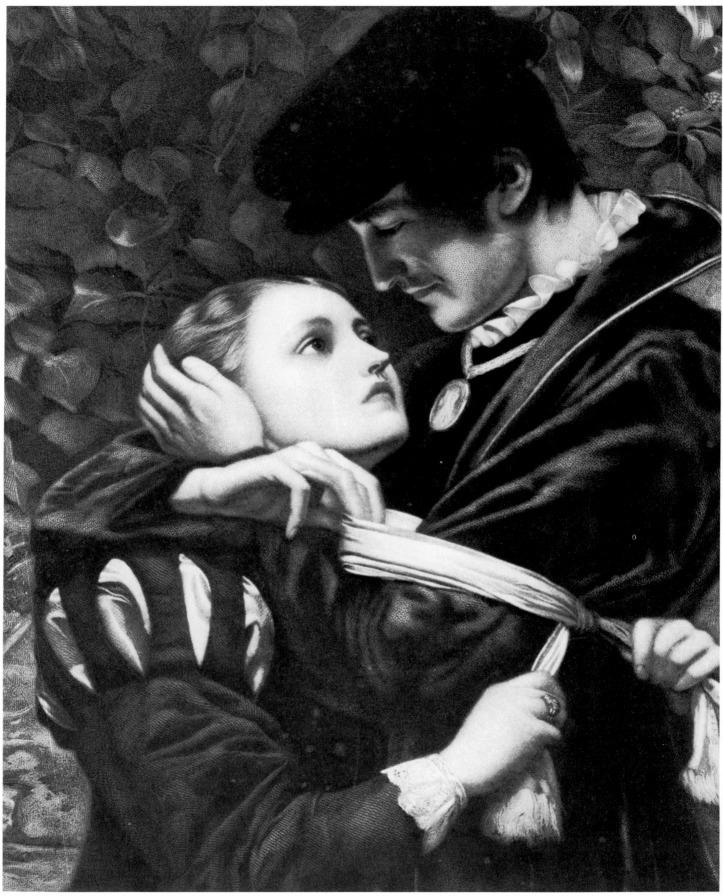

52 The Huguenot (detail)

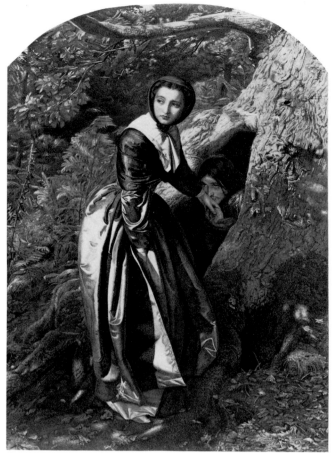

53 The Proscribed Royalist

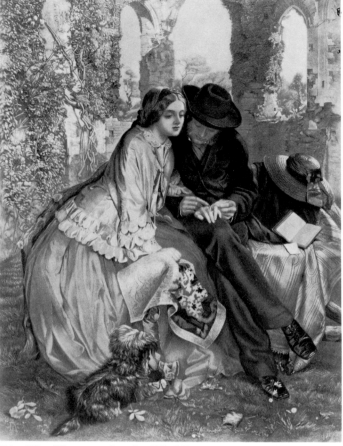

54 The Measure for the Wedding Ring

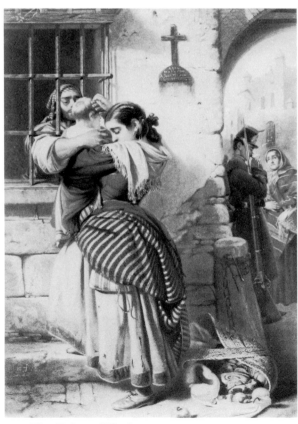

55 The Prison Window

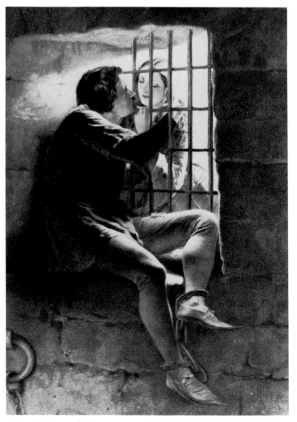

56 Prison Solace

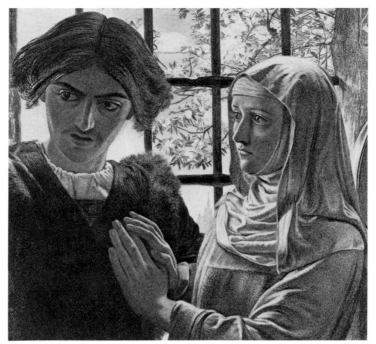

57 Claudio and Isabella (detail)

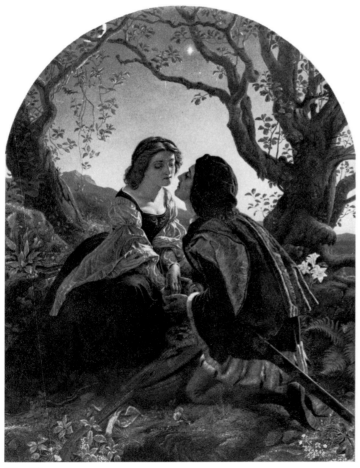

58 Hesperus

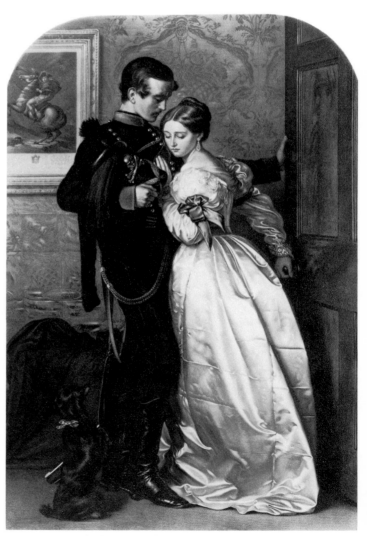

59 The Black Brunswicker

52

60 Les Adieux

61 Effie Deans

62 The Bride of Lammermoor

63 A Welcome Footstep

Heroes of War

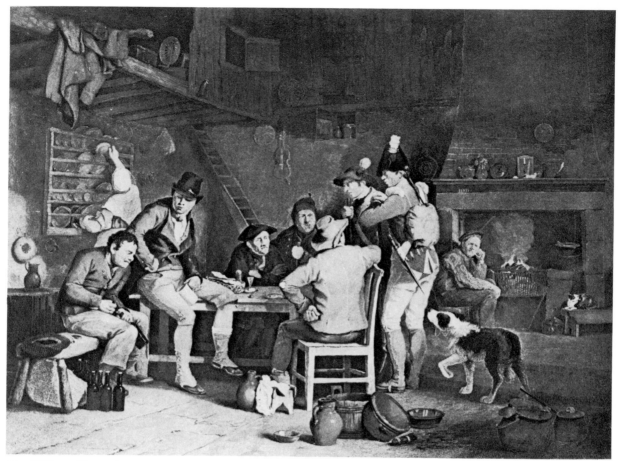

64 Village Recruits

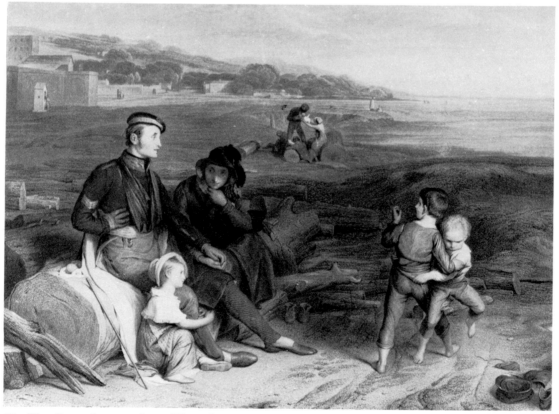

65 The Convalescent from Waterloo

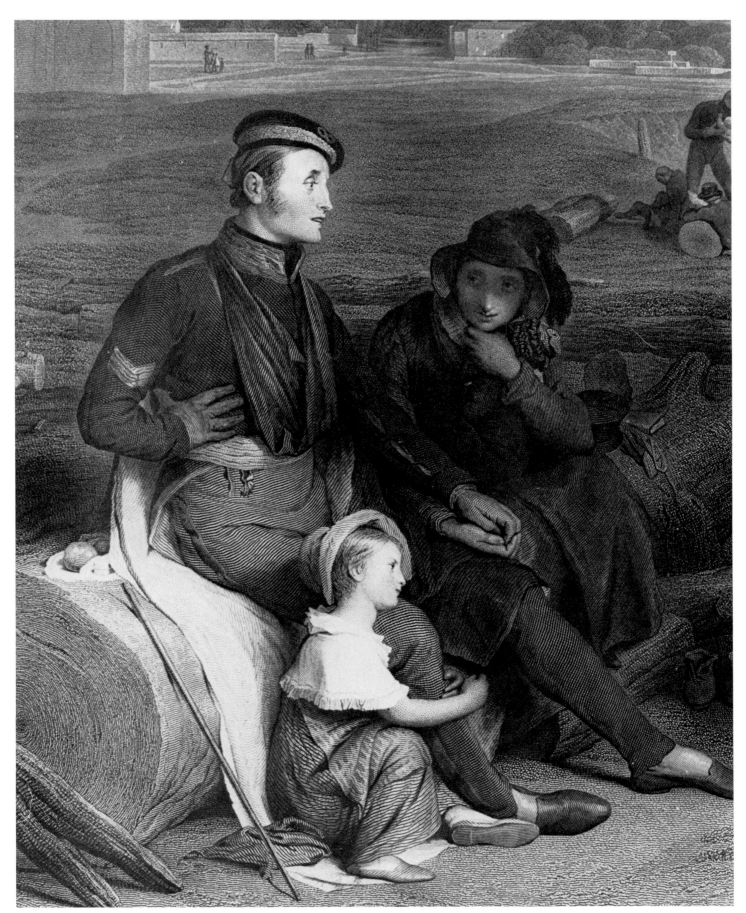

Detail

66 A Lesson for Humanity

67 'Home!' Return from the Crimea

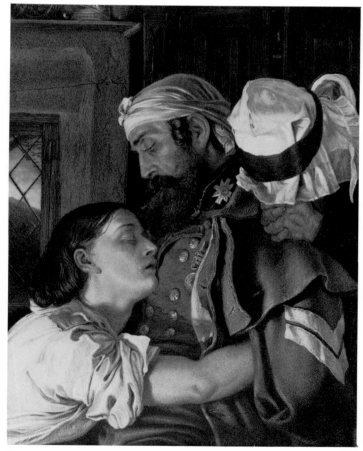

Detail

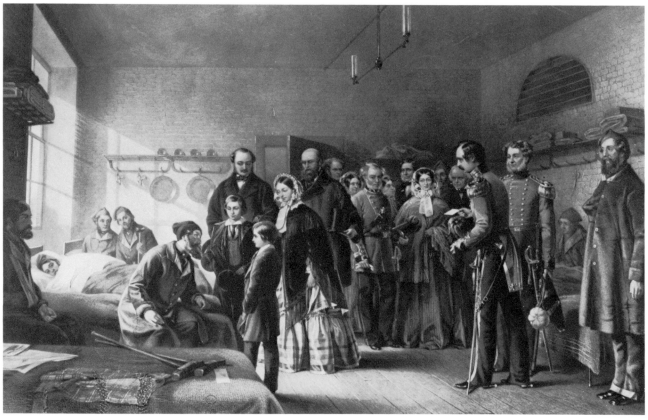

68 Queen Victoria's First Visit to her Wounded Soldiers

69 The Champion of England

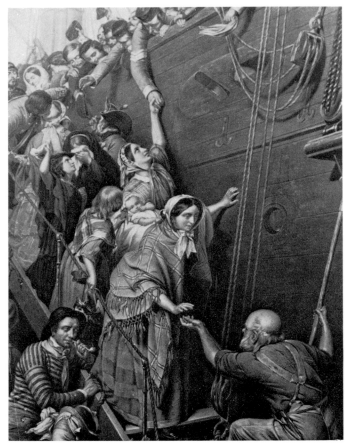

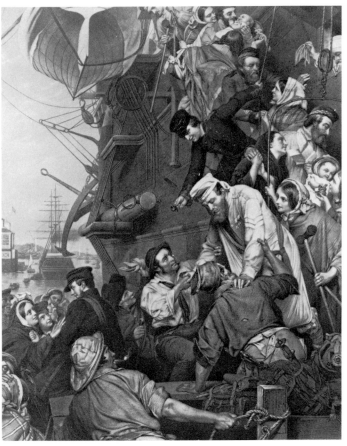

70 (a) Eastward Ho! August 1857 (b) Home Again

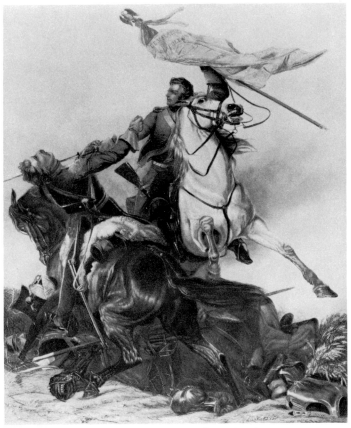

71 Fight for the Standard

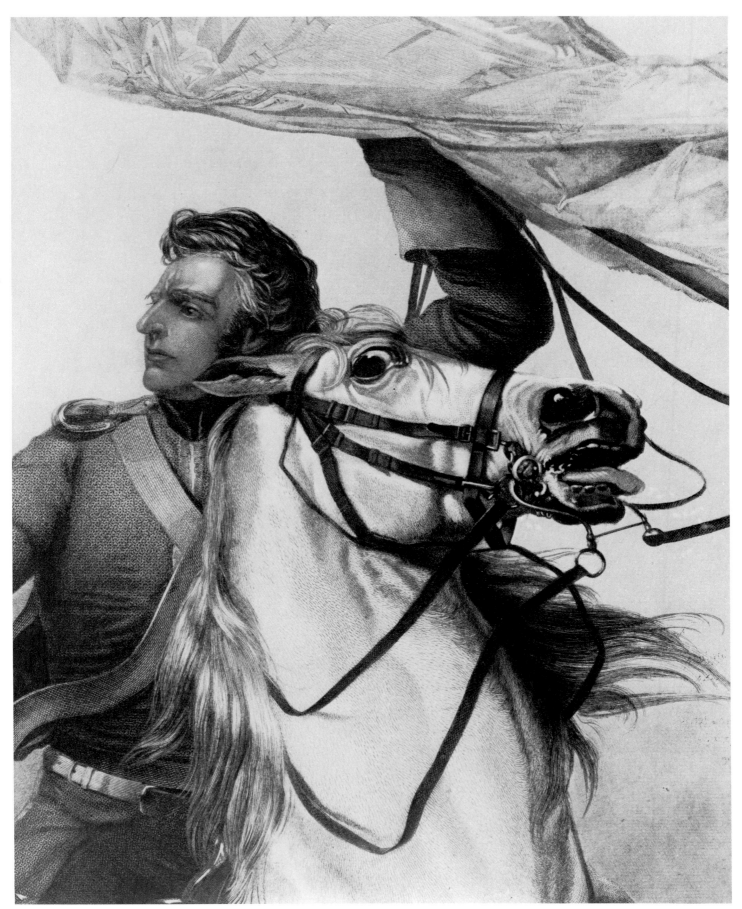

Detail

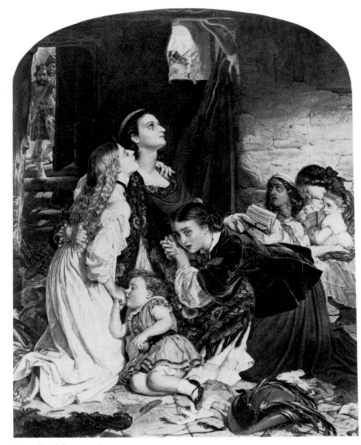

72 In Memoriam

Detail

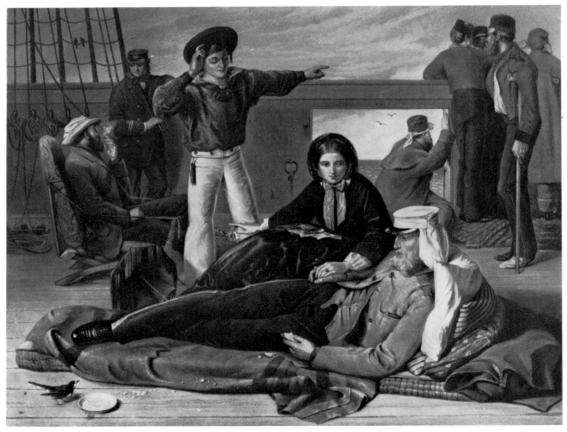

73 Nearing Home

Historical Persons,
Places and Events

74 The Royal Cortege in Windsor Park

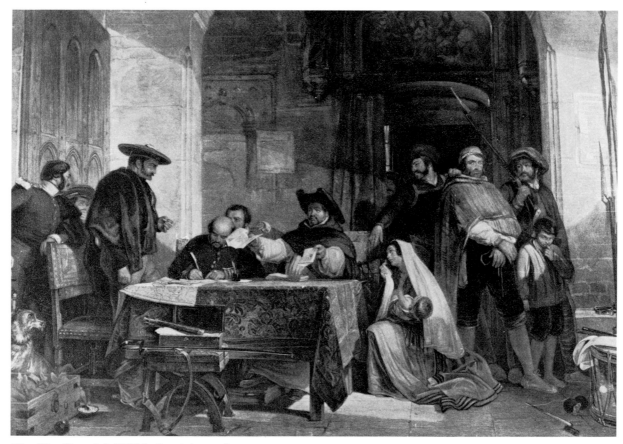

75 The Spanish Wife's Last Appeal

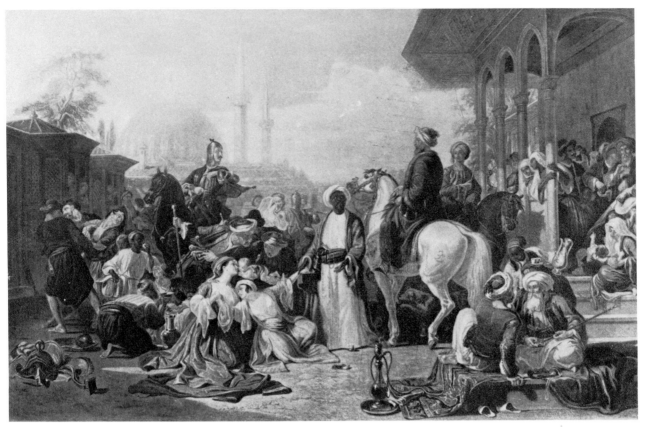

76 The Slave Market, Constantinople

77 Raffaelle and the Fornarina

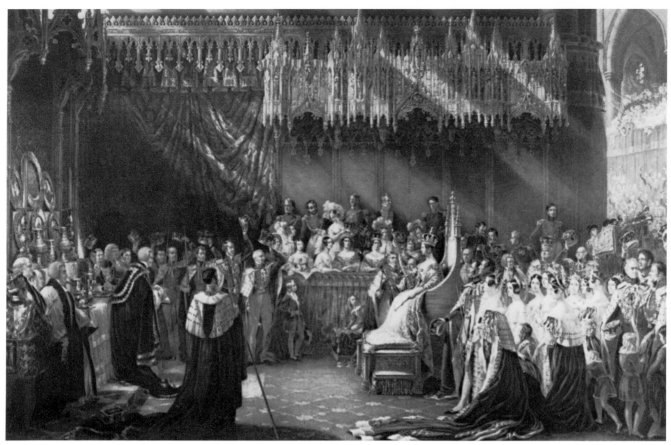

78 Coronation of Her Most Gracious Majesty Queen Victoria

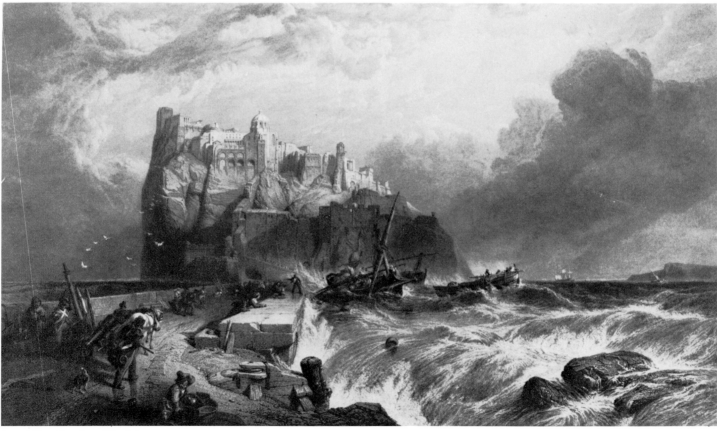

79 The Castle of Ischia

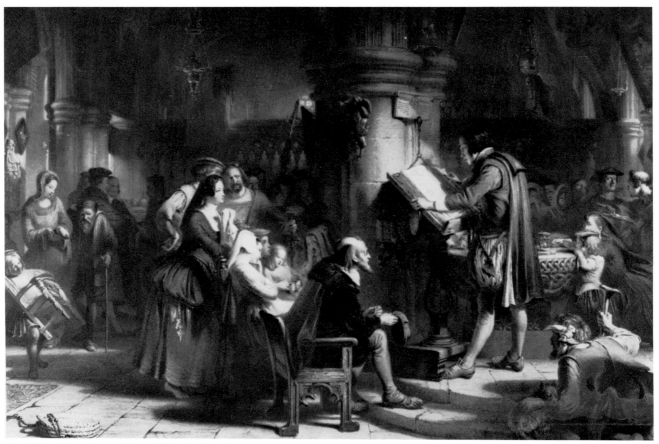

80 **First Reading of the Bible in the Crypt of Old St. Paul's**

81 **The Invention of the Stocking Loom**

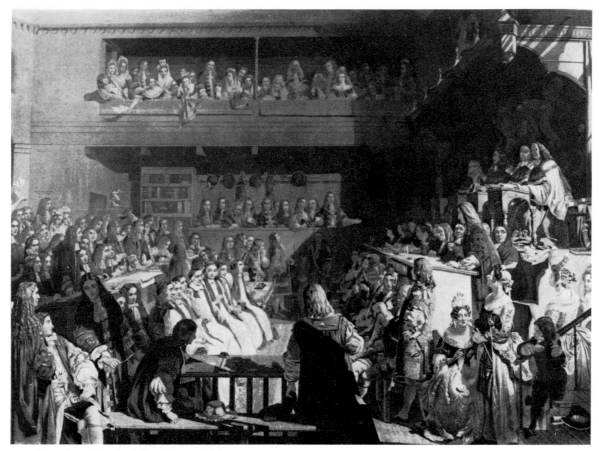

82 The Acquittal of the Seven Bishops

83 Prince Charles Edward in Hiding after the Battle of
 Culloden (detail)

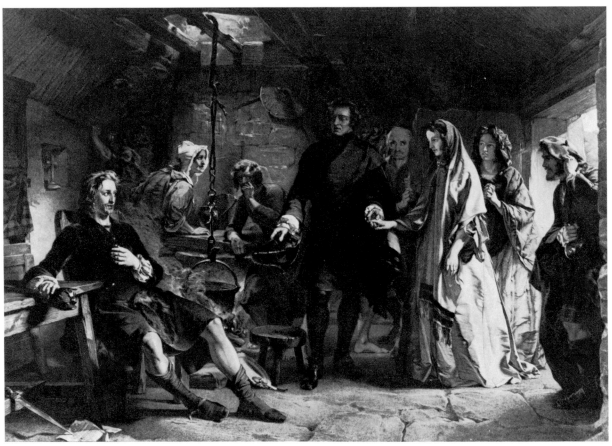

84 **Flora Macdonald's Introduction to Prince Charles Edward**

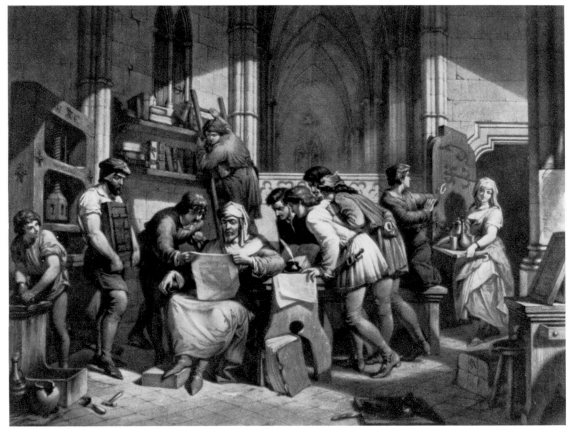

85 **The Caxton Memorial**

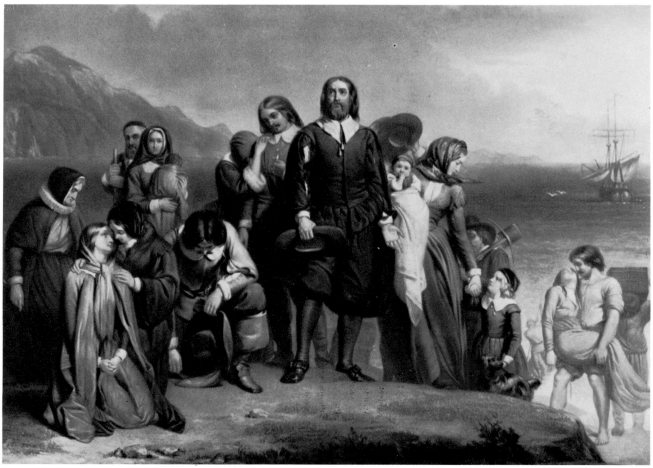

86 Landing of the Pilgrim Fathers

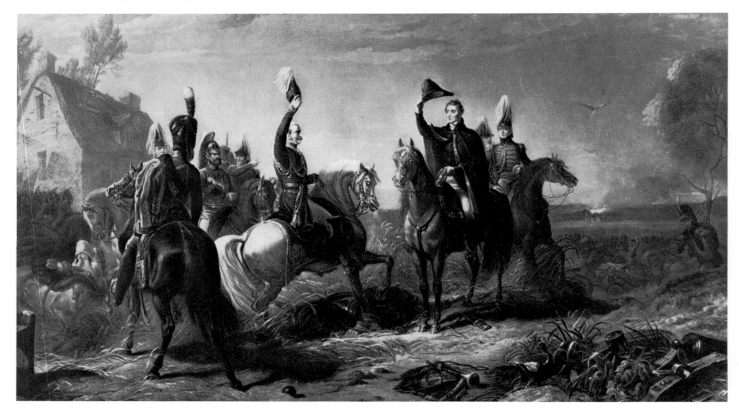

87 The Meeting of Wellington and Blucher on the Evening of the Victory at Waterloo

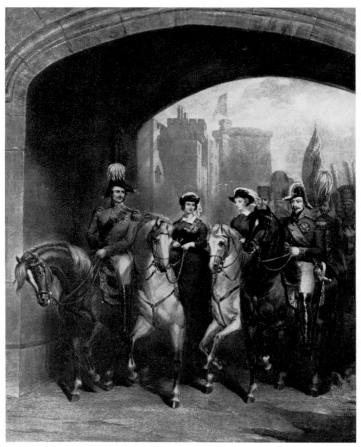

88 The Alliance

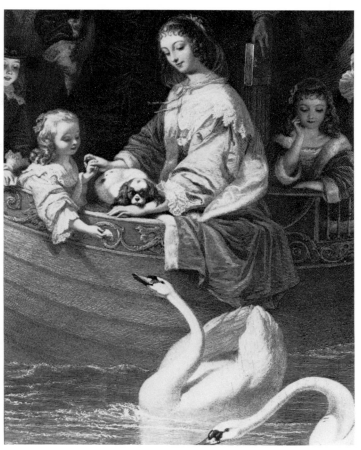

Detail

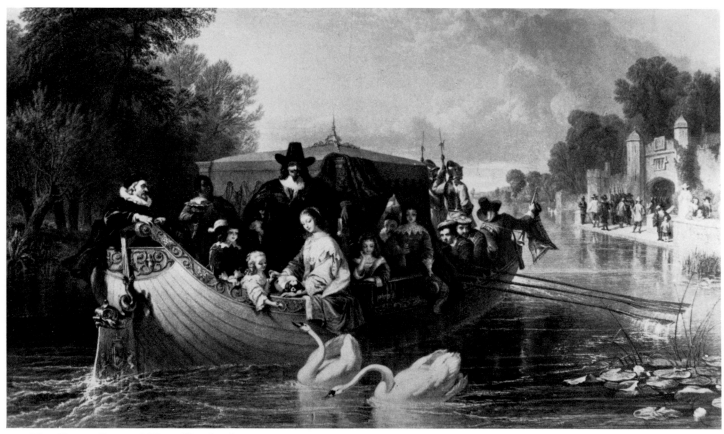

89 The Happy Days of King Charles I

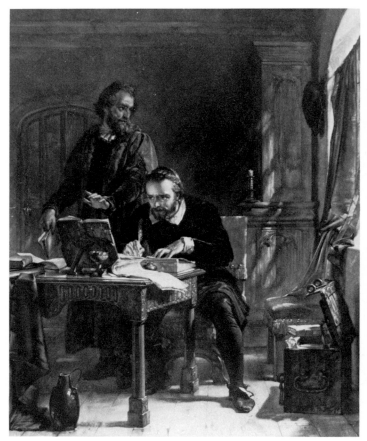

90 Tyndale Translating the Bible (detail)

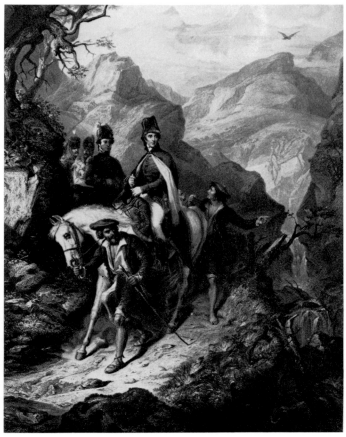

92 England's Greatest General Crossing the Pyrenees

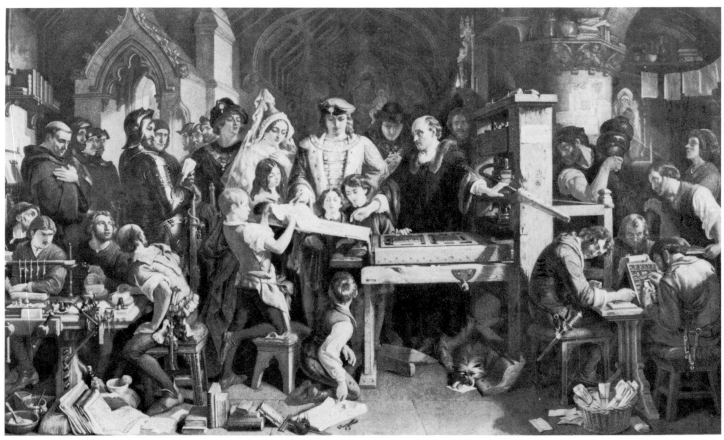

91 Caxton Shewing the First Specimen of his Printing to King Edward the Fourth, at the Almonry, Westminster

93 **Queen Victoria's First Visit to her Wounded Soldiers (detail)**

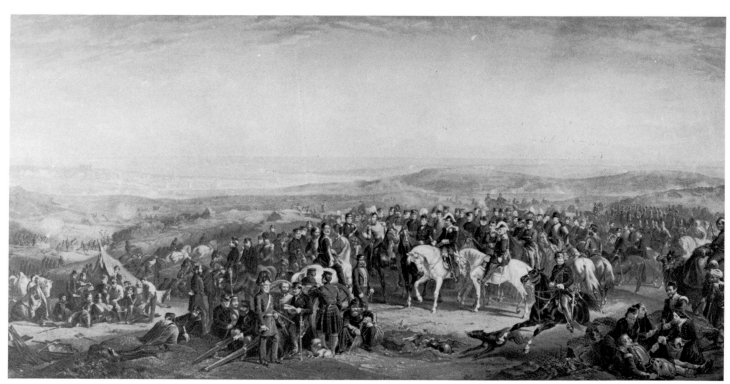

94 The Allied Generals with the Officers of their Respective Regiments before Sebastopol

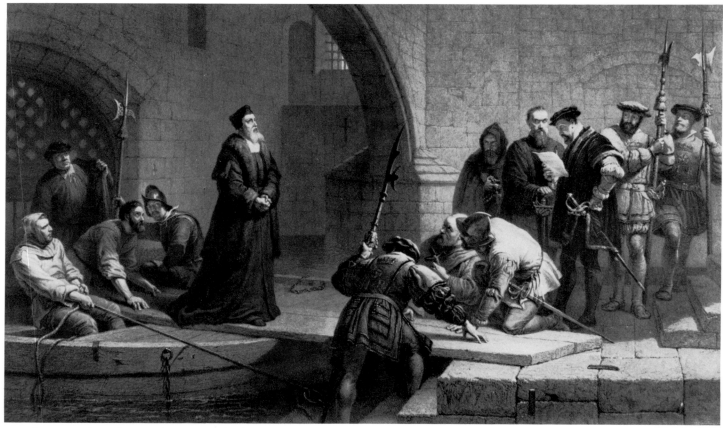

95 Cranmer Landing at the Traitor's Gate

96 Hogarth before the Governor at Calais (detail)

98 Pope makes Love to Lady Mary Wortley Montagu

97 Shakespeare before Sir Thomas Lucy

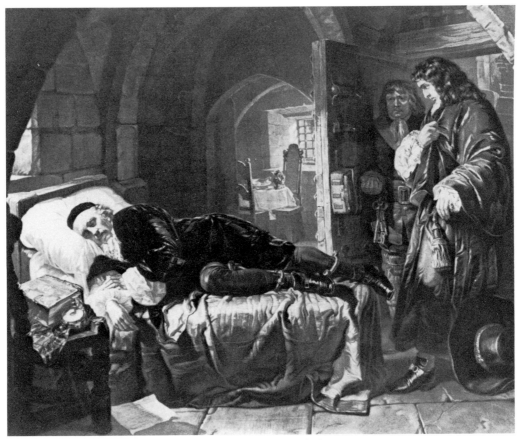

99 The Last Sleep of Argyll before his Execution A.D. 1685

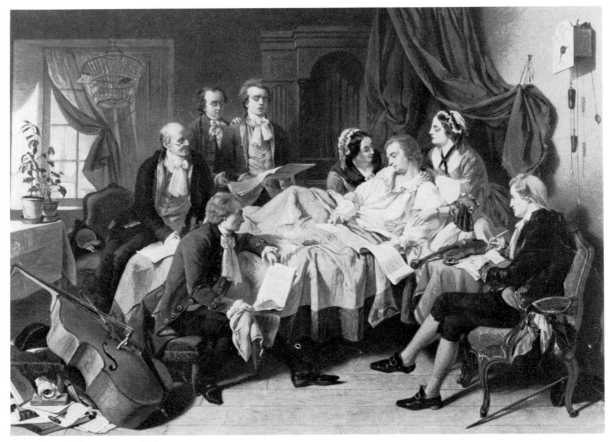

100 Last Moments of Mozart

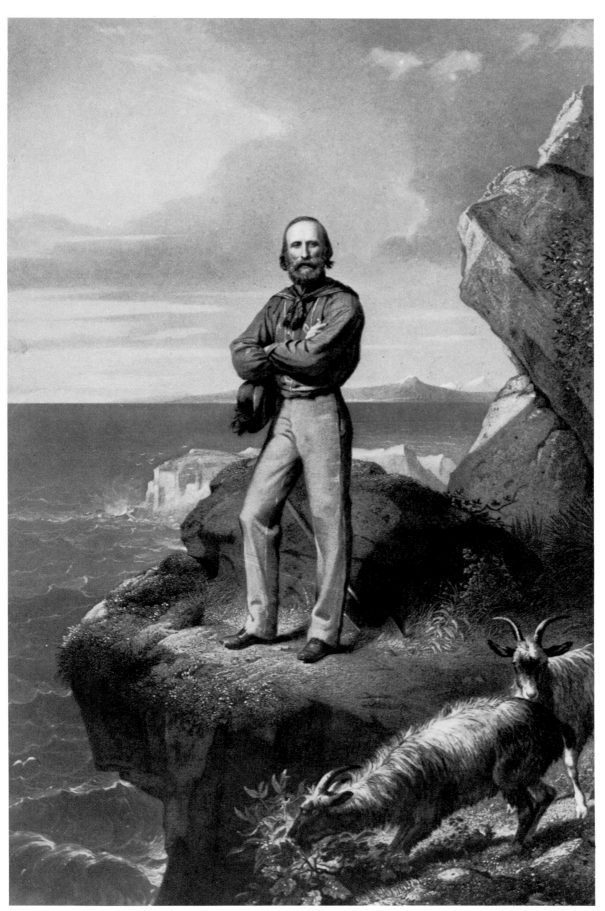

101 Garibaldi in his Island Home, Caprera

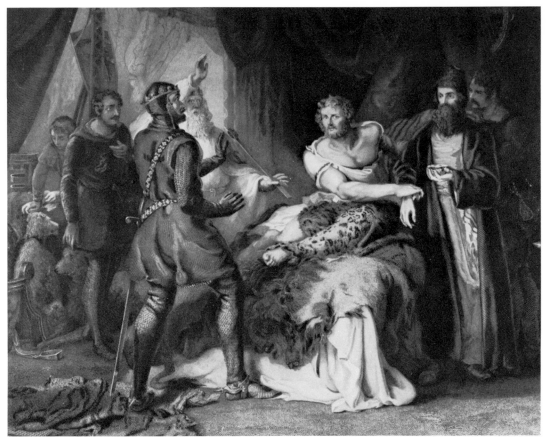

102 Richard and Saladin

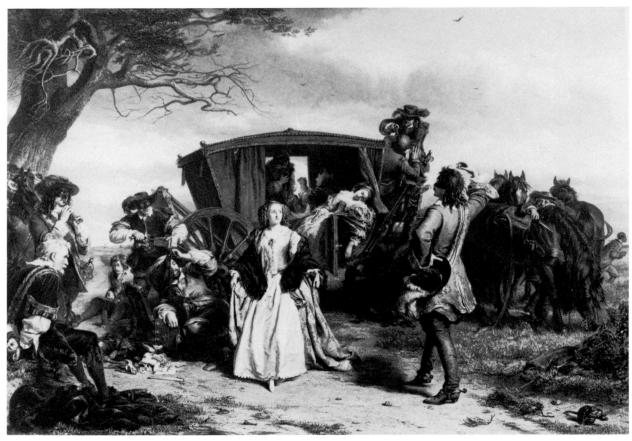

103 Claude Duval

104 The Palace at Westminster

105 Grace Darling (detail)

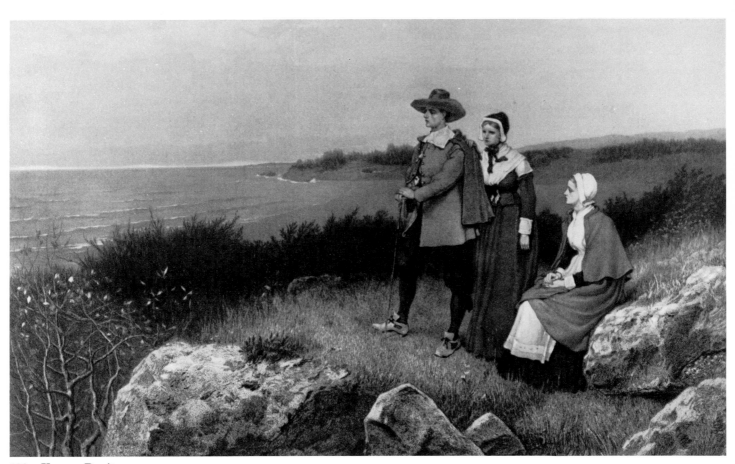

106 Young Puritans

The Bible

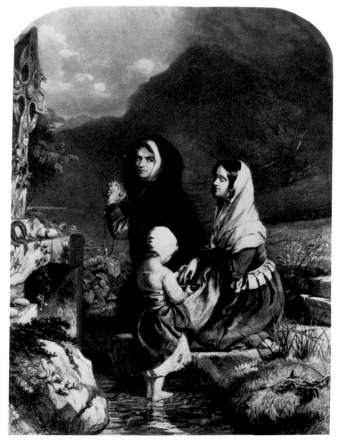

107 Blind Girl at the Holy Well

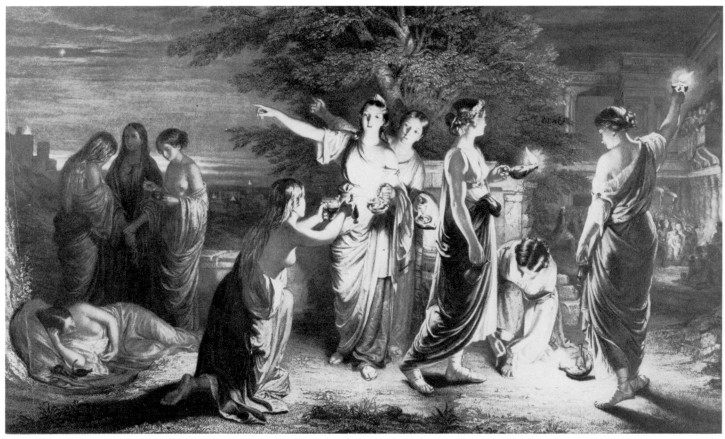

108 The Wise and Foolish Virgins

109 Jephthah's Daughter (detail)

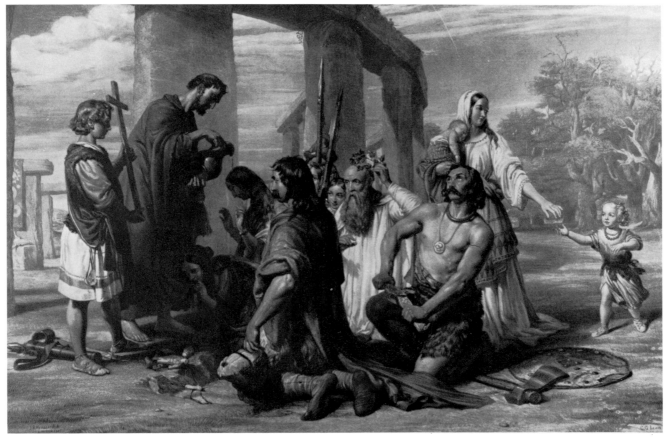

110 The First Introduction of Christianity into Great Britain

83

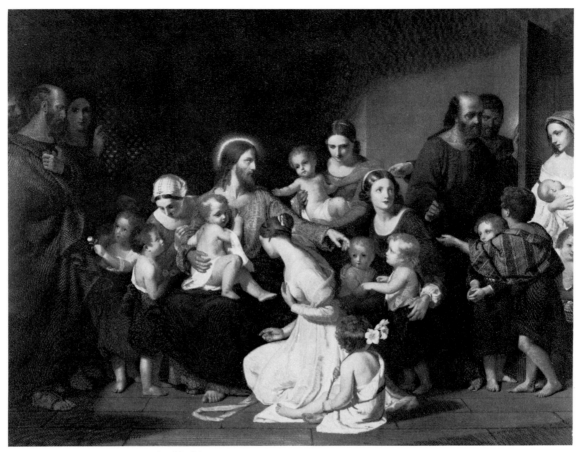

111 Christ Blessing Little Children

Detail

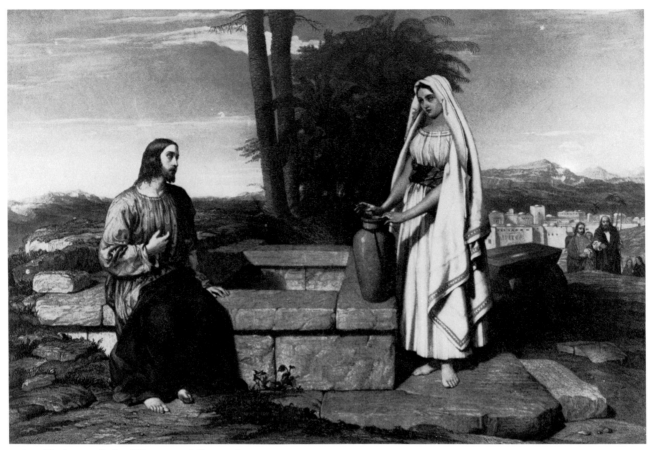

112 **Christ and the Woman of Samaria**

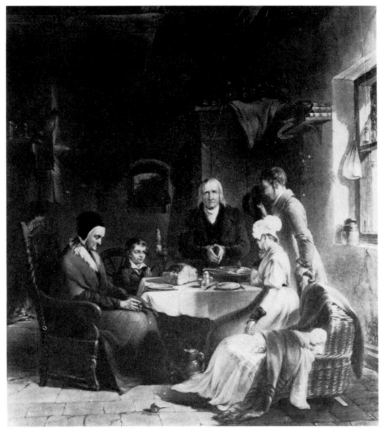

113 **Cottage Piety**

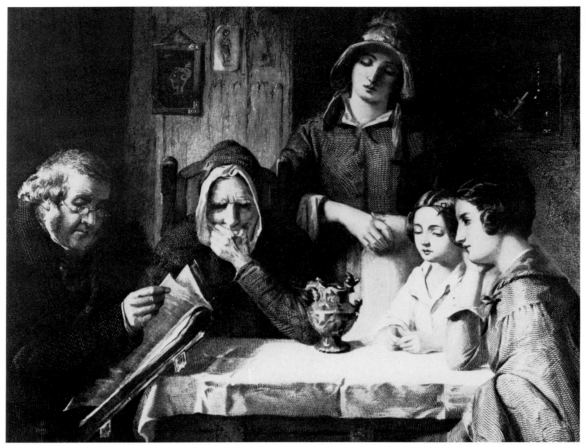

114 Cottage Devotion (detail)

115 Young Timothy (detail)

116 The Last Judgement (a) The Plains of Heaven (detail)

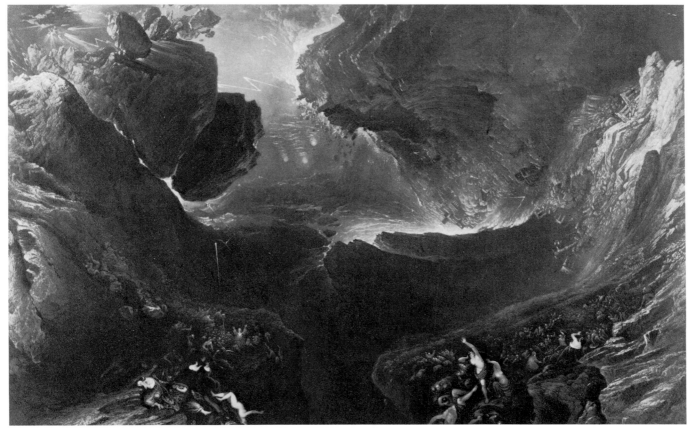

(b) The Great Day of His Wrath

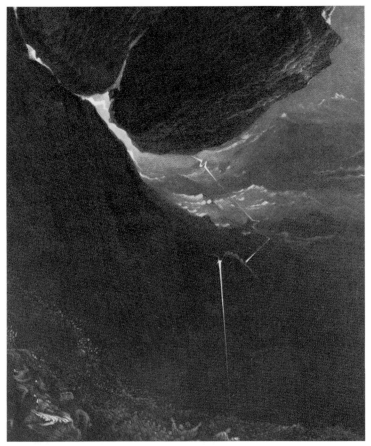

(b) The Great Day of His Wrath (detail)

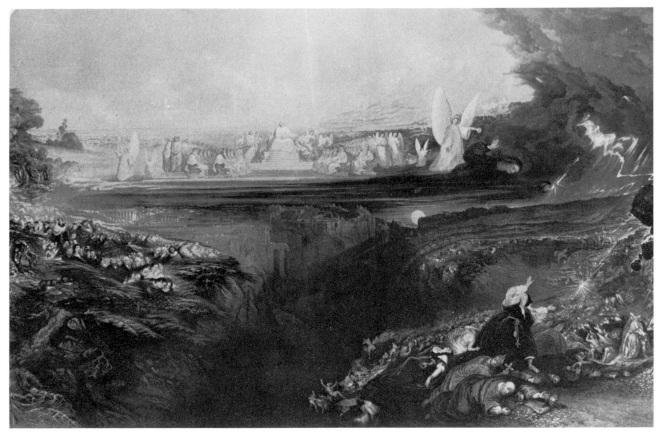

(c) The Last Judgement

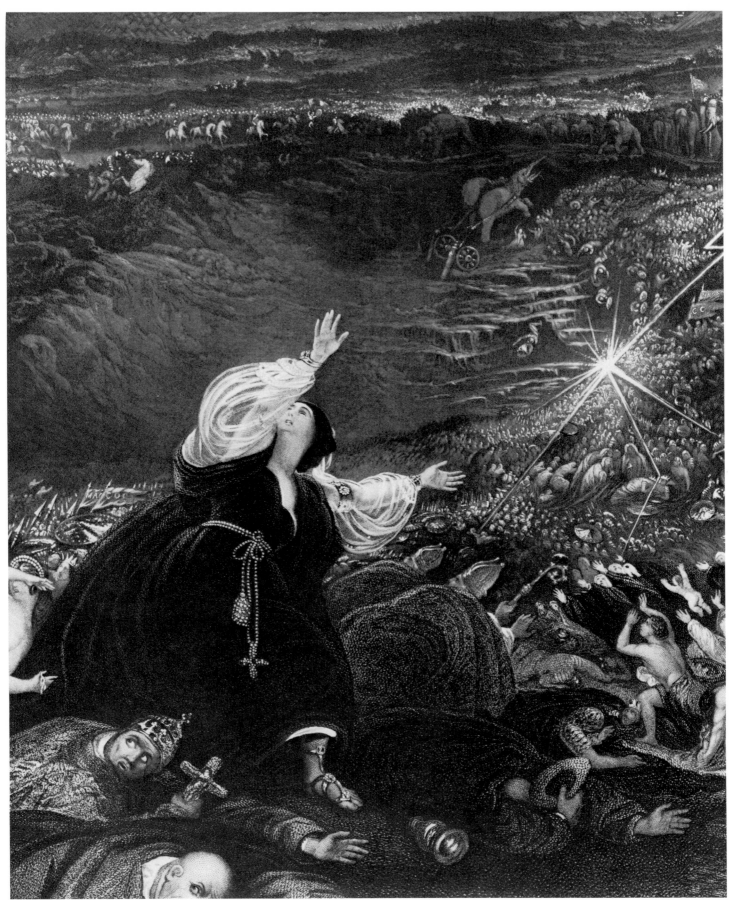

Detail

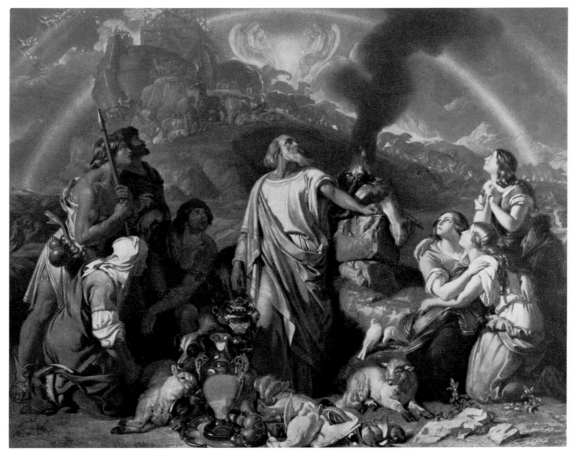

117 Noah's Sacrifice

118 St. John Leading the Virgin to his Own Home

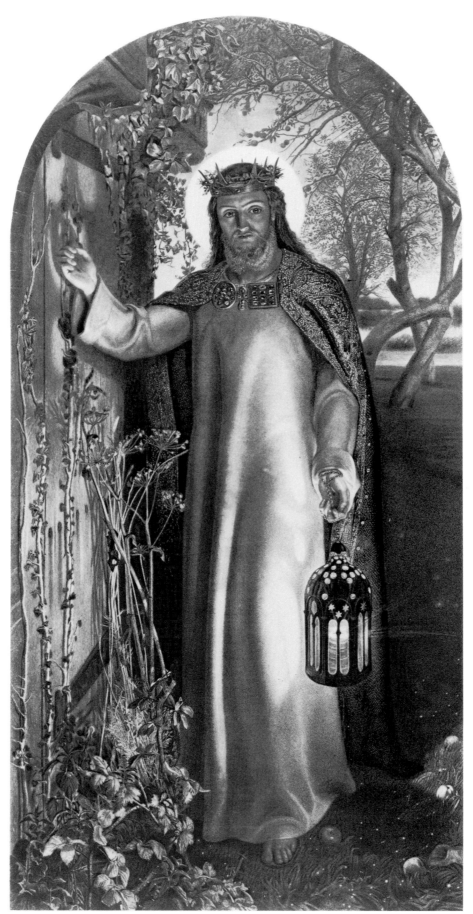

119 The Light of the World

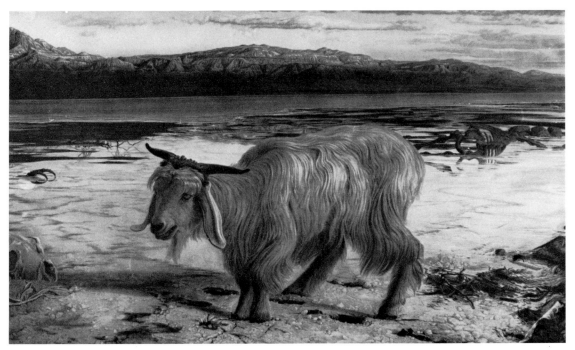

120 The Scapegoat

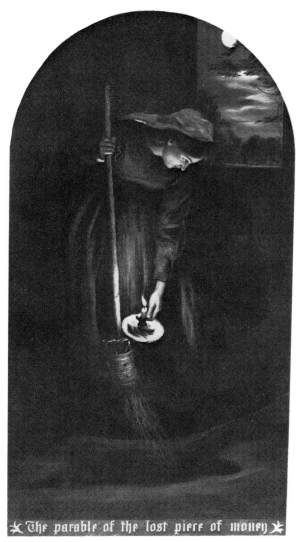

121 The Parable of the Lost Piece of Money

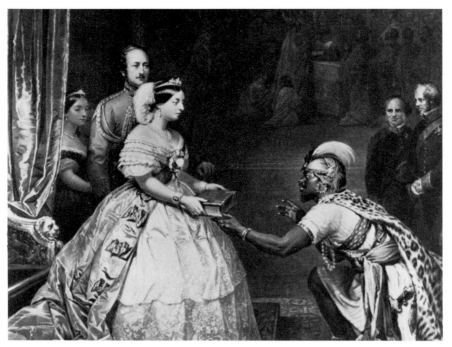

122 The Bible: That is the Secret of England's Greatness

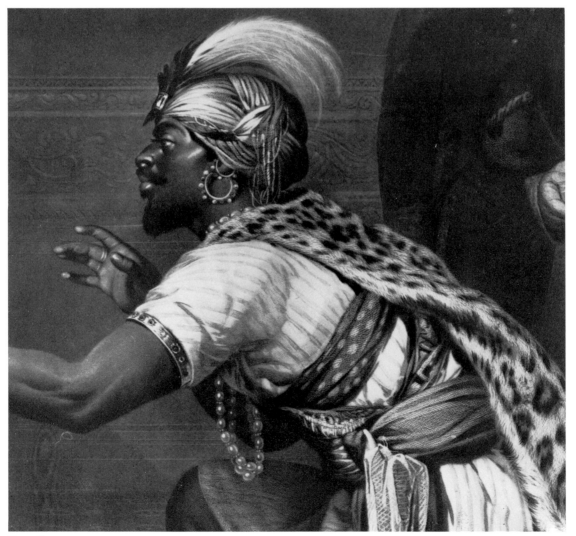

Detail

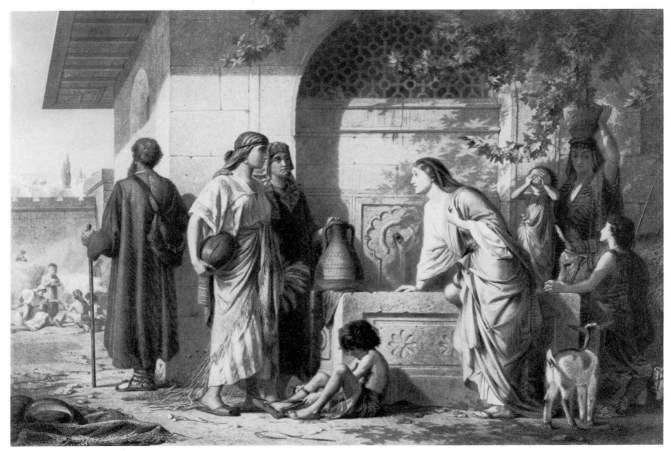

123 **Joseph and Mary**

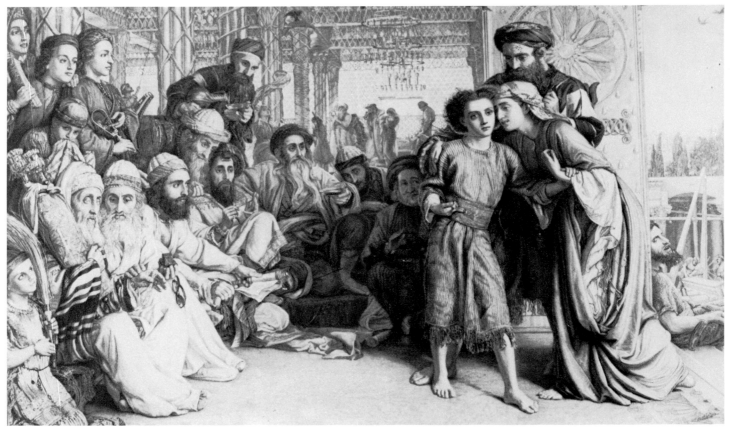

124 **Finding of the Saviour in the Temple**

94

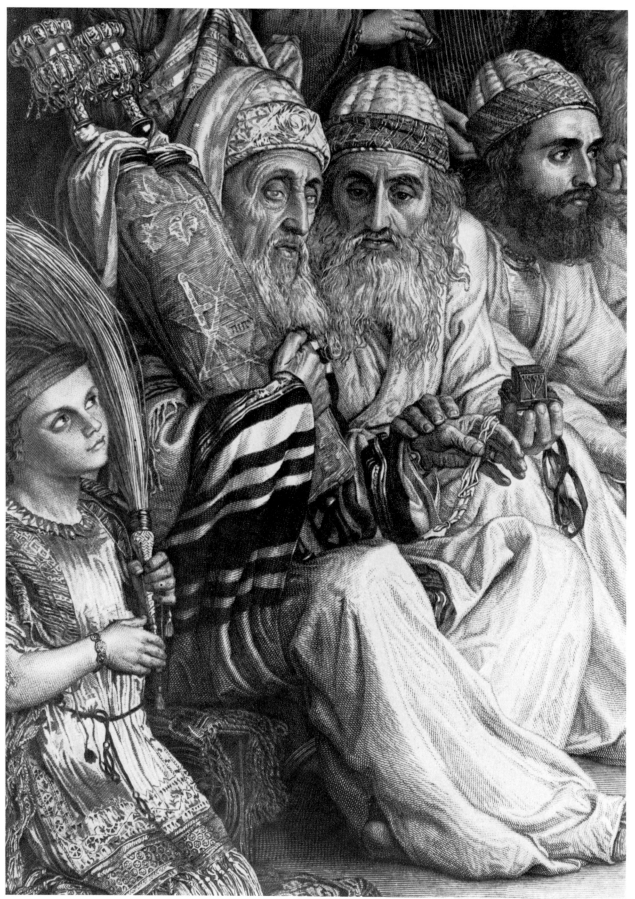

Detail

125 Mors Janua Vitae

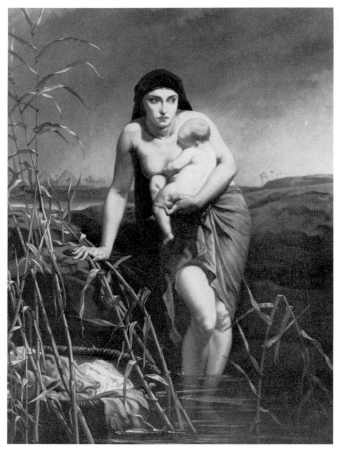

127 The Mother of Moses

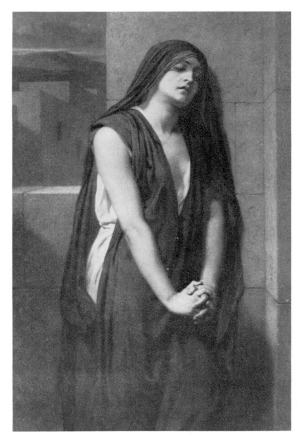

126 The Mother of Our Lord (a) Mater Dolorosa

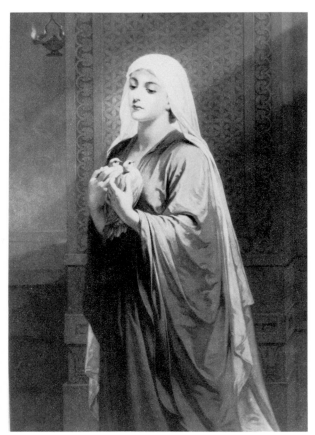

(b) Mater Purissima

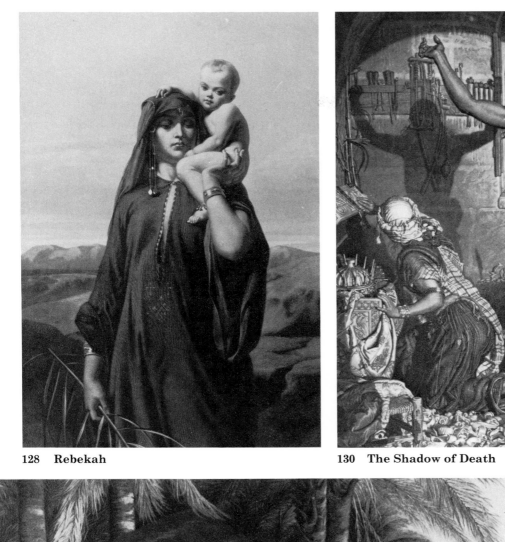

128 Rebekah

129 The Shadow of the Cross

130 The Shadow of Death

97

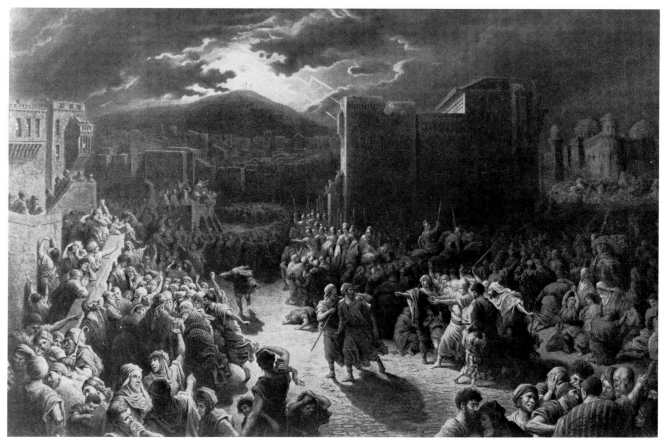

131 The Night of the Crucifixion

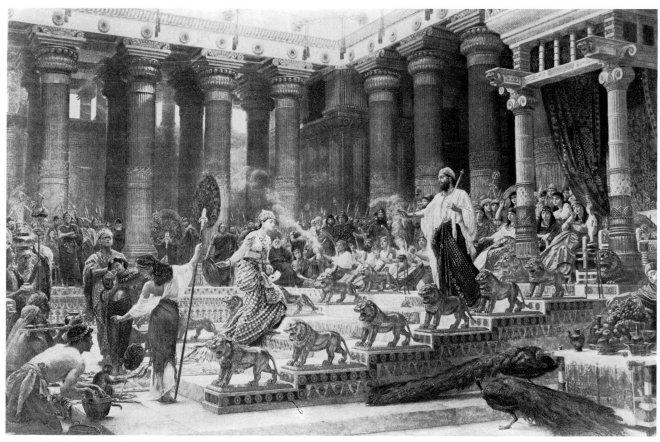

132 The Queen of Sheba's Visit to King Solomon

Themes from Contemporary Life

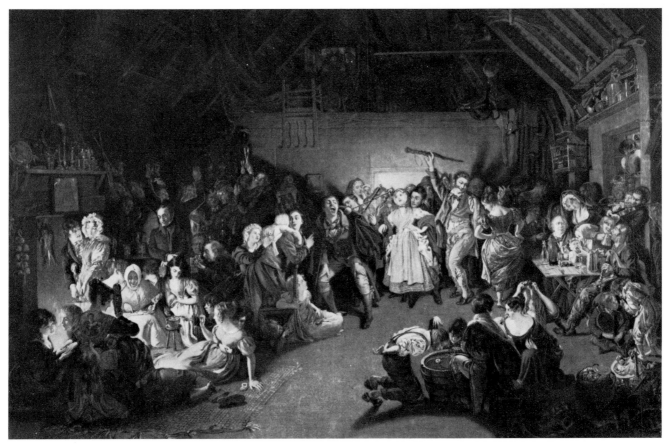

133 All Hallows Eve

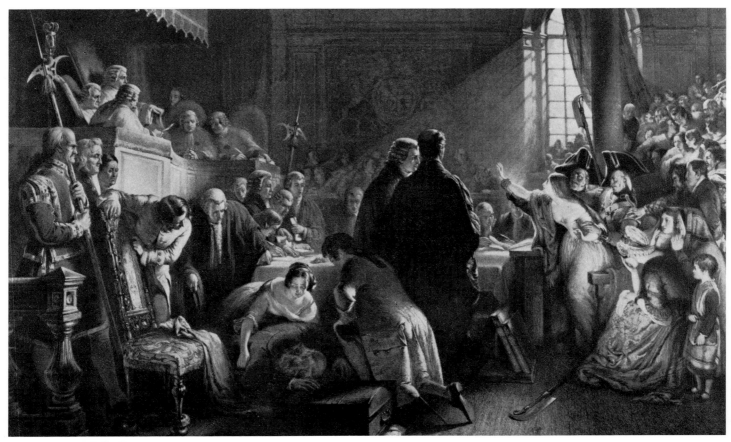

134 Trial of Effie Deans

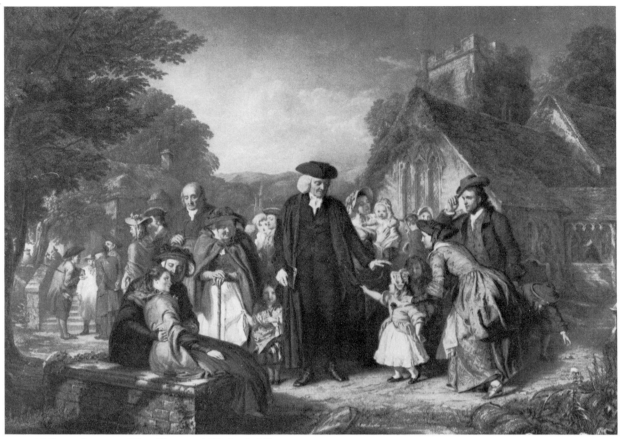

135 Village Pastor (The Vicar of Wakefield)

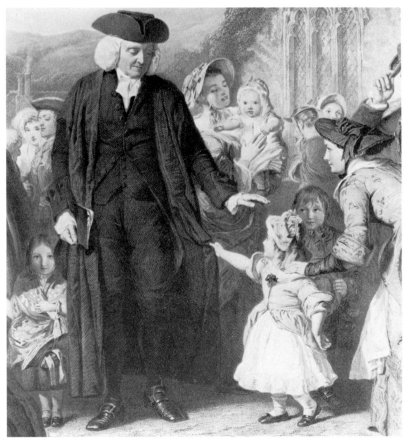

Detail

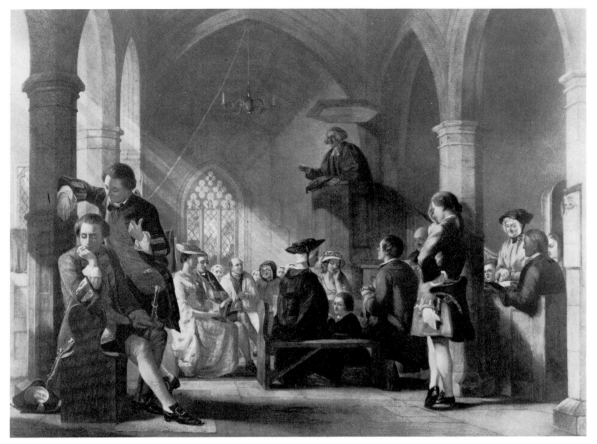

136 The Scoffers

Detail

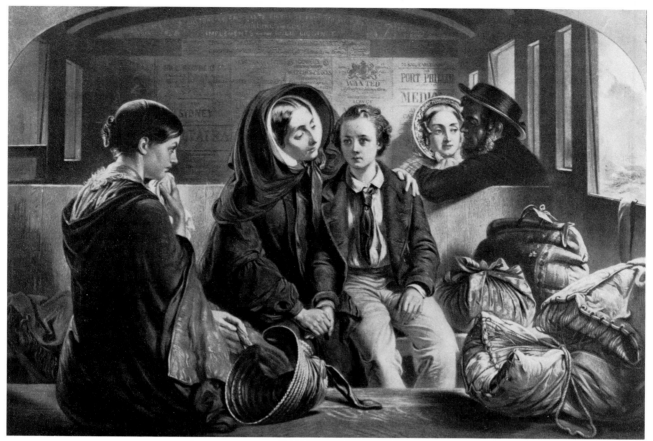

137 The Departure (Second Class)

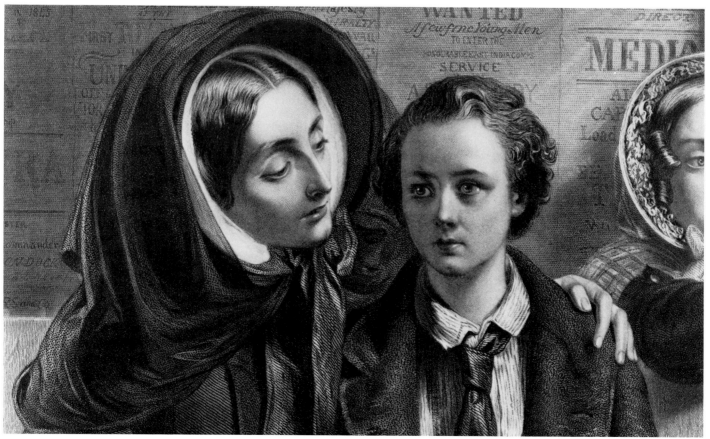

Detail

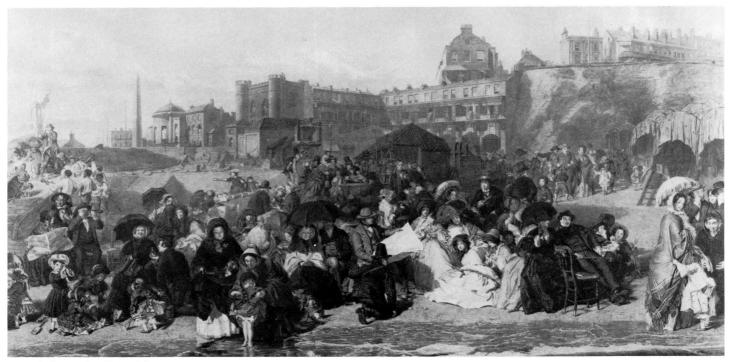

138 Life at the Sea-side

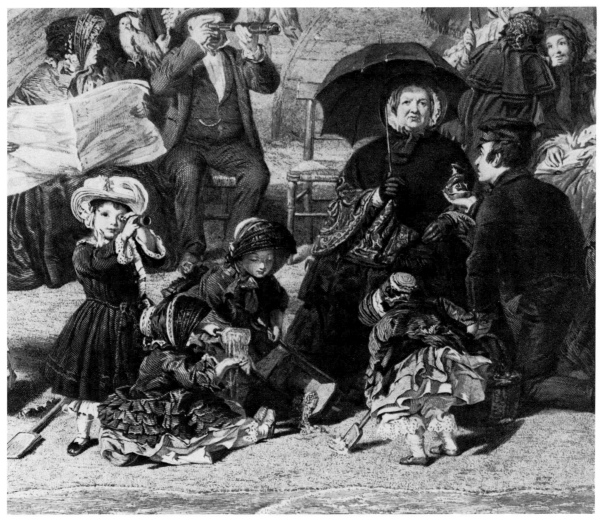

Detail

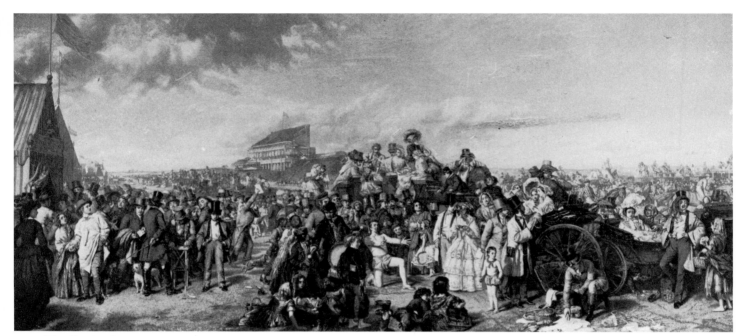

139 The Derby Day

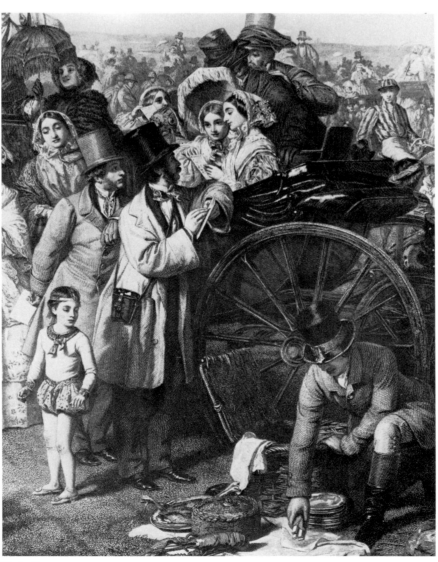

Detail

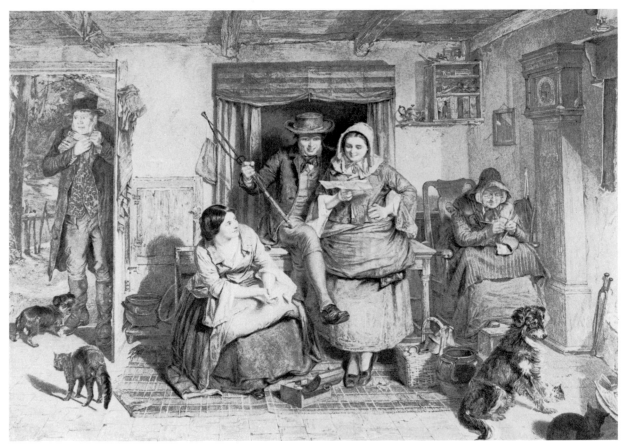

140 A Listener Never Hears Gude o Himsel'

141 My Ain Fireside

106

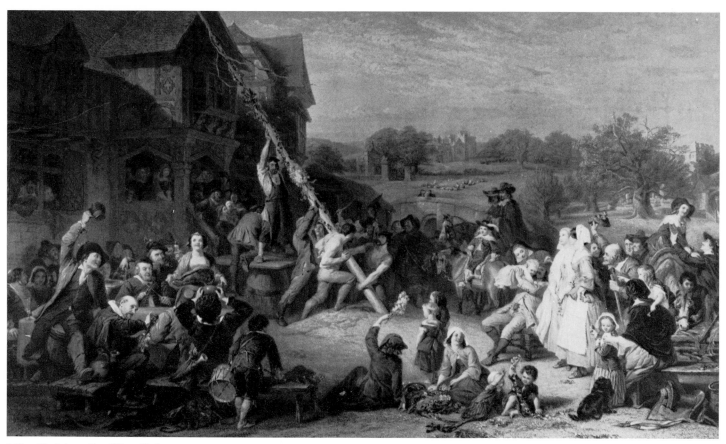

142 Raising the May Pole

143 The Birthplace of the Locomotive (detail)

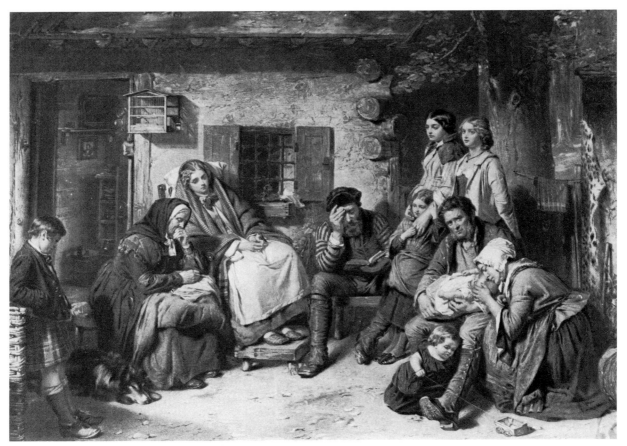

144 Sunday in the Backwoods of Canada

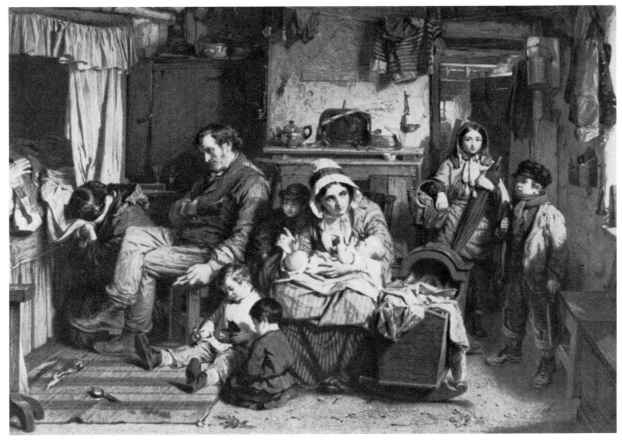

145 From Dawn to Sunset

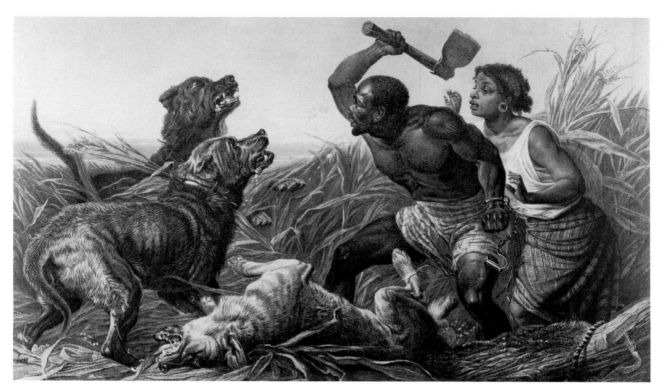

146 The Hunted Slaves

147 The Emigrant's Letter

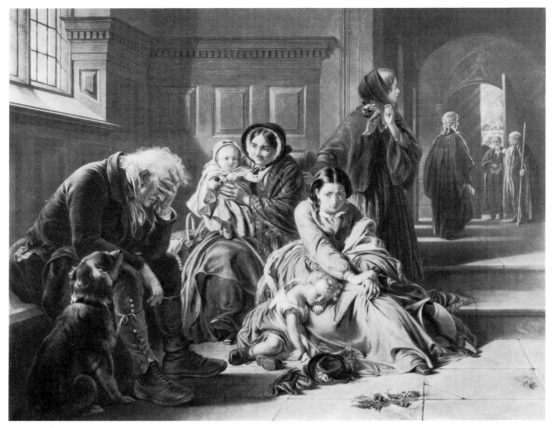

148 (a) Waiting for the Verdict

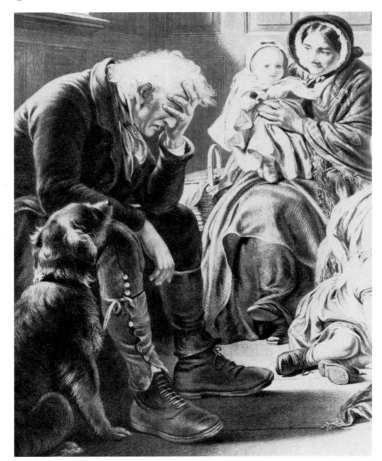

Detail

110

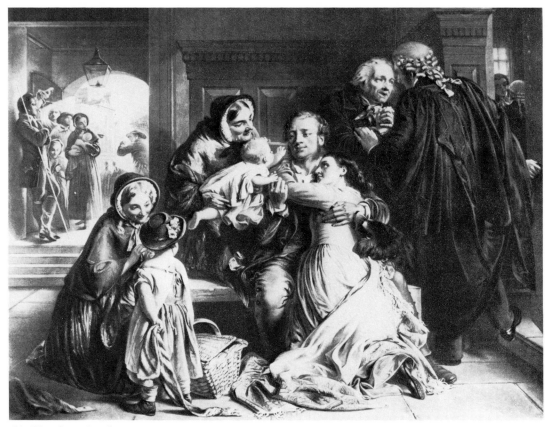

(b) The Acquittal

Detail

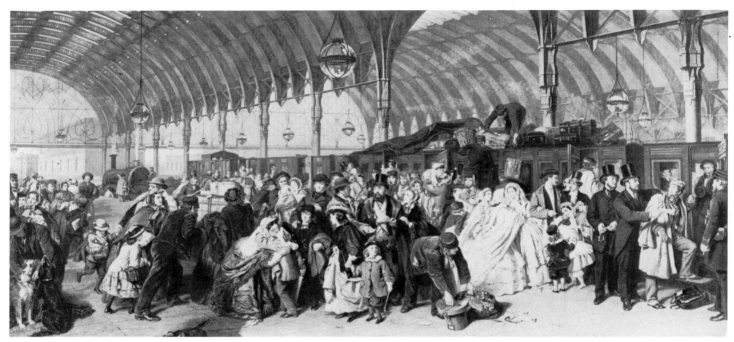

149 The Railway Station

Detail

150 The Last of the Clan

151 The Poor: the Poor Man's Friend

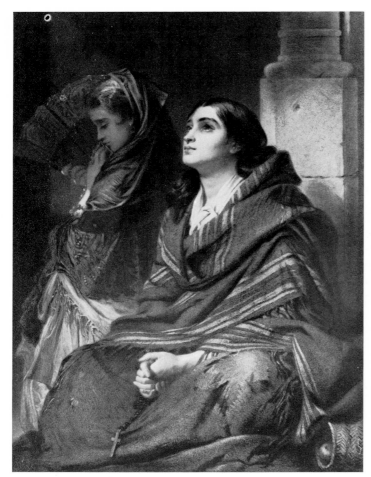

152 Prayer in Spain

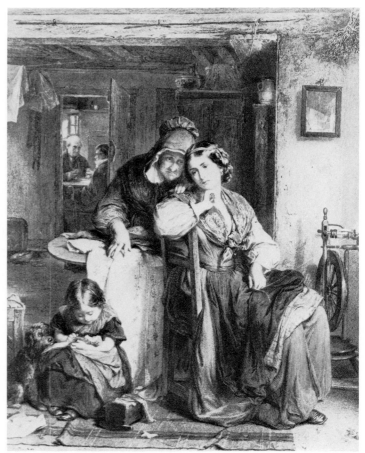

153 The Silken Gown

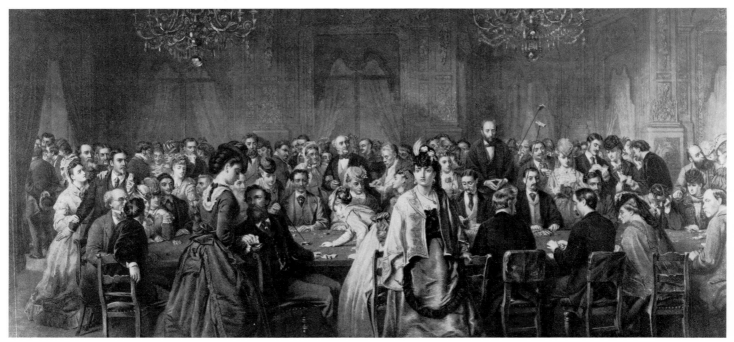

154 Salon d'Or, Homburg

114

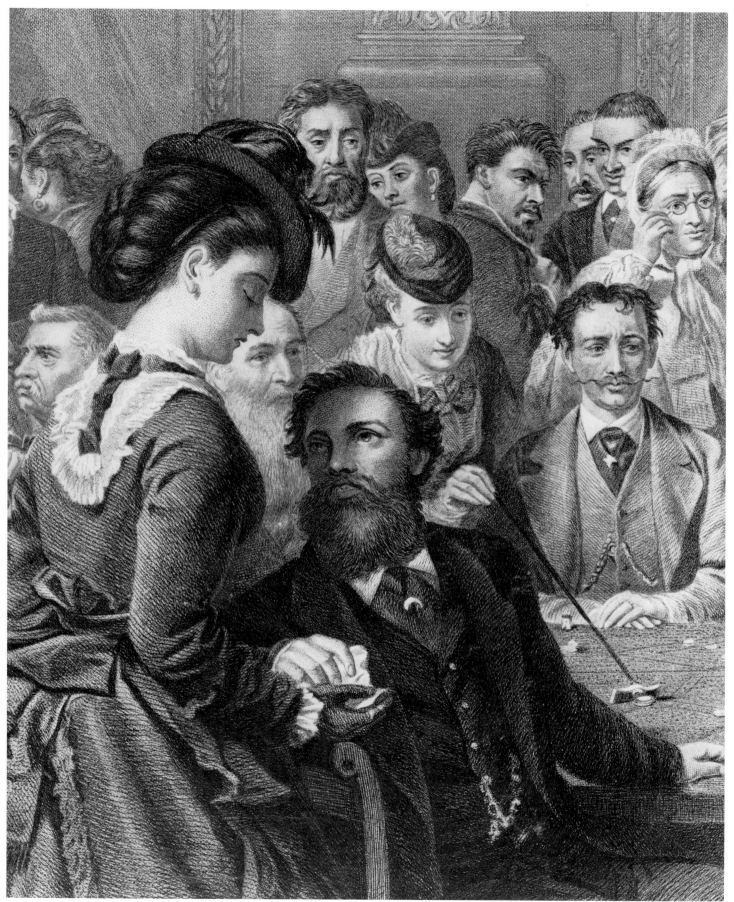

Detail

155 'La Gloria'—a Spanish Wake (detail)

156 Devonshire House

157 The Road to Ruin (a) College

116

(b) The Royal Enclosure at Ascot

(c) Arrest

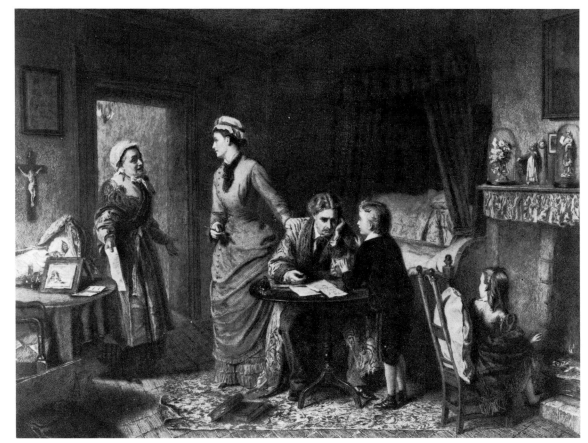

(d) Struggles

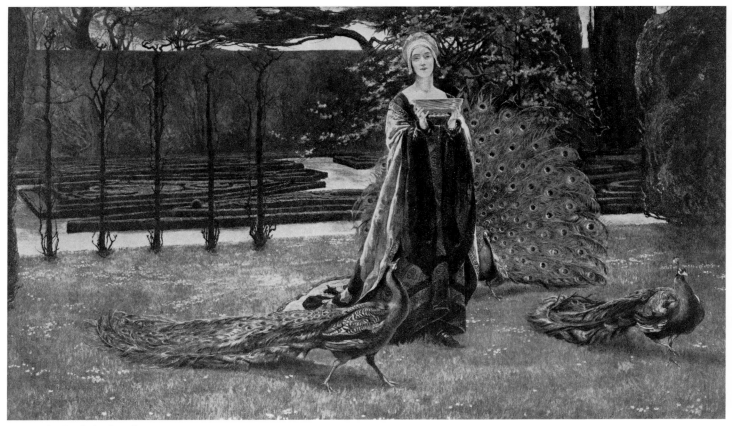

158 My Lady's Garden

159 After Dinner Rest Awhile

Literature, Legend and the Antique

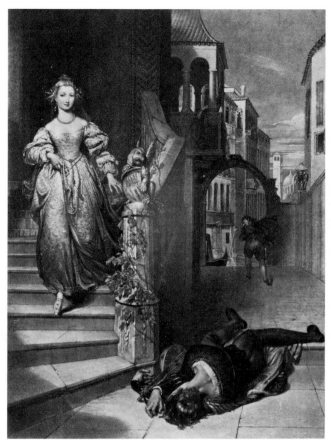

160 The Appointed Hour

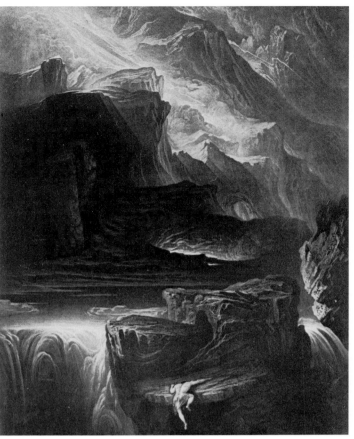

161 Sadak in Search of the Waters of Oblivion

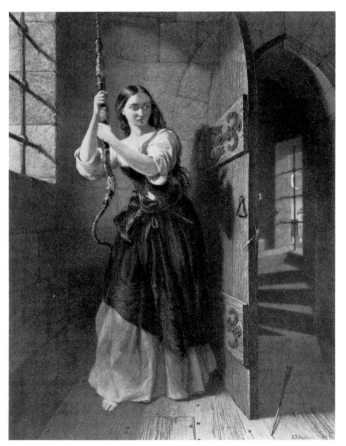

162 The Alarm Bell

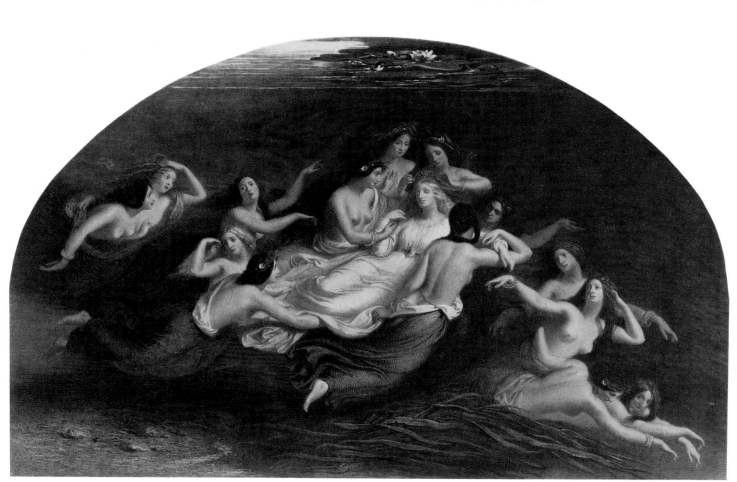

163 Sabrina

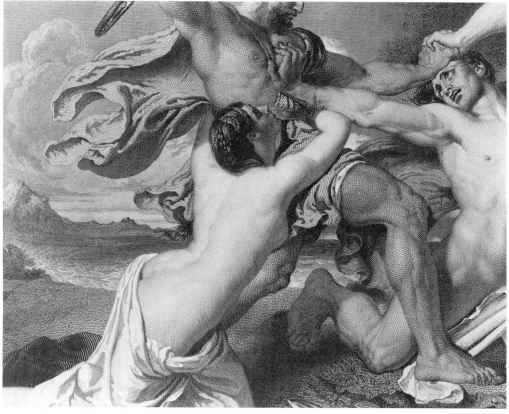

164 The Combat (detail)

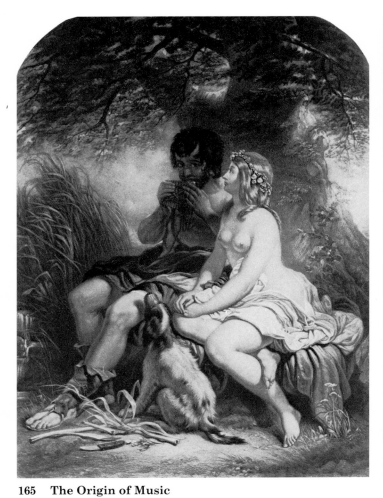

165 The Origin of Music

166 Lady Godiva

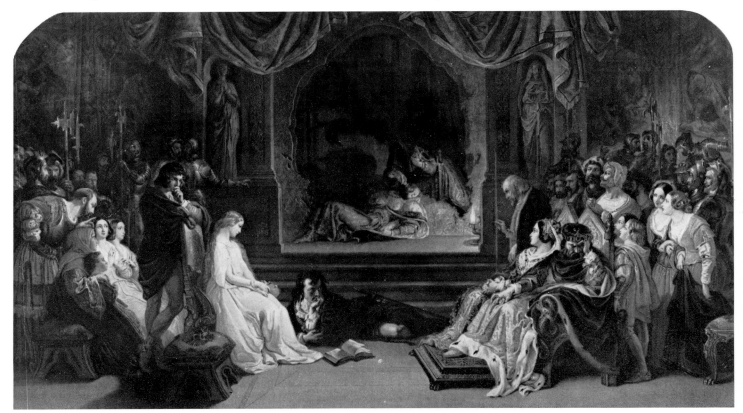

167 The Play-scene in Hamlet

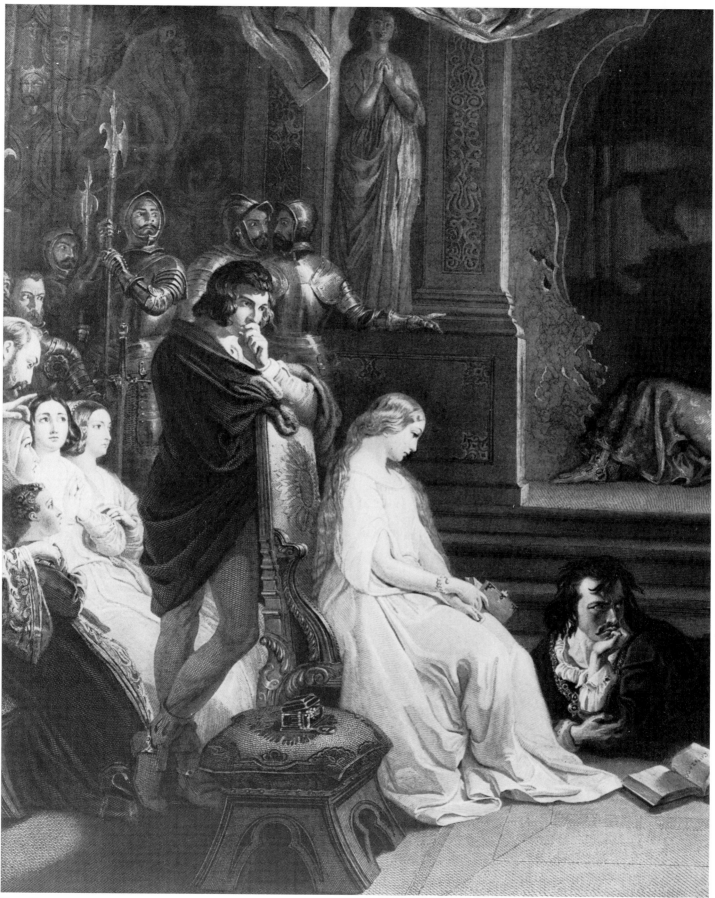

Detail

168 The Pursuit of Pleasure: a Vision of Human Life (details)

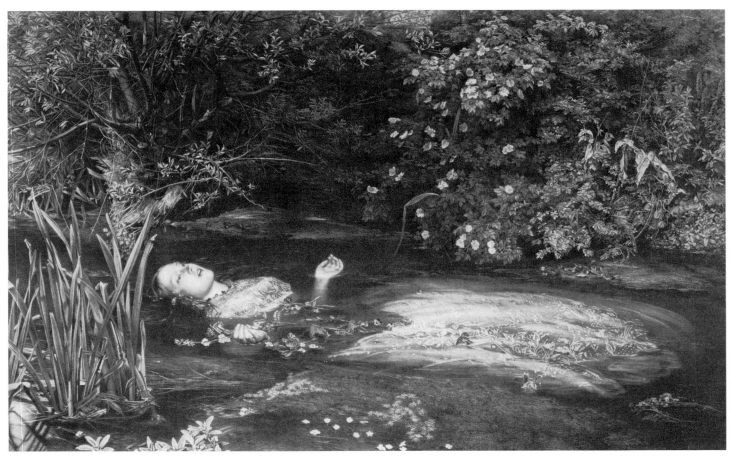

169 Ophelia

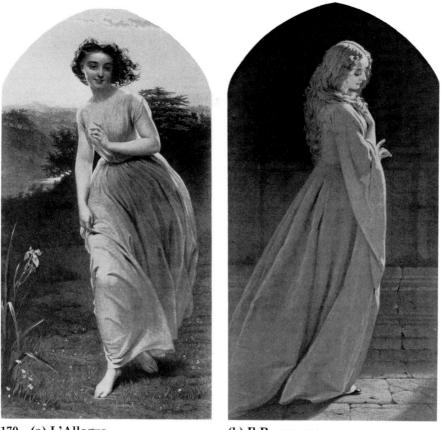

170 (a) L'Allegro (b) Il Penseroso

171 Isabella: or the Pot of Basil

172 Rosalind and Celia

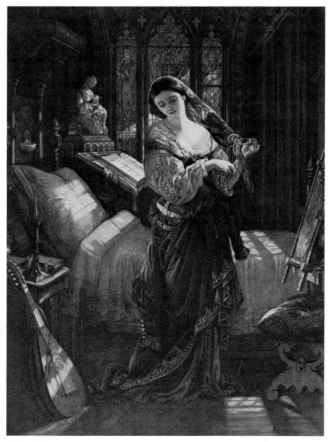

173 The Eve of St. Agnes

174 The Legend of the Briar Rose (a) The Briar Wood

(b) The Council Chamber

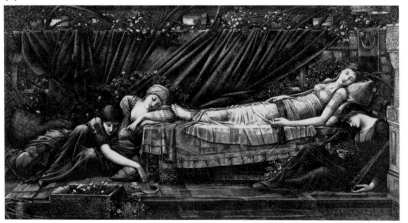

(c) The Garden Court

(d) The Rose Bower

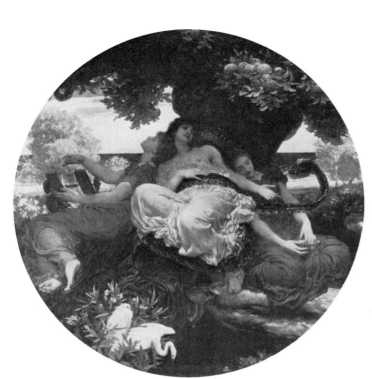

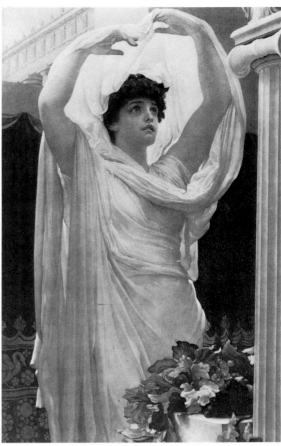

175 The Garden of the Hesperides

177 Invocation

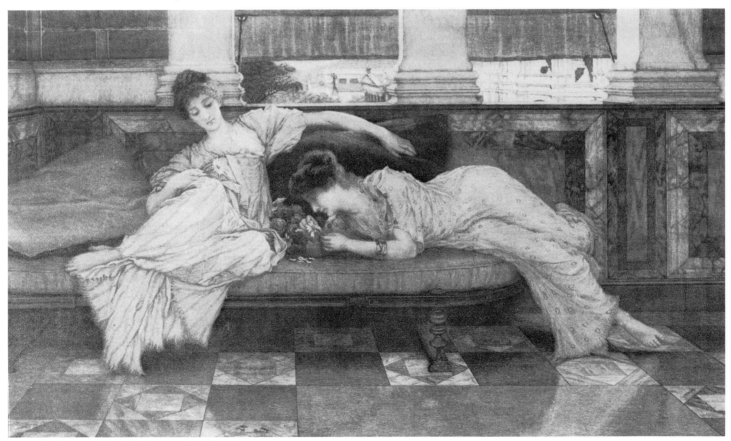

176 He Loves Me—He Loves Me Not!

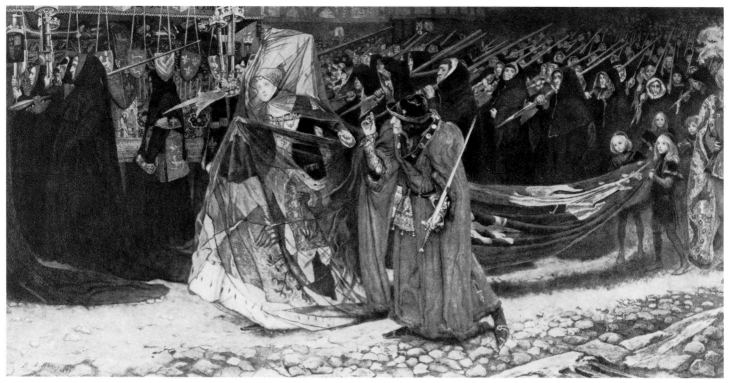

178 Richard, Duke of Gloucester and the Lady Anne

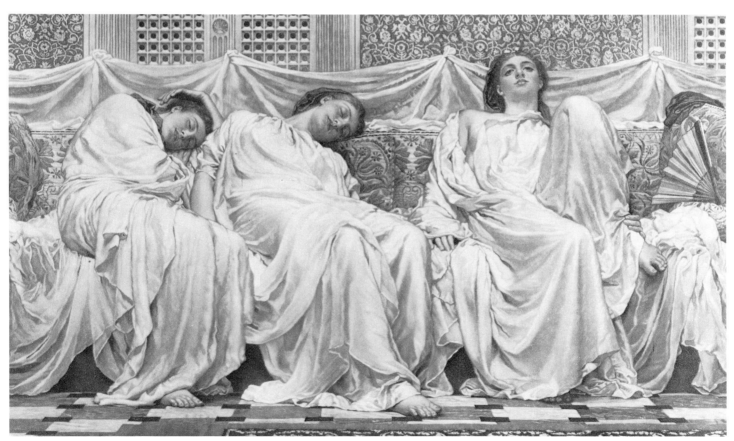

179 Dreamers

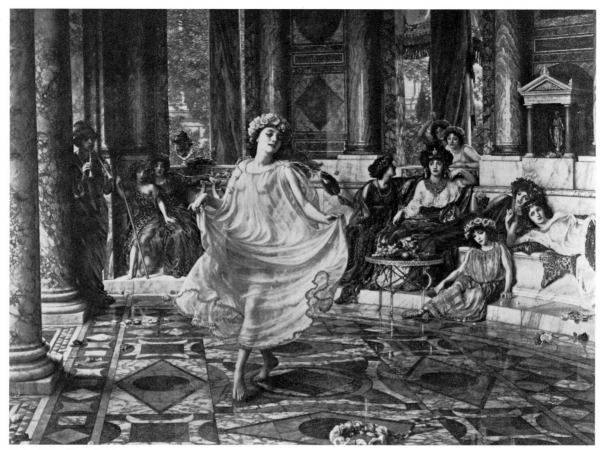

180 The Greek Dance

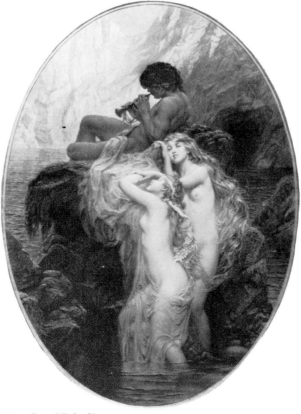

181 Sea Melodies

Notes to the Illustrations and List of Abbreviations

The engravings have been arranged in thematic groups showing the main areas of interest of the Victorian public and the pre-occupations which dominated certain decades, though some perennial themes continued to appear in different forms. The prints run chronologically within the groups, illustrating the evolution of techniques and fashions.

Photographic enlargements of details are sometimes given instead of the whole picture, when, in reduction, this would look like a photograph of the original painting and not of the engraving. In some cases, details have been moved to other sections for thematic purposes.

Each note contains a technical description of the print and its history in small type, followed by a descriptive analysis of the subject matter in larger type. Sources are listed in small type at the end of each note and given in full in the list of abbreviations.

AJ	*The Art Journal*, London 1849–1912
AU	*The Art-Union*, London 1839–48
AU (Reports)	*The Art-Union of London Annual Reports*, 1839 onwards
Balston	Thomas Balston, *John Martin 1789–1854: his Life and Work*, London 1947
Beck	Hilary Beck (Guise), *Victorian Engravings*, London 1973
Beraldi	H. Beraldi, *Les Graveurs du XIX siècle*, Paris 1885
BI	The British Institution
BM	British Museum
BN: Fonds	Bibliothèque Nationale, *Inventaire du fonds français après 1800*, Paris 1930–65
Delteil	L. Delteil, *Théophile Chauvel: catalogue raisonné*, Paris 1900
DNB	*Dictionary of National Biography*
Frith	W. P. Frith, *My Autobiography and Reminiscences*, 2 vols, London 1887–8
H. Graves	H. Graves & Co, *Catalogue of Publications*, London 1899
W. Holman Hunt	*Pre-Raphaelitism and the Pre-Raphaelite Brotherhood*, London 1905
Le Blanc	C. Le Blanc, *Manuel de l'amateur d'estampes*, Paris 1854–89
C. S. Mann	*The Works of Sir Edwin Landseer: Catalogue Raisonné with Photographs of All Works. The Exhibition Catalogue of 1874*, MSS, 4 vols, 1874–7, VAM
J. G. Millais	*The Life and Letters of Sir John Everett Millais*, 2 vols, London 1899
Nagler	F. Nagler, *Künstlerlexikon*, Munich 1835
NG	National Gallery, London
NPG	National Portrait Gallery, London
PA	*Printsellers' Association List of Engravings*, London 1847–75, 1892, 1912
RA	Royal Academy of Arts
Reynolds (1953)	Graham Reynolds, *Painters of the Victorian Scene*, London 1953
Reynolds (1966)	Graham Reynolds, *Victorian Painting*, London 1966
RSA	Royal Scottish Academy
Ruskin, *Notes*	J. Ruskin, *Notes on Some of the Principal Pictures exhibited in the Rooms of the Royal Academy*, London 1855–9
Sandby	W. Sandby, *The History of the Royal Academy of Arts*, 2 vols, London 1862
R. H. Shepherd	Richard Herne Shepherd, *Notes on the Royal Academy Exhibitions* 1869, 70, 74, 76, 78
Slater	H. Slater, *Engravings and their Value*, London 1929
Stocks	J. P. Stocks, *A Catalogue of Line Engravings by Lumb Stocks RA—Engraver. 1812–1892*, typescript 1978
Theime u. Becker	Theime u. Becker, *Allgemeines Lexikon der Bildenden Künstler*, Leipzig 1907–50
VAM	Victoria and Albert Museum
Whitman	A. Whitman, *Nineteenth Century Mezzotinters: Samuel Cousins RA*, London 1904, and *Samuel William Reynolds*, London 1904
C. Wood (1971)	Christopher Wood, *Dictionary of Victorian Painters*, London 1971
C. Wood (1976)	Christopher Wood, *Victorian Panorama*, London 1976

Measurements are given in centimetres, height before width, and are of the plate mark unless otherwise stated.

CHILDREN

1 Children and Rabbits 1842, 1874

VAM E.157.1970

A mixed mezzotint with an arched top (68·3 × 52·3) by Alfred Lucas (worked *c* 1847–86) after the painting of 1839 by Sir Edwin Henry Landseer, RA (1802–73); published by G. P. McQueen, 27 October 1874. PA stamp XOU. The edition included 250 proofs of which 125 were artist's proofs.

This painting of the children of the Hon Col Seymour Bathurst playing with their pet rabbits was originally engraved by Tom Landseer in 1842. This is one of Landseer's charming, early works and is beautifully translated into black and white by Lucas. The children are feeding the parental rabbits with turnips while the babies eat out of a dish. A King Charles spaniel lies under the stool.

PA (1847–75), A. Graves, *Catalogue of the Works of the Late Sir Edwin Landseer* RA (1874) no 262 p 21, C.S. Mann II p 50, RA (1839) no 548, Winter (1874) no 472, H. Graves p 63, AU (1840) p 183 (1842) p 145.

2 The Youthful Queen of the Hop Garden 1843

VAM E. 290.1970

A stipple engraving (61 × 48·2) by James Posselwhite (1798–1884) after a painting by William Frederick Witherington, RA (1785–1865), formerly in the collection of William Wells of Redleaf; published by William Spooner, 1 March 1843. Printed by S. Hawkins. A painting with similar subject matter, entitled *The Hop Garden*, dated 1834, is in the Sheepshanks Collection, VAM (no 233).

This pretty bucolic subject of children playing in among the hops is recognizable as an early Victorian work by its freedom from moral undertones. It is interesting as an example of stippling. This method was quicker and therefore cheaper than line engraving because apprentices were employed punching in the large background areas. In line engraving a quick method for filling in backgrounds was later found in the engraving machine.

Beck 2.

3 Detail from The Convalescent from Waterloo 1845

BM 48.1.8.20

This detail of a line engraving by George Thomas Doo shows boys wrestling; their caps and boots lie on the grass nearby. Notes on the complete picture can be found in the section entitled Heroes of War, **65**.

4 The Play-ground 1853

VAM E.313.1970

An engraving (53·3 × 97·2) by Ferdinand Jean Joubert (1810–84) after the painting of 1852 by Thomas Webster, RA (1800–86) in the collection of Lord and Lady Wantage (no 255); published by the Art-Union of Glasgow for the year 1853. A smaller version of the painting with the same title is in the Guildhall Art Gallery, Corporation of London (no 744). Another large plate was engraved by Henry Lemon and published on 6 June 1864.

One of Thos Webster's pictures of child-life. Here the boys have been let out of school and are playing in the play-ground. Various games are being played, spinning tops, marbles, football; and the traditional cricket bat is in the foreground. One boy has left the fun to greet his parents on the left. A woman on the right has a basket which contains some form of food.

Slater pp 418, 472, Beraldi VIII p 280, RA (1852) no 60, (1951–2) no 314.

5 See-saw 1854

BM 66.10.13.1047

An engraving with stipple (56·5 × 81·2) by Francis Holl, ARA (1815–84) after the painting of 1849 by Thomas Webster, RA (1800–86); published by Lloyd Bros in 1854 in an edition including 425 proofs of which 150 were artist's proofs and 50 were presentation proofs. The artist's proofs cost 8 guineas. PA stamp WXO. Francis Holl usually combined engraving in line with stipple, see *The Village Pastor*, **135**, *Rebekah*, **128** and *The Birthplace of the Locomotive*, **143**.

This is an informal, candid picture of boys see-sawing on a sawn-off tree trunk, capturing the moment when the smaller boy finds himself alarmingly far from the ground and unable to swing the balance. Harmless scenes like this were soon to give way to heart-rending situations arising from the wars in the Crimea and India. *The Smile*, *The Frown* and *The Slide* were all earlier than this one.

PA (1847–75), AJ (1886) p 352, RA (1849) no 91, H. Graves p 101.

6 The Mother's Dream 1853

BM 13.10.15.45

A mezzotint with stipple and an arched top (71·7 × 53·3) by William Henry Simmons (1811–82) after the painting dated 1852 by Thomas Brooks (1818–91); published by Henry Graves & Co as a companion print to *The Believer's Vision* by the same artists. An edition of 125 proofs of which 50 were artist's proofs was declared to the PA on 13 July 1853.

The mother seated by her sick child dreams an angel has come to take him to Heaven. The same theme occurs in *The*

Angel's Whisper by Edward Goodall where a similar technique is used to convey the whispy luminosity of the angel. A rattle lies at the foot of the chaise-longue.

PA (1892), RA (1852) no 487, H. Graves p 7, DNB XVIII p 260.

7 The Orphans 1854

BM 1866.10.13.55
A mixed mezzotint (70·5 × 54·2) by William Henry Simmons (1811–82) after Alexander Davis Cooper. PA stamp ZTE. The PA records a publication of 175 proofs including 25 presentation proofs, 50 artist's proofs, 50 proofs before letters and 50 lettered prints, by Henry Graves & Co, December 1854.

Death is the cause of separation between these three girls and their mother who, according to the tombstone, died on 20 July 1854 aged 32. She is present in spirit form and hovers over her children, unseen by them.

PA (1892).

8 Detail from The Boy with Many Friends 1858

BM 66.10.13.1054
An engraving (55·2 × 72) by Peter Lightfoot (1805–85) after the painting of 1841 by Thomas Webster, RA (1800–86) in the Jones Bequest, VAM (no 536, 1882); published by Thos McLean in 1858 in an edition including 350 proofs of which 100 were artist's proofs. PA stamp OSO. Slater records another later publication dated 1 March 1877. The plate was completed two years before its first publication and a proof was exhibited in 1856 at the Royal Academy (no 1019).

The boy has many friends on account of the pile of fruit and pies on his lap. The big bully has taken a proprietorial position behind him. Various inedible forms of barter, marbles and books, are being offered.

AJ (1886) p 351, PA (1847–75), Slater p 445, RA (1841) no 65, (1856) no 1019, C. Wood (1971) p 187.

9 Many Happy Returns of the Day 1859

BM 66.10.13.1041
An engraving (61·5 × 79·7) by Lumb Stocks, RA (1812–92) after the painting by William Powell Frith, RA (1819–1909); published by the Art-Union of Glasgow 1859–60.

Ruskin disapproved of this innocuous domestic scene as an example of spoiling. The child who is being spoilt sits under a bower of leaves before the birthday cake, while her brothers toast her in sherry from the sherry decanter and the maid gathers up her presents and looks on respectfully from the door. The gasolier hangs from the high ceiling, paintings are arranged on the dark wall and the lace curtain waves in the high sash windows. The chairs, from the grandfather's to the children's, are appropriately designed. The grandfather, who has witnessed countless birthday parties, reads his newspaper by the window.

Stocks no 18, Ruskin *Notes* (1856) p 18, RA (1856) no 131, the engraving (1859) no 1210, Slater p 605, DNB XVIII p 1280.

10 Detail from Come Along 1860

BM 70.8.13.375
An engraving (47 × 57·1) by Francis Holl, ARA (1815–84) after the water-colour painted c 1846 by Joseph John Jenkins, RWS (1811–85); published by the Art-Union of London in 1860 and printed by McQueen. Unlike so many plates, this Art-Union publication was delivered on time and the Annual Report of 1860 notes that distribution to the subscribers had taken place. This is an example of an engraver undertaking a plate for a fellow engraver. J. J. Jenkins began life as the son of an engraver and became himself a prolific line engraver working chiefly for *Heath's Book of Beauty* and *The Keepsake* until his health caused him to give up the arduous skill of engraving for water-colour painting and he subsequently became a full member of the RWS in 1850 and its secretary for ten years. This charming subject harks back to Jenkins's days on *The Keepsake* as the style was out of date in 1860.

In spite of the date, 1860, the subject is free of moral overtones as it reproduces a painting done twenty years earlier in a less earnest age. A little girl follows her mother or elder sister across a stream balancing on the stepping stones. The pastoral style is that of the picturesque annuals.

AU (Report) 24 (1860) and 49 (1885), AU (Almanack) 1862, Bryan (1904) III p 63.

11 His Only Pair 1862

BM 20.1.12.98
A mixed mezzotint (58·4 × 68·6) by William Henry Simmons (1811–82) after the painting dated 1860 by Thomas Faed, RA (1826–1900); published by Henry Graves & Co 18 February 1862, in an edition of 325 proofs of which 200 were artist's proofs. PA stamp RAA. The painting was exhibited in 1860 with the line 'The mother, with her needle and her shears, gars old cleas look amaist as weel's new'.

The small boy, whose only pair of trousers is being mended, sits on the broken dresser wrapped in an old piece of cloth and barefooted like his sister. The mother has a tranquil smile upon her face in spite of the broken woodwork and cracked window panes of her pitiful dwelling.

Slater p 584, RA (1860) no 257, AJ (1871) p 2, H. Graves p 23, PA (1892), DNB XVIII p 260, Bryan II p 142 and V p 83.

12 Detail from Charity 1863

BM 10.13.1046
A mixed mezzotint (66 × 86·7) by William Henry Simmons (1811–82) after the painting of 1860 by Thomas Brooks (1818–91); published by Moore, McQueen & Co 24 June 1863 in London and distributed in Paris by François Delarue and in Berlin by Carl Gluck. PA stamp YWL. This print was published as the centre to the companion prints *Hope* and *Faith*. The painting was exhibited at the Royal Academy in 1860 with the legend 'The true religion and undefiled'.

Two mothers with daughters of about the same age, confront each other across the poverty line. The more fortunate woman has found the time to bring comfort and sustenance to the other in the form of a Bible and basket of food. In this detail the well-dressed child offers the basket of free food to the poor, her rich clothes emphasising the shabbiness of their dwelling. The Victorians believed that

charity was a personal responsibility and choice, and children were trained to be charitable.

RA (1860) no 575, DNB XVIII p 260.

13 Bed-time 1863

BM 66.10.13.1069
A mezzotint with etching (72·3 × 50·5) by Charles Algernon Tomkins (c 1821—after 1897) after E. C. Barnes, RSBA (worked c 1856–83); published by Moore, McQueen & Co 26 August 1863 in an edition including 225 proofs of which 100 were artist's proofs. PA stamp XJU. The prints were distributed in Paris by François Delarue.

This print shows a mother carefully carrying her baby up to bed. Her daughter climbs the rough wooden stairs, barefoot regardless of splinters. The walls are rough and unpainted and the cobbles are uncovered, yet there is a warmth about this composition which is lacking in the similar subjects *Seven p.m.* and *Seven a.m.*, **23**. In these, the middle-class appurtenances, the carved bannister, the expensive stair-carpet and moulded ceiling, the well-shod children, weigh against the fact that the woman is not their mother but a uniformed maid. There is a pictorial and atmospheric rigidity about these prints unlike the earlier subject, although all three were engraved by the same man.

PA (1892).

14 Foot Ball 1864

VAM E.103.1970
An engraving with top corners rounded (51·7 × 101) by Henry Lemon (worked mid-century) after the painting dated 1839 by Thomas Webster, RA (1800–66); published by Moore, McQueen & Co 6 June 1864 in London, and in Paris by François Delarue in an edition of 325 of which 50 were artist's proofs.

Football was traditionally a game for the masses. 'Foot Ball Day' fell annually on Shrove Tuesday when shutters were put up and houses closed to prevent damage from hooliganism. The game fell into disrepute and 'Foot Ball Day' died out about 1830. Through the 19th century the game developed in the public schools, the style and rules varying according to the ground available, courtyard or field. Rugby played an open game on its fields which became the standard form, though 'hacking', intentional kicking on the shins, was not abolished at Rugby until 1877. The boy in the centre rear has suffered a hacking and is pulling his opponent's hair in revenge. The tackle has ended with a pile-up in the nettles.

Slater p 438, PA (1847–75), RA (1839) no 363, the engraving (1864) no 853.

15 My First Sermon 1865

VAM E.89.1970
A mixed mezzotint with arched top (64·2 × 46·3) by Thomas Oldham Barlow, RA (1824–89) after the painting dated 1863 by Sir John Everett Millais, PRA (1829–96) in the Guildhall Museum, Corporation of London (no 701), published by Moore, McQueen & Co in London and Thomas Agnew & Sons in Manchester and Liverpool, 19 May 1865. An original

edition of 725 of which 450 were artist's proofs, was declared by Henry Graves two months earlier which suggests the plate changed hands or else the three publishers collaborated. This was not unusual, Graves and McQueen also collaborated in the case of *The Black Brunswicker*, **59**.

This scene of a smartly dressed little girl sitting up wide-awake in church was a companion print to *My Second Sermon* in which the child is asleep, also engraved by T. O. Barlow. A water-colour version of this work is in the VAM (399.1901). Both subjects were painted in the church of Kingston-on-Thames and are portraits of the painter's daughter Effie Millais. The engraving was exhibited at the Royal Academy in 1865 (no 858) two years after the painting.

Slater p 124, J. G. Millais II p 496, Graves p 75, AJ (1890) p 95, RA (1863) no 7, Winter (1898) no 26, PA (1847–75).

16 Detail from **Awake** 1868

BM 1921.6.1.5. Leggatt Gift
A mixed mezzotint (71·1 × 52·8) by Thomas Oldham Barlow, RA (1824–89) after the painting by Sir John Everett Millais, PRA (1829–96) in the City Art Gallery, Perth, published by Henry Graves & Co, 1 June 1868. There were 725 proofs of which 450 were artist's proofs. PA stamp NLD.

Two pictures, *Sleeping* and *Waking*, were exhibited at the Royal Academy in 1866 and were portraits of Millais's daughters, Alice and Mary. Apparently they did not enjoy posing for their father. Mary, the subject of this engraving, said 'It was so horrid, just after breakfast, to be taken upstairs and undressed again, to be put to bed in the studio'. When she tired of gazing seraphically upwards she would wait until her father was not looking, and kick off all the bed clothes, much to his annoyance.
The mezzotint was exhibited at the RA 1868, (no 919).

J. G. Millais I pp 392, 395, 397; Millais PRB, PRA, (1967) 69.

17 Remembrance 1869

BM 13.10.15.51
A mezzotint with stipple (57 × 50·5) by James John Chant (c 1820–after 1876) after William Charles Turner Dobson, RA, RWS (1817–98), published by Henry Graves & Co 10 January 1869 in an edition of 200 proofs of which 125 were artist's proofs. PA stamp CGE.

Two charming little girls have gathered forget-me-nots and are on their way across the fields to the country churchyard in the distance. The elder child has a wreath over her arm and a knowing look in her eye as she lays the other arm around the younger sister. Perhaps they are motherless. Maternal deaths in childbirth were distressingly high and it is not surprising that the pathetic situation of orphaned children was a frequent theme.

H. Graves p 17, PA (1892).

18 The Signal on the Horizon 1871

BM 86.12.6.99
A mixed mezzotint (72·3 × 54) by William Turner Davey (1818–c 1890) after the painting of 1857 by James Clarke Hook, RA (1819–1907) published by Pilgeram & Lefèvre, 24 June 1871 in an edition of 225 proofs of which 100 were artist's proofs. PA stamp OLC.

Father, mother and children are arranged on some steep steps above a coastal village waiting for the return of a ship which has just been sighted. The painting was exhibited at the Royal Academy (1857 no 160) with the legend 'Her Union Jack is at the Fore'. The woman is interested solely in her baby whom she is about to cover with a sail. The figure of the elder boy impressed Ruskin who described it as 'The sweetest most pathetic picture of an English boy that has been painted in modern times; as for the thought and choice of scene . . . they are so true, so touching and so lovely . . . it would need a little finished idyll of Tennyson to express them lightly'.

PA (1847–75), RA (1857) no 160, Ruskin, *Notes* (1857) p 19.

19 Detail from **Light and Darkness** 1871

BM (old crown)
An engraving (66·8 × 86·3) by William Ridgway (worked *c* 1863–85) after George Smith (1829–1901); published by the Art-Union of London for subscribers of 1871. The subject is drawn from Luke I: 79

To give light to them that sit in darkness and in the shadow of death, to guide our feet into the way of peace.

The girl seated on the right is blind and is reading a book, probably the Bible, by touch. Her father and the rest of the family are gathered round. The spinning wheel on the right suggests that before the invention of Braille this girl was limited to spinning. Now she can read. There is another impression VAM (no 19549).

AU (Report) 34 (1870), RA (1865) no 406.

20 A Wee Bit Fractious 1872

BM 86.12.6.41
A mixed mezzotint (75 × 54·3) by William Henry Simmons (1811–82) after the painting of 1871 by Thomas Faed, RA (1826–1900); published by Pilgeram & Lefèvre, 1 November 1872 in London, and by William Schaus in America, in an edition including 325 proofs of which 175 were artist's proofs. The painting was exhibited (RA 1871 no 150) with the quotation 'See yon wee bumptious bairnie, clasped on its mither's knee . . .'

This print is free from moral undertones and is a straightforward mother and child composition. A variation on the theme of fractious children is Nicol's *Steady Johnnie, Steady!* in which the grandmother takes charge.

PA (1892), RA (1871) no 150, the engraving (1873) no 1312, DNB XVIII p 260 and XXII p 623, Bryan II p 142 and V p 83.

21 Absorbed in Robinson Crusoe 1873

BM 86.12.6.79
A mixed mezzotint (50·2 × 81·2) by Frederick Stacpoole, ARA (1813–1907) after the painting dated 1871 by Robert Collinson (born 1832); published by Pilgeram & Lefèvre, 8 January 1873 in London and William Schaus in New York, in an edition of 375 of which 200 were artist's proofs. The mezzotint was exhibited at the Royal Academy in 1873 (no 1238).

Popular novels were becoming still more widely read. The young boy, lost in his book, lies on a flowery cliff with the ocean stretching out before him and a slight sea breeze

blowing the grass and the smoke in the distance. Boats are drawn up on the beach and minute people can be seen on the jetty.

PA (1892), RA (1871) no 362, (1873) no 1238.

22 Baith Faither and Mither 1875

BM 86.12.6.45
A mixed mezzotint (69·2 × 88·3) by William Henry Simmons (1811–82) after the painting dated 1864 by Thomas Faed, RA (1826–1900); published by Pilgeram & Lefèvre, 25 March 1875 in London and M. Knoedler & Co in New York, in an edition including 675 proofs of which 375 were artist's proofs. PA stamp UPJ. The painting was exhibited (RA 1864 no 315) with the line 'He was faither and mither, and a' things tae me'.

Thomas Faed's obvious sentiment here falls on the figure of a rough widower tenderly fitting a newly made glove to the small hand of a child. The other children look on, some with resentment and one small boy plays with a puppy. The elder daughter wears a hat and fur collar probably once worn by her mother.

PA (1847–75), RA (1864) no 315, the engraving (1875) no 1096, RSA (1865) no 506, AJ (1871) p 2, Royal Jubilee Exhibition, Manchester (1887) no 396, DNB XVIII p 260, XXII p 623.

23 (a) Seven p.m. 1875

VAM E.122.1970
One of a pair of mixed mezzotints (72·4 × 52·7) by Charles Algernon Tomkins (*c* 1821–after 1897) after George Goodwin Kilburn (1839–1924); published by G. P. McQueen, 1 January 1875. PA stamp ZRO. The edition included 250 pairs of proofs of which 125 pairs were artist's proofs. Companion print to *Seven a.m.* by the same artists.

This print shows a uniformed nursemaid ascending the stairs of a well-to-do house, with her two charges. The children have possibly been down to say goodnight to their parents or they have been out in the garden, seen on the right under the Venetian blind, to pick snowdrops.

23 (b) Seven a.m.

VAM E. 121.1970

The same children are being brought downstairs for breakfast, smartly dressed with neat bows in their hair. The maid has her morning uniform on, which she will later change for her black evening uniform.
This print compares with *Bed-time*, **13** also engraved by Charles Algernon Tomkins.

PA (1847–75).

24 Detail from **Death of Nelson** 1876

BM 76.2.12.17
An engraving (44·5 × 123) by Charles William Sharpe (*c* 1830–70) after the painting by Daniel Maclise, RA (1806–70) in the Palace of Westminster; published by the Art-Union of London in 1876. A small version of the painting entitled *Here Nelson Fell* was exhibited at the Royal Academy in 1866 (no 47).

This detail depicts a drummer boy on the deck of Nelson's

flagship and shows how even young children went to the wars. There are many engraved versions of this historic moment in 1805.

AU (Report) 30 (1866), Reynolds (1966) p 36, AU (Almanack) 1876, C. Wood (1971) p 97.

25 Looking Out for a Safe Investment 1878

BM 86.12.6.132

A mixed mezzotint (76·1 × 59) by William Henry Simmons (1811–82) after Erskine Nicol, ARA, RSA (1825–1904); published by Pilgeram & Lefèvre, 1 February 1878 in London and by William Schaus in New York in an edition including 450 proofs of which 275 were artist's proofs. PA stamp VSO.

Two more of Erskine Nicol's tough Scottish lads, looking for a tradeable item in the sweet shop, possibly a gingerbread man. The small boy wears handed-down trousers several sizes too large for him. They have their school bags with them and the older boy carries a slate.

PA (1892), RA (1876) no 942, R. H. Shepherd, *Notes* (1876) p 46.

26 Stolen by Gypsies 1875, 1882

VAM E.136.1970

An engraving (55·5 × 73·4) by Lumb Stocks, RA (1812–92) after the painting dated 1868 by John Bagnold Burgess, RA (1830–97); published by the Art-Union of London. The plate was begun by Charles Henry in 1875 and completed after his death in 1879, by Lumb Stocks. It was published in 1883 and exhibited at the Royal Academy in 1882 (no 1275). In the same year another engraving by Stocks after Burgess was exhibited, *The Spanish Letter-writer*.

In this print, the well-dressed little girl stands shyly before her captors who try to teach her to dance. Her rescuers can be seen descending the stairs on the left.

Stocks no 2, AU (Report) 46 (1882) pp 5, 6, RA (1882) no 1275, (1868) no 391, DNB XVIII p 1280.

27 Pomona 1882

VAM E.190.1970

A mixed mezzotint (54·3 × 40·4) by Samuel Cousins, RA (1801–87) after the painting by Sir John Everett Millais, PRA (1829–96); published by Arthur Tooth & Sons, 2 October 1882 and The Fine Art Society. The copyright was registered in Washington. PA stamp OHX. There was an original edition of 1000 including 50 artist's proofs. The model was Margaret Millais, a niece of the painter.

This is typical of Millais's late pot-boilers. As prints they had no special story to tell, though in this case there is a story; it is drawn from classical myth and might have been too obscure for the average print buyer.

Ovid tells the story of the courtship of Pomona, an old Italian goddess of fruit and gardens, by the silvan deities and how the god of the turning year, Vertumnus, wooed and won her. Although she was mainly a country goddess, she had a special priest at Rome, the Flamen Pomonalis, and a sacred grove at Ostia called the Pomonal. She was always represented as a beautiful maiden with fruit in her bosom and a pruning knife in her hand. As Millais's niece was too young to have a bosom in which to keep her apples, she has them in the wheelbarrow. Millais has overlooked the pruning knife.

Whitman no 220 2nd state, PA (1892), J. G. Millais II pp 161, 497, repr 183, RA (Winter) 1898 no 41, DNB IV p 1276.

ANIMALS AND RURAL LIFE

28 The Young Bird 1812

VAM E.220.1970

A line engraving (40·6×32·7) by John Burnet, FRS (1784–1868) after his
own painting dated 1812; published by himself in collaboration with
Messrs Boydell & Co, 1 May 1812 and later republished by Moon, Boys &
Graves as a companion print to *The Jew's Harp* by Burnet after Sir David
Wilkie (1810).

Here the influence of Dutch low life painting transposed
by Wilkie and by Burnet into an English idiom with rather
more humour and less vulgarity than its continental
counter-part can be seen. The child was to become a main
element in popular subject painting. Burnet was ex-
clusively a line engraver and it is interesting to see his
technique applied to an interior which would later have
been rendered by mixed mezzotint. Already the Victorian
belief in family life, domesticity and happy poverty are
exemplified.

Slater p 197, C. Le Blanc I p 551 no 34, Nagler II p 247, *Catalogue of
Engravings*, Moon, Boys & Graves (1829) p 20.

29 Bolton Abbey in Olden Time 1837

VAM E.277.1970

A mezzotint (66×76·9) by Samuel Cousins, RA (1801–87) after the painting
dated 1834 by Sir Edwin Henry Landseer, RA (1802–73), in Chatsworth
House, Derbyshire.

This plate, published in the year of Queen Victoria's
accession and exhibited at the Royal Academy that year,
was the first of many interpretations of this picture which
was to become one of the most popular and much
reproduced subjects. This one and *The Old Shepherd's
Chief Mourner*, **30**, were best sellers like *The Light of the
World*, **119**, which demonstrates the change in public taste
over 40 years. This was also Samuel Cousins' first entry at
the Royal Academy. The preliminary etching is in the BM.
William Turner Davey produced a plate which was
published by Thos Boys & Sons in 1856 in an edition of
1525, and two years later J. R. Jackson engraved a plate for
Dixon & Ross who published nearly 2000 prints with 1000
artist's proofs. Still the market was not saturated as A.
Graves records a further two plates of the single figures of
the boy and the girl entitled *The Falconer's Son* and *The
Angler's Daughter* by William Chevalier and William
Finden respectively.

Sir Augustus Callcott is portrayed as the Abbot taking an
inventory of produce for the Abbey; Jacob Bell as the
falconer's son and Landseer's daughter as the fishmonger
or angler's daughter. There is a lavish display of dead
livestock, typical of Landseer, and showing the influence
of Dutch still life painting. The work was commissioned by
the 6th Duke of Devonshire who had inherited the ruins of
Bolton Priory from his ancestor the 2nd Earl of Cumber-
land who bought it in 1542. The village named after Bolton
Abbey is in the West Riding of Yorkshire.

Whitman no 199, A. Graves, *Catalogue of the Works of the Late Sir Edwin
Landseer* RA (1874) p 17 no 196. PA (1847–75), C. S. Mann I p 79, RA (1834) no
13, Slater p 243, H. Graves p 62, F. G. Stephens, *Sir Edwin Landseer* (1881)
repr this engraving pl V.

30 The Old Shepherd's Chief Mourner 1838, 1869

VAM E.165. 1970

A mixed mezzotint (65·5×71) by F. Hollyer after the painting dated 1837
by Sir Edwin Henry Landseer, RA (1802–73) in the Sheepshanks
Collection, VAM (no 93), published by J. McQueen, 5 June 1869 in an
edition including 100 artist's proofs. PA stamp OSR. This is a later version
of a perennial favourite. The original engraving was made by B. P.
Gibbon and published in 1838. (An impression is VAM no 1837.) Another
plate was engraved by Charles George Lewis. Two lithographs were
produced by Jacob Bell, (C. S. Mann repr both versions IV pp 103 and
110). This plate was published with the companion print *The Shepherd's
Grave*, **31**.

The story of canine fidelity beyond death, told in these two
pictures, is similar to if not derived from the legend of
Greyfriars Bobby whose statue is in Edinburgh near St
Giles' Cathedral. He followed his dead master to the
cemetery and sat on the grave until he starved to death. The
connection seems likely as so much Victorian painting
drew on Highland themes due largely to the royal family's
fondness for Balmoral and for Landseer himself. Landseer,
Faed, Lauder, Duncan, Wilkie, Paton and Harvey were
responsible for a vast number of popular prints all with
Scottish origins and inferences.
Ruskin describes Landseer's painting thus:

The close pressure of the dog's breast against the wood [of the
coffin], the convulsive clinging of the paws which have dragged
the blanket off the trestle, the total powerlessness of the head
laid, close and motionless upon its folds, the fixed and tearful fall
of the eye in its utter hopelessness, the rigidity of repose which

marks that there has been no motion nor change in the trance of agony since the last blow was struck on the coffin-lid, the quietness and gloom of the chamber, the spectacles marking the place where the Bible was last closed, indicating how lonely has been the life, and how unwatched the departure of him who is now laid solitary in his sleep—these are all thoughts by which the picture ranks as a work of high art.

Beck 18. PA (1847–75), C. S. Mann I p 134 IV pp 110, 103, Ruskin, *Modern Painters* (1843) I p 88, A. Graves, *Catalogue of the Works of Sir Edwin Landseer* RA (1874) no 233, pp 20, 47, Reynolds (1966) pl 8.

31 The Shepherd's Grave 1838, 1869

VAM E.166.1970
A mixed mezzotint (65·5 × 71) by F. Hollyer after Sir Edwin Henry Landseer, RA (1802–73); published by J. McQueen, 22 June 1869 as a companion print to *The Old Shepherd's Chief Mourner*, **30**. Earlier plates were engraved by B. P. Gibbon in 1838 (VAM 18740, 18741 and 18742) and by Charles George Lewis. Another engraving of this subject, by G. S. Hunt, appeared in *The Magazine of Art*, 1890–91 p 388.

In this sequel to *The Old Shepherd's Chief Mourner*, the faithful dog is alone by the freshly covered mound, watching and hoping for a resurrection.

Beck 19, C. S. Mann I p 112, PA (1847–75), A. Graves, *Catalogue of the Works of the Late Sir Edwin Landseer* RA (1874) no 232 pp 20, 47.

32 Laying down the Law After 1843

VAM E.248.1970
A mixed mezzotint (54·7 × 48·3) by T. Stanfeld after the painting dated 1840 by Sir Edwin Henry Landseer, RA (1802–73) in Chatsworth House, Derbyshire. The date and publisher of this plate are not known, though the original plate by Tom Landseer was published in 1843 and another engraving by George Zobel was published by Thomas McLean in 1851. W. T. Davey also engraved the subject in small size.

Here anthropomorphism is taken to an absurd degree in a picture which was obviously meant to be amusing, at least to the owners of the dogs. It shows a court scene in which the judge and jury are all dogs, complete with quills and ink well. The French poodle belonged to the well-known socialite, Count d'Orsay and the Blenheim spaniel was especially introduced at the request of the Duke of Devonshire. There is an impression without it in the Queen's Collection. The painting was exhibited in 1961 (*Sir Edwin Landseer RA*, RA no 81) with the alternative title *Trial by Jury*.

C. S. Mann I repr p 72 IV p 18a, *The Magazine of Art* 1890–91 repr p 396 PA (1847–75), RA (1840) no 311, Winter (1874) nos 205 and 503. A. Graves, *Catalogue of the Works of the Late Sir Edwin Landseer* RA, no 275 p 22.

33 Shoeing the Horse 1848

VAM E.266.1970
A mixed mezzotint (88·9 × 69·2) by Charles George Lewis (1808–80) after the painting dated 1844 by Sir Edwin Henry Landseer, RA (1802–73) in the Bell Collection, Tate Gallery (no 606); published by F. G. Moon, 1 June 1848 in an edition of 1582 of which 182 were artist's proofs. A smaller plate also by C. G. Lewis was published by Gambart & Co in 1859, and there was a third size engraved by the same man. The subject was still popular in

1880 when it was re-published by Henry Graves in mezzotint by J. C. Webb.

In this scene all the characters are portraits. The horse was Old Betty, a mare belonging to Jacob Bell, Landseer's financial manager and friend. The farrier is thought to be Bell himself, and the bloodhound was his dog Laura. The donkey remains anonymous. In this edition, the sky was printed in blue while the rest of the print remained black and white.

PA (1847–75), A. Graves, *Catalogue of the Works of the Late Sir Edwin Landseer* RA (1874) no 330 p 26, RA (1844) no 332, *Sir Edwin Landseer* (1961) no 85, C. S. Mann I repr pl 39, Slater p 442, Ruskin *Modern Painters* (1846) II Chap 4. *The Year's Art* (1881) p 167, A. Graves, *Charles George Lewis* in *The Printseller* (1903) p 201.

34 Detail from **An English Merry-making in the Olden Time** 1852

VAM E.158.1970
An engraving with stipple (62·2 × 94) by William Holl (1807–71) after the painting dated 1847 by William Powell Frith, RA (1819–1909) in the Proby Collection at Elton Hall; published by the Art-Union of London in 1852. Over 23,000 impressions were distributed. A small oil-sketch is in the Jones Collection, VAM (no 510–1882).

The scene depicts a happy country gathering under the spreading English oak on the village green in olden times, and this detail shows a man and a pretty woman dancing through an arch of hands in a game of oranges and lemons. This nostalgic picture stirred memories of country life as it might have been before the migration to the cities, though the print found its way into suburban terraces rather than country houses.

W. P. Frith I pp 122–27, AU (Reports) 15 (1851), 16 (1852), 52 (1888), Slater p 388, Theime u. Becker XVII p 372, AJ (1871) p 103, *Frith* Exhibition Whitechapel London (1951) no 13.

35 The Monarch of the Glen 1852

VAM E.314.1970
An engraving (73·3 × 70·5) by Thomas Landseer, ARA (1795–1880) after the painting dated 1851 by Sir Edwin Henry Landseer, RA (1802–73), published by Henry Graves & Co 18 August 1852 with eight lines of verse from the *Legends of Glen Orchay*:

'When first the day-star's clear, cool light
Chasing night's shadows grey
With silver touched each rocky height
That girded wild glen-strae,
Uprose the monarch of the glen,
Majestic in his lair,
Surveyed the scene with piercing ken
and snuffed the fragrant air.'

The painting of a stag sniffing the morning air on the Scottish hills was intended for the Refreshment Room at the House of Lords and Landseer offered it to the Government for 300 guineas. The offer was rejected by a vote of the Commons and the painting was then purchased by Lord Londesborough for 800 guineas while the copyright went to Henry Graves for a further 500 guineas. The

engraving was enormously popular and is one of the most famous, if not *the* most famous, Victorian print. Thomas Landseer engraved many plates after his brother's work and was helped by the latter's fame and fortune. This plate, reviewed in *The Art Journal* of 1853 (p 100), was described as uniting 'in the highest degree the qualities of delicacy, richness and artistic feeling'. Sir Edwin worked on the plate himself. He engraved the nose of the deer.

Beck 20, C. S. Mann I p 121, repr p 141, A. Graves *Thomas Landseer* ARA in *The Printseller* (1903) p 101, PA (1847–75), Slater p 429, H. Graves p 50, RA (1851) no 112, Winter (1874) nos 436 and 522. AJ (1853) p 100.

36 The English Gamekeeper 1858

VAM E.268.1970
A mixed mezzotint (78·4 × 60) by Frederick Stacpoole, ARA (1813–1907) after a painting by Richard Ansdell, RA (1815–85); published by Henry Graves & Co in an edition of 275 proofs of which 150 were artist's proofs, declared to the PA in July 1858. This was the companion print to *The Scotch Gamekeeper* (VAM E.269.1970).

This print depicts a true English countryman, a game-keeper, with his dogs and bag at a stile. Ansdell's animal paintings and scenes of country life were much published as engravings. His *Fight for the Standard*, **71**, conveys a more obvious form of patriotism.

AJ (1859) ix, PA (1847–75), RA (1855) no 520, H. Graves repr p 8.

37 Bonjour Messieurs 1862

BM 66.12.8.49
An engraving with stipple (54 × 90·8) by John Henry Robinson, RA (1796–1871) after the painting of 1857 by Frank Stone, ARA (1800–59) published by Thomas McLean 1 July 1862. PA stamp ZCX. The edition included 225 proofs of which 100 were artist's proofs.

Another Victorian subject returning to the theme of rural simplicity which implied happiness. Though the cartload of pretty paysannes are French, the same belief prevails. Ruskin describes the subject in his *Academy Notes* (1857):

A fisher's cart-horse trots to market along the top of the Calais cliffs, in the morning air. The idle fisher boy tosses his limbs for gladness and the fisher girls are laughing—crowned with the sacredness of a happy life, and strength of careless peace and helpful innocence.

RA (1857) no 355, Ruskin (1857) p 29, PA (1847–75).

38 The Forester's Daughter 1864

BM 66.10.10.1040
A mixed mezzotint with an arched top (65 × 53·3) by William Holl (1807–71) after William Powell Frith, RA (1819–1909) and Richard Ansdell, RA (1815–85), published by Moore, McQueen & Co in an edition of 250 proofs of which 125 were artist's proofs declared to the PA 9 March 1864.

The frequency with which women appear with animals in Victorian paintings leads naturally to the idea of women as animals, prized for their looks and breeding. In this sample the girl would be admired more for the former than the latter.

Ansdell's animal pictures were much engraved and bought by the animal-loving public. They enjoyed that corner of the market not saturated with Landseers.

PA (1847–75).

39 The Stag at Bay 1865

VAM E.130.1970
An engraving (60 × 99·5) by Thomas Landseer, ARA (1795–1880) after the painting of 1846 by Sir Edwin Henry Landseer, RA (1802–73) in the Guinness Collection, Dublin; published by John O'Malley, 23 December 1865. The plate was originally published by Thomas Maclean and E. Gambart on 11 December 1847 in an edition of 825 of which 175 were artist's proofs. In 1852 T. McLean published a small plate, engraved by Charles Mottram, possibly to coincide with the publication of *The Monarch of the Glen*, **35**, that year. In 1866 another, medium-sized, plate came on the market, engraved by George Zobel and published by Henry Graves. Saturation point had not been reached as Alfred Lucas engraved a portion of the subject under the title *Defiance*, and a small plate of this same detail was engraved by S. T. Soilleux. The original plate by Tom Landseer was also published by Jerrard & Son on 1 May 1859.

Although this is an entirely different subject, it could be interpreted as the demise of the 'Monarch of the Glen', for here the stag is shown floundering in a loch, about to be killed by the hounds. The sky is dark and stormy in contrast to the peace and tranquility of *The Monarch of the Glen*.

A. Graves, *Catalogue of the Works of the Late Sir Edwin Landseer* RA (1874) no 350 p 28, C. S. Mann I p 70, A. Graves, *Thomas Landseer* ARA in *The Printseller* (1903) p 101, Slater p 429, H. Graves p 62 repr on title page, PA (1847–75), RA (1846) no 165, Winter (1874) nos 234 and 478.

40 (a) and (b) Labour and Rest 1870

VAM E.150 and 151.1970
A pair of engravings (41·5 × 64·8 and 41 × 63) by Edward Radclyffe (1810–63) after John Absolon (1815–95); published by J. McQueen, 29 July 1870 in London and Paris.

The subject and mood of these prints was not contemporary in 1870 and it is likely that they were first published much earlier. The scene is of haymaking in the English summer followed by refreshments under the shade of a tree. The two young women are probably from the big house, taking their morning stroll. In the first print, the farm worker respectfully pulls his forelock and in the second, the girls have become quite familiar as they listen to farm gossip with the rest. The village church, without which no English landscape is complete, can be seen in the distance.

41 Otters and Salmon 1871

VAM E.154.1970
A mezzotint with engraving (53 × 77·2) by Charles George Lewis (1808–80) after the painting dated 1842 by Sir Edwin Henry Landseer, RA (1802–73); published by J. McQueen, 28 April 1871 in an edition including 100 artist's proofs. PA stamp TPY. Apart from this plate by C. G. Lewis, an earlier, larger plate was engraved by J. Richardson Jackson and published by F. G. Moon in 1847 as a companion to *Not Caught Yet* which was also engraved by Lewis (VAM E.155.1970). A woodcut of the first study (1840) was made by S. Williams in 1843 for William Scrope's *Days and*

Nights of Salmon Fishing. There is another plate engraved by B. P. Gibbon.

In this sporting subject, the otter pins down his catch, a baleful salmon, against a background of the waterfall up which the salmon was heading. The salmon's lacerations are shown with Landseer's usual gory accuracy.

C. S. Mann I p 115, IV p 101, AU (1842) p 65, PA (1847–75), A. Graves *Catalogue of the Works of the Late Sir Edwin Landseer* RA (1874) no 301 pp 24, 25 and no 280. RA (1842) no 96, Winter (1874) no 354.

42 Just Caught 1872

VAM E.156.1970
An engraving (52 × 76·8) by Alfred Lucas (worked c 1847–c 1886) after a painting by Richard Ansdell, RA (1815–85); published by G. P. McQueen, 12 August 1872. The edition included 125 proofs of which 100 were artist's proofs. PA stamp SBX. Two other plates of this subject are recorded, the largest size by H. T. Ryall, published by Gambart & Co 27 May 1847, and the smaller size engraved by R. B. Parkes published by J. Dickinson & Co, 1 June 1872. The PA describes both as mezzotints.

Alfred Lucas displays the engraver's virtuosity in the way he conveys the different textures of fox fur, feather, thatch, grass and snail's shell.

Beck 23, PA (1847–75).

43 Dominion 1878

VAM E.298.1970
A mixed mezzotint (63 × 87·2) by William Henry Simmons (1811–82) after the painting entitled *Van Amburgh and his Animals* dated 1839 by Sir Edwin Henry Landseer, RA (1802–73) in the Royal Collection, Buckingham Palace; published by Henry Graves, 1878, in an edition including 325 proofs of which 200 were artist's proofs. The plate was engraved three years earlier. The second, later, version of this painting dated 1847 was not engraved.

This subject is typical of the way Landseer and Victorian painters in general introduced an educational, religious or moral element into straightforward animal painting. The little lamb, and the title, indicate that there is more to this picture than mere portraiture of the lion tamer and his big cats. Genesis I: 28: 'And God said unto them . . . replenish the earth, and subdue it: and have dominion over the fish of the sea, and over the fowl of the air, and over every living thing that moveth upon the earth'. The large lion resting on the right is a relation of Landseer's bronze lions in Trafalgar Square of 1873. The second version of the painting was made for the Duke of Wellington who, when told the price was 600 guineas, wrote out a cheque for double the amount, thereby destroying the myth of his meanness.

PA (1892), C. S. Mann I p 103, II p 172, H. Graves p 45, A. Graves, *Catalogue of the Works of the Late Sir Edwin Landseer* RA (1874) no 261 p 21, RA (1839) no 351.

44 A Little Freehold 1878

BM 18.10.10.3
A mezzotint (72·4 × 55·3) by Thomas Lewis Atkinson (born 1817) after Samuel John Carter (1835–92), published by Louis Brall & Sons in

Bloomsbury, 19 November 1878. The edition included 25 presentation prints and 275 artist's proofs. PA stamp VBA.

In this example of anthropomorphic animals, the squirrels adhere to two great institutions of Victorian times, private property and family life.

PA (1847–75), RA (1876) no 1257.

45 Tell—The Champion St. Bernard 1881

BM 86.11.27.22
A mixed mezzotint (60·3 × 67·3) by William Henry Simmons (1811–82) after a painting by Samuel John Carter (1835–92); published by Thos Agnew & Sons 1 January 1881 in London, Manchester and Liverpool with the copyright registered in New York by M. Knoedler. PA stamp SVO. The edition included 225 proofs of which 100 were artist's proofs.

The little laird is overshadowed by the St Bernard who appears to be taking his young master for a walk. Children with animals remained an irresistible combination throughout the 19th century.

PA (1892).

46 February Fill Dyke 1884

VAM E.325.1970
An etching (43·8 × 60) by Théophile Narcisse Chauvel (1831–1909) after the painting of 1881 by Benjamin William Leader, RA (1831–1923) in the Birmingham City Museum and Art Gallery (no 607), published by Arthur Tooth & Sons, 1 June 1884, in an edition including 300 artist's proofs. The print was also published in America and the copyright was registered in Washington.

This is one of the best known of the late reproductive prints and was made by one of the many French etchers who came over to London to escape the Paris Commune and tended to take over the work of the English engravers. This famous picture shows a depressing English February with the muddy road filled with water and the leafless branches glinting in a watery light. The snow has melted and spring is coming. Most prints for the mass market were produced by etching or photogravure by this stage, although pure mezzotint was used for exclusive publications after Leighton and Moore.

Delteil no 96, records the date as 1885, Slater p 220, Beraldi VI p 159, *Revue de l'Art Ancien et Moderne* (1899) V p 109, Blackburn's *Academy Notes* (1881) repr p 13, RA (1881) no 42, PA (1892).

47 In a Welsh Valley 1902

VAM E.322.1970
An etching (54·6 × 76·5) by Théophile Narcisse Chauvel (1831–1909) after the painting by Benjamin William Leader, RA (1831–1923), published by Arthur Tooth & Sons, in 1902, in London, Paris, New York and Berlin.

At the beginning of the 20th century, prints had virtually ceased to be story-tellers, the educational and moral elements had gone and they became mere decoration like this landscape. The circulation of reproductive prints had evolved into an international business, as with this print.

PA (1912), Slater p 220. This etching post-dates Delteil.

ROMANTIC LOVE

48 The Gentle Shepherd 1841

VAM E.88.1970

A mixed mezzotint (49·2 × 56·8) by Frederick Bromley (worked c 1840–60) after Alexander Johnston (1815–91); published by Welch & Gwynne, 20 March 1841. *The Gentle Shepherd* is the title of a poem by Allan Ramsay:

> Last morning I was gay . . .
> But Meggy saw na me.

Why Meggy, the object of desire, should be swathed in diaphanous gowns, barefoot and on tiptoe in the cold, misty, Scottish morning, while the gentle shepherd himself is well supplied with coats, hat and rug is of typically romantic inconsequence. She is a fantasy figure with vaguely Florentine origins. She could be on tiptoe to show off her well-turned ankles, or merely on account of the frosty ground.

Slater p 185, RA (1840) no 72, DNB X p 941.

49 A Peep into Futurity 1842

VAM E.99.1970

A fine line engraving (49·2 × 39·7) by Richard Golding (1785–1866) after the painting entitled *Irish Girl Burning the Nuts*, dated 1841, by Daniel Maclise, RA (1806–70); published by the Royal Irish Art Union in 1842.

The Irish girl is dreaming of her lover as she gazes into the fire, where she has placed two nuts, one representing her lover and the other herself. The outcome of the courtship is to be decided by the behaviour of the nuts, by their jumping towards or away from each other. The cat, beautifully engraved, looks on with indifference. Other methods of fortune telling, with cards and with a book and mirror, have already been tried. Fish are smoking over the fire and a gun, horse's snaffle, crucifix and rosary, the essentials of life, surround the fire place.

Beck 15, AJ (1867) p 7, Strickland II p 76, NDB VIII p 78.

50 The Momentous Question 1843

BM 63.10.17.182 and VAM E.252.1970

A mixed mezzotint (68 × 54·3) by Samuel Bellin (1799–1894) after a drawing by Sarah Setchel (1804–94); published by Thomas Boys, 2 January 1843. The plate changed hands and in 1850 it was published again, by Lloyd Bros as a companion print to *The Heart's Resolve*. Slater records the publication date as 11 May. A preparatory etched state is in the BM (63.10.17.180). This impression is a proof before published proof state and is inscribed in ink.

The subject is drawn from *Tales of Hall* by the poet the Rev George Crabbe which was first published in 1819 and depicts the interior of a dungeon in which a remorseful young man languishes in leg irons. His true love leans forward with serious concern and asks the momentous question. We assume it is the question of his guilt or innocence.

Slater p 148, PA (1847–75), AJ (1894) p 125, A. Graves, *The Royal Academy of Arts* (1905) VII p 80.

51 The Order of Release, 1651 1856

BM 1921.6.1.1. Leggatt Gift

A mezzotint with arched top (76·2 × 54·3) by Samuel Cousins, RA (1801–87) after the painting dated 1853 by Sir John Everett Millais, PRA (1829–96) in the Tate Gallery (no 1657); published by Henry Graves & Co 1 May 1856, in an edition of 950 proofs of which 475 were artist's proofs. This impression is a signed India proof. This was Cousins' first plate after Millais and was engraved in 1854. It is a fine example of the rich tones achieved by mezzotint.

Samuel Cousins continued to work on plates for Millais until 1884 after which he handed over to the younger T. L. Atkinson. Millais's son described Cousins as 'a quiet, plodding, honest worker'. The painting increased in value from £400 to £2853 between 1853 and 1878.

The scene takes place in a bare waiting-room. The absence of distracting background detail concentrates interest on the figures, particularly the woman, as the man's face is concealed. The Highlander's wife has arrived with baby and sheepdog to secure the release of her husband. Mrs Ruskin, later Lady Millais, posed and held a genuine order of release obtained by Millais from Sir Hildegrave Turner, Governor of Elizabeth Castle, Jersey. The hidden face of the wounded man increases the emotional intensity of the composition based on marital fidelity.

Whitman no 217, repr 112, Slater p 244, J. G. Millais I pp 180–5 repr 181, II p 496, Reynolds (1966) p 94, H. Graves p 74, RA (1853) no 265, *Millais* RA (1967) no 38. Algernon Graves, *Catalogue of the Works of S. Cousins* RA (1888) no 233 p 14.

52 Detail from The Huguenot 1857

VAM E.5110A.1910

A mezzotint with arched top (74·2 × 51) by Thomas Oldham Barlow, RA (1824–89) after the painting of 1852 by Sir John Everett Millais, PRA (1829–96) in the Gallery of Modern Art, The Huntingdon Hartford Collection; published by Henry Graves & Co in an edition of 450 proofs before letters, 475 artist's proofs and 25 presentation proofs. All the

artist's proofs were sold out. This impression is the first mezzo proof and is signed and dated by Barlow, 24 January 1857.

This was the first of Millais's four pictures on the theme of selfless love. Here the obstacle to its consummation is one of faith. The girl is a Papist and the man, a Protestant Huguenot. They meet behind a secret-looking and overgrown old wall on the evening before 24 August 1572. They anticipate the Massacre of St Bartholomew's Day and have heard the proclamation of the Duc de Guise, 'When the clock of the Palais de Justice shall sound upon the great bell at daybreak, then each good Catholic must bind a strip of white linen round his arm and place a fair white cross in his cap'. Many would have worn the white band to escape death and the girl is hoping her man will live for her rather than die for his faith. He is one of the committed young anti-Papists the Duke hoped to eliminate and therefore doomed to die. Arthur Lemprière who posed actually lived to become a general. Miss Ryan modelled for the girl and also the Puritan in *The Proscribed Royalist*. The public were not wholly won over by the pathos of the moment and the question of consummation, one wit punned on the title 'The Hug or Not?'.

Beck 46, J. G. Millais I p 135, PA (1847–75), Reynolds (1966) pp 63, 66, H. Graves p 74, RA (1852) no 478, *Millais, PRB, PRA* RA (1967) no 35.

53 The Proscribed Royalist 1858

VAM E.297.1970 and BM 21.6.1.3
An engraving with stipple engraving and an arched top (76·2 × 54·3) by William Henry Simmons (1811–82) after the painting of 1853 by Sir John Everett Millais, PRA (1829–96) published by Gambart & Co 15 January 1858 in London and Paris. There were 250 artist's proofs at 8 guineas included in the edition. There was a later edition published in 1868 by Gambart and Graves. An engraving from the original lot was exhibited at the RA (1859) no 1185.

The subject is set during the Civil War. A cavalier fleeing from his Roundhead pursuers, hides in the trunk of an oak while a Puritan girl risks her life to bring him food. Arthur Hughes, a fellow Pre-Raphaelite, posed for the man and Miss Ryan for the girl. The background was painted in a little wood near Hayes, Kent. The giant oak became known as Millais's oak and was still standing in 1898 after Millais's death.

Beck 45, J. G. Millais I repr p 173 II p 497, Slater p 583, Le Blanc III p 517 no 4, PA (1847–75), H. Graves p 74, RA (1853) no 520, (1859) no 1185, (1898) Winter no 45, Sandby II p 334.

54 The Measure for the Wedding Ring 1859

VAM E.134.1970
A mixed mezzotint (71·4 × 52·4) by William Henry Simmons (1811–82) after the painting dated 1855 by Michael Frederick Halliday (1822–69); published by E. Gambart & Co, 1 January 1859 in London and Brussels in an edition of 225 of which 50 were artist's proofs. PA stamp CHM.

The engaged couple are seated on a rustic bench in the ruins of a church. They have been enjoying the innocent pleasures of tapestry and poetry reading. The forthcoming marriage is uppermost in the man's mind and he measures

his bride's finger for the size of the ring. The creeper seems symbolically knotted behind them. The long engagement was a common theme.

Beck 27, PA (1847–75), RA (1856) no 568, AJ (1869) p 272, DNB VII p 996.

55 The Prison Window 1860

BM 21.6.1.10. Leggatt Gift
A mezzotint (76·2 × 54·6) by Thomas Oldham Barlow, RA (1824–89) after the painting of 1857 by John Phillip, RA (1817–67); published by Thomas McLean and E. Gambart, 1 May 1860 in an edition including 525 proofs of which 300 were artist's proofs. There was a later edition dated 31 July 1860. The mezzotint was exhibited at the Royal Academy in that year (no 914).

The scene takes place outside a prison in Seville. The wife of the prisoner shows him his baby through the bars, while her mother distracts the guard by offering him a cigarette. The women both have baskets of shopping, though the wife's shopping has toppled into the gutter in her haste to seize the moment. Although the setting is exotically foreign, the theme is the familiar one of female fidelity in the face of separation and hardship.

PA (1847–75), RA (1857) no 225, (1860) no 914, H. Graves p 81, Slater p 124, DNB XV p 1076.

56 Prison Solace 1863

VAM E.168.1970
An engraving (67·3 × 49·8) by William Holl (1807–71) after the painting of 1859 by Robert Carrick (died 1895), published on 24 June 1863 in London by Moore, McQueen & Co, in Paris by François Delarue and in Berlin by Carl Gluck & Co. PA stamp AWC2. There were 475 impressions of which 250 were artist's proofs. The engraving was exhibited the following year (no 826) at the Royal Academy.

Here the prisoner tries to kiss his faithful but unattainable true love through the grill of his cell. We see again the heavily symbolic iron bars, as in *Les Adieux*, 60, and as if to emphasize the restrictions on the man, his legs are manacled together. A bird in flight, seen through the grill, adds a pathetic note to the composition. Although the faces are clearly Victorian the costumes suggest that this situation is a thing of the past. *The Prison Window*, 55, published ten years later shows that this rather masochistic theme was still popular.

PA (1847–75), RA (1864) no 826, (1859) no 26.

57 Detail from Claudio and Isabella 1864

VAM E.131.1970
An engraving with stipple (73·5 × 47) by William Henry Simmons (1811–82) after the painting of 1850–3 by William Holman Hunt, OM (1827–1910) in the Tate Gallery (no 3447); published by E. Gambart & Co 15 June 1864 in an edition of 225 proofs of which 100 were artist's proofs. Gambart bought the copyright in 1856. PA stamp BEU.

This illustration of Shakespeare is drawn from *Measure for Measure*, III. i:

> *Claudio* Death is a fearful thing
> *Isabella* And shamed life a hateful

Claudio Ay, but to die, and go we know not where:
To lie in cold obstruction, and to rot.

The interior was taken from the Lollards' prison at Lambeth Palace.

Beck 43, W. Holman Hunt I pp 211–215 repr p 344, *Holman Hunt Exhibition* Walker Art Gallery and VAM (1969) nos 17 and 18, pl 36, RA (1853) no 44, PA (1847–75), Le Blanc III p 517 no 19, M. Lutyens 'Selling the Missionary' in *Apollo*, Nov 1967 repr p 382 DNB XVIII p 260.

58 Hesperus 1863

BM 66.10.13.1045
An engraving with stipple and an arched top (72·4 × 52·7) by William Henry Simmons (1811–82) after the painting dated 1857 by Sir Joseph Noel Paton, RSA (1821–1901) in the Corporation Galleries, Glasgow (no 714); published by Alexander Hill, 1 January 1863, in an edition including 475 proofs of which 250 were artist's proofs. PA stamp LZE.

This sentimental love scene in Mediaeval dress seems bland after the strong meat of *In Memoriam*, **72** and *Home—Return from the Crimea*, **67**, by the same painter and shows, with *The Pursuit of Pleasure*, **168**, what Paton did when not stimulated by current affairs. The title comes from the name of the evening star, seen high up between the branches of the tree. Hesperus was sacred to lovers, who here hold hands uncertainly while the mandolin lies temporarily silent.

PA (1847–75), RA (1860) no 316, the engraving (1863) no 1010, RSA (1857) no 203, AJ (1882) p 224.

59 The Black Brunswicker 1864

VAM E.353.1970
An engraving with aquatint (75 × 51·4) by Thomas Lewis Atkinson (born 1817) after the painting dated 1860 by Sir John Everett Millais, PRA (1829–96) in the Lady Lever Art Gallery, Port Sunlight. Henry Graves and Moore, McQueen collaborated in the publication of an original edition of 675 of which 350 were artist's proofs, on 16 June 1864. There was a later edition published in 1867. PA stamp ARN.

This subject was meant as a pendant to *The Huguenot*, **52** and again dwells on the insurmountable obstacles to true love. Here the girl has her hand on the door trying to shut it and keep her man from answering the call to arms. The couple are finely dressed, clearly of the upper class, unlike the couple in *The Order of Release*, **51**, and the dog is a domestic pet and not a working collie. The Black Brunswickers were among the finest German cavalry and were practically annihilated at Waterloo. They wore a black uniform with the insignia of a death's head and cross bones, like the Nazi SS.
The painting was made in a corner house in Bryanston Square. The model was Kate Dickens and the man was a guards officer. Each posed against dummy figures as it would not have been quite nice for them to pose together. An alleged resemblance to Queen Victoria and the Prince Consort gave the print a certain notoriety. This is one of Atkinson's best plates.

Beck 47, J. G. Millais vol I p 351, II p 495, RA (1860) no 29, Winter (1898) no 21, *Millais*, Walker Art Gallery 1967, *Charles Dickens*, VAM 1970, Slater p 110, PA (1847–75), Graves p 74.

60 Les Adieux 1873

VAM E.288.1970
A mezzotint with etching (73·4 × 48) by Joel Ballin (1822–85) after the painting of 1872 by Joseph Jacques (called James) Tissot (1836–1902) in the Bristol City Art Gallery (no K2432), published by Pilgeram & Lefèvre, 30 May 1873. There were 200 artist's proofs. PA stamp YCE.
Pilgeram and Lefèvre were the successors to Ernest Gambart and took over his premises at 1A, King Street, St James's. The copyright of this plate, and of many in the latter third of the century, was registered in Washington as well as London. After the Commune in Paris there was an influx of foreign painters and etchers, of which these are two.

Although this romantic piece is set in Regency dress, the theme is the usual Victorian one of thwarted desire. Here a high cast-iron fence and gate seem to stand for all the unbendable rules of good society. Although these are the elegant bounds of someone's property and not the bars of a prison, the theme is similar to that in *Prison Solace*, **56**. Nice detail is added by the pair of scissors and the fingerless lace gloves. The man has taken his one glove off and there is a tantalising glimpse of the girl's bare forearm.

J. Laver, *The Vulgar Society*, (1936) p 27, PA (1847–75), RA (1872) no 644, RA *Bicentenary Exhibition* (1968/69) no 400, Theime u. Becker, II p 419, Beck 62.

61 Effie Deans 1879

BM 86.11.27.70
A mixed mezzotint (78 × 58·2) by Thomas Oldham Barlow, RA (1824–89) after the painting by Sir John Everett Millais, PRA (1829–96), published by Thos Agnew & Sons, 20 October 1879 in London, Liverpool and Manchester, with the copyright also registered in Washington. There was an edition of 2000 of which 675 were artist's proofs, after which the plate was destroyed. PA stamp TWA.

This is an illustration to Sir Walter Scott, in the same manner as *The Bride of Lammermoor*, **62**. Here Arthur James posed with Mrs Langtry and a Mrs Stibbard. The engraving was in the Royal Jubilee Exhibition, Manchester, in 1887 (no 995). The garden wall appears frequently in Victorian painting, sometimes simply as background, sometimes to convey intimacy or secrecy, as in Millais's earlier *The Huguenot*, **52** and sometimes, as here, to provide a division between the sexes. By this time the observing dog had become a cliché in Millais's work.

Slater, p 124, J. G. Millais I pp 87, 88 repr p 99, II p 495. Thos Agnew, *Catalogue of Publications* (1905), repr p 60.

62 The Bride of Lammermoor 1882

BM 86.11.27.69
A mezzotint (68·8 × 58·5) by Thomas Oldham Barlow, RA (1824–89) after the painting of 1878 by Sir John Everett Millais, PRA (1829–96) published by Thos Agnew & Sons, 10 January 1882 in London, Manchester and Liverpool, and by Knoedler & Co in New York. PA stamp HXV. Agnew declared 1000 proofs.

In this illustration of the work of Sir Walter Scott, the Master of Ravenswood was also modelled by Arthur James,

nephew of Lord James of Hereford, and Lucy Ashton by a girl who worked in a flower shop in Gloucester Road.

The painting and the engraving were exhibited together in the Royal Jubilee Exhibition, Manchester in 1887. The painting had been sent to Paris in 1878 and won for Millais the Médaille d'Honneur.

J. G. Millais II pp 87, 88 repr p 95. Thos Agnew, *Catalogue of Publications* (1905) repr p 60. Slater, p 124. PA (1892).

63 A Welcome Footstep 1899

VAM E.197.1970

A mixed mezzotint (75·6 × 47·6) by Edward Gilbert Hester (1843–1903) after a painting by Marcus Stone (1840–1921); published by Arthur Tooth, 30 December 1899 in England and America, with the copyright registered in Washington. PA stamp NIY. There were 725 impressions of which 500 were artist's proofs.

Marcus Stone's sentimental pre-marital young women were popular in print form. This one awaits her intended sitting on a garden bench. On the tripod table are the middle-class woman's solutions to the problem of leisure—needlework, water-colours, drawing and picking flowers. Boredom must have been one of the less attractive rewards of late 19th-century prosperity, as the intensity of expression seen in the mid-century engraved women gives way to dog-like vacancy in the later prints. The man whose footstep is heard at the garden gate will, hopefully, provide the standard alternative to solitary needlework.

PA (1912).

64 Village Recruits 1838

VAM E.247.1970

An engraving (50·5 × 62·2) by Charles Fox (1794–1849) after the painting by Sir David Wilkie, RA, RSA (1785–1841); published in 1838.

The manuscript *Catalogue Raisonné of Pictures by Sir David Wilkie*, probably compiled by Messrs Hogarth, Print and Picture Dealers *c* 1842, in the National Art Library VAM contains a photograph of this print with the verse it illustrates:

> Deck'd wi scarlet, sword and musket,
> Drunk wi dreams as fause as vain
> Flushed and flatter'd roos'd and buskit
> Wow! But was wondrous fain.
> Rattling, roaring, swearing, drinking,
> How could thought her station keep.
> Drums and drumming (faesto thinking)
> Doz'd reflection fast asleep.

The young man on the left draws the cork of the first of a row of full bottles while the older man sits by the fire listening sceptically to the soldiers' stories of military glamour. Charles Fox was active during the first half of the century and produced many small plates for the annuals. This is one of his best-known large plates.

Theime u. Becker, XII p 266, Le Blanc II p 249 no 2, *The Wilkie Gallery* (1848/50) repr p 121, AU (March 1839) p 33.

65 The Convalescent from Waterloo 1847

BM 48.1.8.20

A line engraving (49·5 × 56·2) by George Thomas Doo, RA (1800–86) after the painting of 1822 by William Mulready, RA (1786–1863) in the VAM, Jones Bequest, no 506–1882. This plate was engraved for and published by the Art-Union of London. It was first advertised in 1842. Two years later the plate was 'near completion'; four years later the plate had apparently been delayed by the long illness of Doo; and the subscribers of 1845 were pacified by a series of 'outlines' by Rimer, illustrating Thomson's *Castle of Indolence*. Finally the print appeared in 1847 and then it was only available in proof impressions at five guineas.

Mulready's family group was beautifully transcribed in line, by G. T. Doo. We see the solicitude of the faithful wife and the trust of the little girl who hugs a paternal leg which fortunately returned from the battle of Waterloo intact.

AU (Report) 6, 7, 8 and 10 (1842–3, 4, 6), Slater p 280, RA (1822) no 135, AU (Almanack) (1862), DNB XIII p 1179.

66 A Lesson for Humanity 1855

BM 18.4.23.6

An engraving with machine engraving (71·7 × 120) by Charles George Lewis (1808–80) after the painting by Thomas Jones Barker (1815–82); published by J. Garle Browne in Leicester, 22 July 1855 and by Hering & Remington in London in an edition including 905 proofs of which 130 were artist's proofs.

The scene shows Napoleon rebuking his officers at the battle of Bassano with the words 'There gentlemen, that dog teaches us a lesson of humanity'. This quotation appears on the lettered prints.
The faithful dog guards the dead bodies of his master and horse, having presumably followed them into the thick of the battle. Napoleon points out the group from his horse on the right. According to Slater there was an earlier edition dated July 1854 as well as this one. The English devotion to dogs would have ensured a market for both editions. The theme of canine fidelity after death is the same as that of *The Old Shepherd's Chief Mourner*, **30**.

PA (1892), Slater p 442, A. Graves in *The Printseller* (1903) p 203.

67 'Home!' Return from the Crimea 1856

VAM E.126.1970

A mixed mezzotint with an arched top (83·5 × 68·5) by Henry Thomas Ryall (1811–67) after the painting dated 1856 by Sir Joseph Noel Paton, RSA (1821–1901); published by Alexander Hill & McClure & Son, 21 November 1856 in an edition of 1775 of which 750 were artist's proofs.

The subject, which is one of the most telling comments on the effect of the Crimean war on the ordinary people of England, is described by Ruskin in his *Academy Notes* (1856):

A most pathetic and precious picture, easily understood and entirely right as far as feeling is concerned.

The soldier, mortally wounded, has just reached home and sinks down without even shedding his coat. His old mother weeps on his shoulder and his wife swoons against his chest. He lays his one remaining arm about her. The baby born in her father's absence adds to the poignancy. The village church can be seen through the leaded window.

Queen Victoria commissioned a replica of the painting.

Beck 32, PA (1847–75), DNB XVII p 552, RA (1856) no 35, RSA (1863) no 257.

68 Queen Victoria's First Visit to her Wounded Soldiers 1858

BM 20.4.20.191
A mixed mezzotint (66·6 × 94) by Thomas Oldham Barlow, RA (1824–89) the painting by Jerry Barrett (1814–1906), published by Thos Agnew & Sons in Manchester, 20 November 1858 in an edition of 1025 of which 300 were artist's proofs.

Here Victoria and her husband and sons are seen speaking to wounded soldiers back from the Crimea. They were housed in the Chatham Hospital which was inadequate and over-crowded. This is one of the modern pictures which revealed the less glamorous aspects of war.

PA (1892), C. Wood (1976) p 26

69 The Champion of England 1860

VAM E.260.1970
A mezzotint (72·4 × 57·5) by George Salisbury Shury (worked c 1859–76) after the painting by Thomas Herbert Maguire (1821–95); published by E. Gambart & Co 1 February 1860 in an edition of 415 of which 50 were artist's proofs declared to the PA two years earlier by Shaw & Sons.

John Crawford was a sailor on *The Venerable* and is shown here nailing the Union Jack to its masthead during the battle of Camperdown. Here, in pictorial form, he becomes the archetypal unknown hero and this print with its stirring nationalism ranks with *Fight for the Standard*, **71** which was published a year later.

The lettered impressions bore these lines of verse:

> The foe thought he's struck
> But he sung out avast!
> And the colours of Old England he
> Nail'd to the mast!

PA (1847–75), Slater, p 826, BI (1858) no 390, Strickland II p 87.

70 (a) Eastward Ho! August 1857 1860

VAM E.119.1970
A mixed mezzotint (82·9 × 64·5) by William Turner Davey (1818–c 1890) after the first version, dated 1858, of a painting by Henry Nelson O'Neil, ARA (1817–80) in a private collection; published by Lloyd Bros 20 September 1860 in an edition of 1475 of which 650 were artist's proofs, as a companion print to *Home Again* by the same artists. An impression of the unfinished engraving was exhibited at Messrs Lloyd's gallery in Piccadilly with the paintings when they had returned from a tour of the provincial cities and towns in 1860. The public success of both prints was confidently predicted in *The Art Journal* of that year. The second smaller version of the painting was made in 1861.

The date in the title indicates that the troops were departing for the Indian Mutiny and not the Crimea as is often thought. The same models appear in both prints, the sailor with the pipe, the woman with the baby and various other figures. This subject, the farewell to those going to war and the joyful welcome home, would have been met with recognition by all levels of society during an age

when the country was continually at war in one or other part of the Empire. *Home—Return from the Crimea*, **67** by Sir J. N. Paton is another example.

Beck 29, PA (1847–75), RA (1858) no 384, Slater p 255, Reynolds (1853) pl 69, AJ (1860) p 222.

70 (b) Home Again 1861

VAM E.120.1970
A mixed mezzotint (83·5 × 65·2) by William Turner Davey (1818–c 1890) after the painting dated 1859 by Henry Nelson O'Neil, ARA (1817–80); published by Moore, McQueen & Co 18 November 1861 in an edition of 1475 of which 650 were artist's proofs, and distributed in Paris by François Delarue and in Berlin by Carl Gluck & Co. This is the companion print to *Eastward Ho! August 1857*, **70a.**

The ship is docked off Gravesend and the wounded heroes disembark into the arms of their families. The young man in the peaked hat shows his medal to his old father on the quay.

Beck 30, PA (1847–75), Slater p 255, RA (1859) no 400, Reynolds (1953) pl 70.

71 Fight for the Standard 1861

VAM E.261.1970
A mixed mezzotint (90·2 × 70·5) by Henry Thomas Ryall (1811–67) after the painting of 1848 by Richard Ansdell, ARA (1815–85); published in an unlimited edition by Dixon & Ross, 15 August 1861. There were 1325 impressions published by Hering & Remington, 2 June 1854.

This stirring portrayal of British supremacy on the field of battle would have been a best-seller during the second half of the 1850s when the national morale was put under pressure by the Crimean War and the Indian Mutiny. In fact the incident depicted here occurred during the Battle of Waterloo when Sergeant Ewart of the Scots Greys captured the Eagle from the 45th Regiment known as the 'Invincibles', on 18 June 1815.

Beck 28, Slater p 559, AJ (1860) p 234, (1867) pp 249-50, PA (1847–75), Sandby II p 347, DNB XVII p 522.

72 In Memoriam 1862

VAM E.164.1970
An engraving with stipple and an arched top (86·4 × 68·5) by William Henry Simmons (1811–82) after the painting dated 1858 by Sir Joseph Noel Paton, RSA (1821–1901); published by Alexander Hill 1 November 1862 in an edition including 475 proofs of which 250 were artist's proofs. Lettered impressions bore a dedication 'Designed to Commemorate The Christian Heroism of the British Ladies in India during the Mutiny of 1857, and their Ultimate Deliverance by British Prowess' and the quotation 'Yea though I walk through the valley of the shadow of death; Yet thou art with me'.

The Cawnpore massacre deeply shocked the country. Six hundred English women and children were brutally killed. Having been kept without water for weeks, they were promised a safe passage by river but once loaded on to the boats, the Indians set fire to the straw awnings and as the burning boats drifted down the river they were fired on from the banks. In the original version of this painting, Indian sepoys burst through the door with fixed bayonets.

The murderers were changed to rescuers to soften the reality of violence and make the painting acceptable. The fine velvets, laces and feathers contrast with the rough stone of the makeshift prison. A loyal Indian ayah has remained with her baby charge.

Beck 31, RSA (1859) no 146, Ruskin *Notes* (1858) p 15, PA (1847–75), DNB XVIII p 260.

73 Nearing Home 1863

BM 66.10.13.1057

A mixed mezzotint (61·3 × 71) by William Henry Simmons (1811–82) after the painting by John Dalbiac Luard (1830–69); published by Moore, McQueen & Co 1 October 1863 in London, François Delarue in Paris and Carl Gluck & Co in Berlin. An edition including 275 proofs of which 100 were artist's proofs was declared to the PA in August 1863. PA stamp ETD.

This is the companion print to *The Welcome Arrival*, an impression is in the BM (66.10.13.1059).

The painting was exhibited at the Royal Academy in 1858 (no 444) with the lines:

Some of our English land birds, settling on the ship, told us we were nearing home.

The bird can be seen accepting crumbs from the wounded soldier on the deck of the ship which is taking him home. A sailor points toward land and those soldiers able to stand and walk with crutches gather on the side of the ship. This is another of the prints about the reality of soldiering (see *'Home!' Return from the Crimea*, **67** and *Home Again*, **70b**).

RA (1858) no 444, PA (1847–75), Bryan III p 254.

74 The Royal Cortege in Windsor Park 1840

BM 11.11.16

A mixed mezzotint (54·5 × 80) by Frederick Bromley (worked c 1840–60) after the painting by Richard Barrett Davis, RBA (1782–1854); published by Hodgson & Graves, 20 April 1840, for the Art-Union of London.

Frederick Bromley was probably one of the sons of the line engraver William Bromley. The painter R. B. Davis was the son of a royal harrier of George III who encouraged and sponsored him. He painted many animal subjects on the Windsor Stud and also the cavalcade at William IV's coronation and his funeral cortege. There is a key to the portraits in the BM. The castle can be seen in the background, left.

AU (March 1839) p 39, (August 1840) p 136, H. Graves p 14.

75 The Spanish Wife's Last Appeal 1841

VAM E.253.1970

A mezzotint with etching (61 × 78·5) by Frederick Christian Lewis (1779–1856) and Charles George Lewis (1808–80) after the water-colour by John Frederick Lewis, RA PRWS (1803–76); published by Henry Graves & Co, 12 June 1841. The plate was also published with the alternative title *Zumalacarregui and the Christino Spy* by Graves & Warrensley (see BM 61.4.13.477). The water-colour was entitled *A Spy of the Christino Army Brought before the Carlist General-in-Chief, Zumalacarregui.*

The incident is set in the Basque province where the peasantry were used by both sides in the civil war to carry intelligence from one general to another. When they were captured they were shot. This Basque peasant has been caught with the incriminating dispatches on him. They are displayed by the seated monk who in real life was the Curé Merino. The Carlist general shown in his habitual non-military dress, red cap and sheepskin zamarra or jacket is standing on the left with his secretary and an aide. The wife of the doomed man is making her last appeal for clemency.

Society of Painters in Water-Colours (1837) no 316, RA (Winter 1891) no 138 entitled *Capture of a Spanish Spy*, AJ (1858) p 42 repr p 41, *The Portfolio* (1892) p 93, AU (1840) pp 134, 184, *A Twelvemonth's Campaign with Zumalacarregui* by Capt Henningsen, H. Graves p 71.

76 The Slave Market, Constantinople 1842

VAM E.259.1970

A mixed mezzotint (64·8 × 90·8) etched by Charles George Lewis (1808–80)

and then engraved by William Giller (worked c 1825–c 1856) in Edinburgh, after the painting of 1839 by Sir William Allan, PRSA (1782–1850); published by Alexander Hill in Edinburgh and F. G. Moon in London, 1 September 1842.

The taste for the exotic acquired from the Romantic Movement in France and anglicised by Byron lingers in this print. The essential elements of the Romantics, the slave women, the wild white stallions, the harem women peeping through the lattice, the turbans and hookahs are there.

RSA (1839) no 50, Slater pp 343 and 442.

77 Raffaelle and the Fornarina 1843

VAM E.147.1970

An engraving (68·6 × 48) by Lumb Stocks, RA (1812–92) after the painting of 1837 by Augustus Wall Callcott, RA (1779–1844); published by the Art-Union of London in 1843. Stocks engraved several plates for the Art-Union of London; see *Stolen by Gypsies*, **26**, *The Spanish Letter-writer* and *Claude Duval*, **103** and he engraved *Many Happy Returns of the Day*, **9**, for the Art-Union of Glasgow.

This is an ideal interpretation of Raphael making drawings of the baker's daughter with whom he was said to be in love. She wears fine clothes and has a Florentine head-dress. The Arno can be seen in the distance.

Stocks no 10, AU (Report) 7 (1843) p 7, RA (1837) no 104, Slater p 605, DNB III p 708, XVIII p 1280, Sandby II p 355, AJ (1856) repr p 11, *The Portfolio* (1875) p 161.

78 Coronation of Her Most Gracious Majesty Queen Victoria 1843

BM 1900.4.11.48

An engraving with stipple (64·2 × 92·7) by Henry Thomas Ryall after the painting by Sir George Hayter (1792–1871); published by Henry Graves & Co, 1 March 1843, in black and white and also in colours. Prints were sold for one guinea and artist's proofs for six guineas.

This engraving of the coronation of the young Queen Victoria in Westminster Abbey in 1837 was extensively advertised in *The Art-Union* with an impressive list of subscribers including no less than fourteen members of the Royal family, several Dukes, the Archbishop of Canterbury, the Chancellor and an unspecified number of foreign ambassadors.

Slater p 559, DNB IX p 304, XVII p 521, *The Art-Union* (1839) pp 39, 60, (1842) pp 46, 68, 145, H. Graves p 34.

79 The Castle of Ischia 1846

BM 45.10.11.3

An engraving (45·7×66) by Edward Goodall (1795–1870) after the painting of 1843 by George Clarkson Stanfield, RA (1828–78); published by the Art-Union of London in May 1846.

This print was due to the subscribers of 1844, but as frequently happened, the Art-Union failed to meet its commitment and the print was two years late. The island of Ischia, off the coast of Italy, south of Naples, frequently changed hands in spite of its forbidding fortifications. In Roman times, the Emperor Augustus gave it to Naples in exchange for Capri, a more desirable island. The 15th-century castle above the main town was where Vittoria Colonna retired after the death of her husband. Here a ship is in trouble on the breakwater.

AU (Report) 7, pp 6, 7, 10, RA (1843) no 192.

80 First Reading of the Bible in the Crypt of Old St. Paul's 1846

BM 46.9.30.1

An engraving (58·4×78·8) by Robert Graves, ARA (1798–1873) after the painting of 1839–40 by Sir George Harvey, PRSA (1806–76); published 1 July 1846.

This picture revived a scandal of the Cromwellian era which occurred shortly after Bishop Boner had been installed as Bishop of London, in the spring of 1640.
Bibles were set up on lecterns in the crypt of St Paul's, and chained to the pillars as shown in the print. They were there for the benefit of the general public who were invited to read from them aloud. One John Porter was particularly good at reading and had an audible voice. He developed a spontaneous congregation much to the annoyance of the bishop, who, out of jealousy, sent Porter to Newgate and had him put in irons, legs, arms and neck, and chained to the wall of a dungeon. Within six or eight days he was found dead. Here he is shown committing the offence, listened to by a cripple with his crutch and dog, and a gathering of beautiful women. A small child staggers under the weight of a chair, brought for the old man who has made the effort to come on his daughter's arm, to hear the person everyone spoke of. The hour glass on the right was probably the device for giving everyone a fair turn to read.

Slater p 353, RA (1846) nos 592 and 740, RSA (1847) no 192, Algernon Graves in *The Printseller* (1903) p 341 notes that this plate was engraved by his uncle in 1846. H. Graves, p 32, AJ (1873) p 125. Another impression is VAM E.109.1971.

81 The Invention of the Stocking Loom 1849

VAM E.133–1970

A line and stipple engraving (57·8×65·7) by Francis Holl, ARA (1815–84)

after the painting of 1847 by Alfred W. Elmore, RA (1815–81), published by Lloyd Bros in an edition of 220 of which 100 were artist's proofs.

The scene is set in the 16th century. The man, a young scholar, has his books, his sword, his wife and baby, but little else. Plaster is falling off the walls on to the bare floor boards and a torn curtain is tacked across the bed alcove. His name was William Lee and he was expelled from St John's College, Cambridge, about the year 1589, for marrying contrary to the statutes. His wife contributed to the support of her family by knitting, and Lee while watching the movement of her fingers conceived the idea of imitating those movements by machine.

Slater p 388, AU (1847) p 142, RA (1847) no 204, AJ (1857) p 114.

82 The Acquittal of the Seven Bishops 1849

VAM E.296.1970

A mixed mezzotint (66×90·2) by Samuel William Reynolds II (1794–1872) after the painting by John Rogers Herbert, RA (1810–90); published by Thos Agnew in October 1849 in an edition of 750 with no artist's proofs. The first edition was published on 1 October 1840 and a third edition on 1 May 1859.

Famous scenes from English history were popular subjects for engraving. J. R. Herbert chose this episode from the 17th-century controversy over the selling of indulgences. Archbishop Sancroft, Archbishop of Canterbury, and six followers, defied the King in the matter of selling indulgences and were put in the Tower. However, the seven bishops had such national popularity that a verdict of guilty would have been politically impossible, hence their acquittal on 30 June 1688. There was national rejoicing and a number of commemorative medals and engraved portraits were published. The Clerk of the Crown was Sir Samuel Anstrey, standing on the right.

PA (1847–75), Slater p 545, Thieme u. Becker XVI p 448, RA (1844) no 388, Sandby II p 179. Not in Whitman.

83 Detail from **Prince Charles Edward in Hiding after the Battle of Culloden** c 1850

BM 66.12.8.3

A mixed mezzotint (81·2×57·1) by Henry Thomas Ryall (1811–67) after the painting of 1843 by Thomas Duncan RSA, ARA (1807–45). This painting belonged to Alexander Hill, the publisher, and was first engraved by Frederick Bacon and subsequently by Ryall. This print was marketed in America by Williams, Stephens, Williams & Co Broadway, New York.

The detail shows Prince Charles Edward asleep in a cave, watched over by Flora Macdonald. The prince is exhausted from his tribulations at the battle and the flight. (See *Flora Macdonald's Introduction to Prince Charles Edward*, **84** by Murray after Alexander Johnston.)

Slater p 559, DNB VI p 173, RSA (1843) no 285, *The Crayon* (New York 1855) I pp 281, 285. J. L. Caw, *Scottish Painting* (1908) p 111.

84 Flora Macdonald's Introduction to Prince Charles Edward 1851

BM 20.4.20.195

A mixed mezzotint (66·7×86·3) by John George Murray (worked

c 1830–56) after the painting by Alexander Johnston (1816–91); published by Mary Parkes, 31 July 1851. The Glasgow Art-Union offered Johnston a premium for the painting which he declined possibly as a gesture of disapproval of the art lottery system.

Flora Macdonald was living in the Hebrides when Prince Charles Edward took refuge there in June 1746 after the Battle of Culloden. Flora obtained a pass to the mainland for herself, a manservant and an Irish spinning maid named Betty Burke. The Prince was disguised as Miss Burke and set off for the mainland with Flora and a crew of six boatmen. At Portree he was hidden in a cave (see *Prince Charles Edward in Hiding after the Battle of Culloden*, **83**) while Flora sought help. After the Prince's escape suspicion fell on the Jacobite heroine who was taken to London and imprisoned in the Tower. Subsequently she was permitted to live outside the Tower under guard. According to Dr Johnson, who saw her in 1773, she possessed 'soft features, gentle manners and an elegant presence'.

Slater p 492, RA (1846) no 374 entitled *The Introduction of Flora Macdonald to Prince Charles Edward Stuart after his Retreat from the Battle of Culloden at the Period when £30,000 was Offered for his Apprehension*. DNB X p 941, AJ (1857) p 58.

85 The Caxton Memorial: Caxton Examining the First Proof Sheet from his Printing Press in Westminster Abbey, March 1474 1852

VAM E.355.1970
A mixed mezzotint (61·5 × 77·2) by Frederick Bacon (1803–87) after a drawing by Edward Henry Wehnert (1813–68), published by Hering & Remington, 23 February 1852 in an edition of 625 of which 200 were artist's proofs.

William Caxton with his assistants, Wynkyn de Worde, Richard Pynson, Lettou and William Machlinia, is shown printing *The Game and Playe of Chesse* on his press which was erected in the Ambry or Almonry of Westminster Abbey by permission, it is said, of the newly elected abbot, John Esteney. The press is supposed to have been afterwards removed to make way for Henry VII's chapel. In the foreground is the palette knife and dabber for the ink and on the left the type has been set up in its wooden frame. Compare this print with *Caxton Shewing the First Specimen of His Printing to King Edward the Fourth at the Almonry, Westminster*, **91**.

Slater, p 117, PA (1847–75), DNB (1909) XX p 1062, *New Society of Painters in Water-Colours* (1850) no 193.

86 Landing of the Pilgrim Fathers 1854

BM 13.10.15.72
A mixed mezzotint (68 × 84·3) by William Henry Simmons (1811–82) after the painting of 1848 by Charles Lucy (1814–73); published by Henry Graves & Co in an edition of 725 proofs of which 200 were artist's proofs declared to the PA on 1 August 1854.

The non-conformists fled to Holland, and from there a number of them set sail in the Mayflower for America on the 6 September 1620. The voyage lasted 63 days during which time John Carver emerged as the group's natural leader. He is probably meant to be the commanding figure in the centre. Engravings about the early Puritans would have been particularly popular in America (for example, *Young Puritans*, **106** by J. J. Chant after G. H. Boughton which was published in England and America in 1874). The Mayflower can be seen at anchor on the right.

RA (1848) no 308, PA (1847–75), H. Graves p 72.

87 The Meeting of Wellington and Blucher on the Evening of the Victory at Waterloo 1854

BM 18.1.12.44
An engraving with machine engraving (72·4 × 120·7) by Charles George Lewis (1808–80) after the painting by Thomas Jones Barker (1815–82); published by Leggatt Hayward & Leggatt, 1 May 1854. The first edition of 1225 of which 350 were artist's proofs, was declared to the PA in 1851 by F. G. Moon and Leggatt Hayward & Leggatt.

This is the companion print to *Nelson Receiving the Swords of the Vanquished*, by the same artists. A key to the other portraits in this plate, apart from Wellington and Blucher, is in the BM (13.5.9.19).
Paintings and engravings about the battle of Waterloo and its heroes continued to be popular 50 years after the event, as a reflection of national pride.

PA (1892), Slater p 442, AJ (1882) p 159.

88 The Alliance c 1855

VAM E.265.1970
A mixed mezzotint (78·7 × 59·7) by Samuel William Reynolds II (1794–1872) after a drawing by Frederick Tayler (1802–89) with portraits drawn by Reynolds.

This is an example of a plate being altered and re-published under a different title. The original plate was entitled *Her Majesty the Queen Leaving Windsor Castle for the Review, 28 September 1837*. The gatehouse and view of the castle are still the same, but the Queen is in military habit and on her right is the King of the Belgians, with Lord Hill, Commander of the Forces, on her left and the Duke of Wellington behind. In re-cutting the portraits, the King of the Belgians has become Prince Albert, Lord Hill has become the Emperor Napoleon and the Iron Duke has changed sex and become the Empress Eugenie. The showy plumes of the Belgian King's headgear have been erased and replaced by the stone work of the gatehouse. The different stippling technique is most evident above Prince Albert's hat. The visit of the Emperor and Empress of France took place on 16 April 1855.
The original plate is reproduced in *Sixty Years a Queen* by Sir H. Maxwell, p 25.

Beck 4.

89 The Happy Days of King Charles I 1856

BM 64.6.25.18
Line engraving by Edward Goodall (1795–1870) after his son Frederick

Goodall, RA, HRI (1822–1904), published by E. Gambart 30 June 1856 in an edition of 2025 of which 100 were artist's proofs.

A pleasant historical subject of 'the good old days'. It is summertime and royal swans are being fed from the royal barge by the prince and princess, while their parents look on. The little spaniel is a King Charles spaniel. A negro servant stands behind the King.

This plate was to have been destroyed after the original edition, but apparently this was not carried out as another edition dated 3 January 1860 exists.

PA (1892), Slater p 350, Reynolds (1866) p 111, RA (1853) no 248.

90 Detail from **Tyndale Translating the Bible** 1856

BM 70.8.13.370

A mezzotint (73·3 × 58·2) by John George Murray (worked c 1830–56) after the painting of 1854 by Alexander Johnston (1815–91); published by the Art-Union of London for subscribers of 1856.

The painting was exhibited at the Royal Academy in 1854 with the following explanation.

Hidden, like Luther at the Wartburg [on the Rhine] not, however, in a castle, but in a humble lodging, Tyndale, like the Saxon reformer, spent his days and nights translating the Bible; but not having an Elector of Saxony to protect him, he was forced to change his residence from time to time at this epoch. Fryth, who had escaped from the prisons at Oxford, rejoined Tyndale there.

Tyndale was working as tutor to the children of Sir John Walsh at Old Sodbury in Gloucestershire, when he formed the resolution to translate the Bible into the vernacular in order to open the eyes of the clergy to the corruptions and decline of the Church. He went to London to carry out his intention but was met with such hostility that he went to Hamburg, and there in 1524 he began his translation. Discovery caused him to move from Cologne, up the Rhine towards Worms. It is during this period that he is portrayed here. News of his printing of the New Testament reached England where strong measures to suppress the book were applied. Of the 3000 octavo copies of the first edition only one still remains. It is in the Baptist College, Bristol.

AU (Report) 20 (1856), RA (1854) no 503.

91 Caxton Shewing the First Specimen of his Printing to King Edward the Fourth, at the Almonry, Westminster 1858

VAM E.299.1970

A mixed mezzotint (68·3 × 102·9) by Frederick Bromley (worked c 1840–60) after the painting dated 1851 by Daniel Maclise, RA (1806–70), published by Henry Graves & Co in 1858 in an edition of 800 of which 475 were artist's proofs. The engraving was exhibited at the Royal Academy of 1858 (no 1143).

This is a more elaborate treatment of the same subject as *The Caxton Memorial*, **85** which was published six years earlier. Here, royal figures, those of King Edward IV and his queen, have been introduced, and the composition is

more detailed including interesting aspects of book binding, compositing and printing itself. The growth in literacy and the general interest in printing and allied techniques, must account for the publication of the two plates within such a relatively short time. This group also includes the young Princes, the King's brothers, Richard and Clarence, John Esteney the Abbot of Westminster and Wynkyn de Worde standing behind Caxton.

PA (1847–75), H. Graves p 72, RA (1851) no 67, (1858) no 1143.

92 England's Greatest General Crossing the Pyrenees 1858

BM 66.12.8.59

An engraving (75 × 58·4) by William Greatbach (worked c 1820–50) and Robert Wallis (1794–1850) after Thomas Jones Barker (1815–82), published by R. Turner, 1 October 1858 at Newcastle-upon-Tyne. PA stamp PTL. There were 350 artist's proofs out of 1425 prints.

Both Wallis and Greatbach produced many small steel engravings for *The Keepsake* and *The Landscape Annual*. In this joint effort, Greatbach engraved the figures and Wallis the landscape. The subject honours the newly created 1st Duke of Wellington and shows him during the Peninsular Wars, up in the Pyrenees where battles with the French took place between 25 July and 2 August 1813. After difficult manoeuvring in the passes and what he described as 'bludgeon work', Wellington drove the French back beyond the mountains.

PA (1892), Slater p 660, Clement and Hutton I p 34.

93 Detail from **Queen Victoria's First Visit to her Wounded Soldiers** 1858

BM 20.4.20.191

The detail of **68** shows a portrait of the young Queen with Prince Albert and sons. Her dress and bonnet are particularly finely engraved.

94 The Allied Generals with the Officers of their Respective Regiments before Sebastopol 1859

BM 68.6.12.43

A mixed mezzotint (75·5 × 129) by Charles George Lewis (1808–80) after the painting by Thomas Jones Barker (1815–82); published by Thos Agnew & Sons, 31 August 1859 in Manchester, John Garle Browne in Leicester and distributed in London by Colnaghi & Co.

In this wide-screen version of the siege, some curious detail occurs. A woman who is kneeling in the foreground, lower right, offers a wounded officer a drink from an elegant wine glass and a soldier, seated on a gun, reads a newspaper. On 17 October 1854 the English, French and Turks began a heavy bombardment and laid siege to Sebastopol on the Black Sea, seen here in the distance. The Russians held out for 11 months and finally evacuated the city on 8 September 1855. They were bound, by the Paris Treaty, not to restore the fortifications which had been blown up by

the allies, but within 15 years they had made Sebastopol a naval arsenal again. The city had been totally destroyed and seven years after the seige the population had not recovered beyond 6000, though the original population had numbered over 40,000.

95 Cranmer Landing at the Traitor's Gate 1859

BM 64.6.25.19
An engraving by Edward Goodall (1795–1870) after his son Frederick Goodall, RA, HRI (1822–1904), published by E. Gambart, September 1859. There were 600 proofs of which 275 were artist's proofs.

The painting (RA 1856, no 359) bore the quotation, 'On through that gate misnamed, through which before went Sidney, Russell, Raleigh, Cranmer, More' (Rogers). Thomas Cranmer, Archbishop of Canterbury, was taken to the Tower of London on 14 September 1553 and is here seen entering Traitor's Gate. Apart from his Protestant opposition to the Catholic rule of Bloody Mary, his arrest for treason stemmed also from Mary's resentment at the part he had played in her mother's divorce. Latimer and Ridley were also confined in the Tower. All three were taken to Oxford for trial. Ridley and Latimer were burnt on 16 October 1555, but Cranmer recanted. He later recanted his recantations and was burnt on 21 March 1556. He plunged the hand which had betrayed him by signing the original recantation into the fire first.

PA (1892), Slater p 350, Bryan II p 261, DNB XXII p 116.

96 Detail from Hogarth before the Governor at Calais 1860

BM 66.10.13.1040
An engraving with stipple (64·1 × 82·5) by W. Joseph Edwards (worked c 1843–c 1867) after the painting of 1851 by William Powell Frith, RA (1819–1909); published by Lloyd Bros, 12 July 1860 in an edition of 1500 proofs of which 500 were artist's proofs.

Here, Hogarth is arrested on a charge of spying. Frith was much influenced by Hogarth and shared his interest in social realities. It was not surprising that Frith painted Hogarth himself in an episode from his life as described by Horace Walpole:

Hogarth has run a great risk since the peace; he went to France accompanied by some friends and was so imprudent as to be taking a sketch of the drawbridge at Calais. He was seized and carried to the governor, where he was obliged to prove his vocation by producing several caricatures ... such as would by no means serve the purpose of an engineer. He was told by the governor that, had not the peace been actually signed, he should have hung him immediately on the ramparts.

RA (1851) no 204, the engraving (1858) no 1149.

97 Shakespeare before Sir Thomas Lucy 1861

BM 66.12.8.46
A mixed mezzotint (66 × 86) by Frederick Hunter after Thomas Brooks (1818–91) published with 125 proofs by Henry Graves, 2 April 1861. PA stamp UVU.

According to popular rumour current in Stratford-upon-Avon in the 17th century, Shakespeare, in 1558, stole a deer from the park at Charlecote. Sir Thomas Lucy, the owner of Charlecote, prosecuted Shakespeare who fled to London to escape the ignominy of having been found out. The case against the truth of this story rests on the absence of deer in Charlecote park at the time. However deer did live in Lucy's wood at nearby Hampton and he did bring to Parliament a bill 'for the better preservation of game and grain' in March of the same year. Shakespeare's mode of revenge is unlikely to have been his alleged placarding of Lucy's park gates with offensive ballads, but rather the creation of Justice Shallow in *The Merry Wives of Windsor* who made a star chamber matter of poaching, and bore arms of 'a dozen white louses' (I. i). In fact the arms of the Lucy family were pikes or *luces*.

PA (1892) H. Graves p 7, DNB XII p 249. Artist's proofs cost five guineas and lettered prints, one guinea.

98 Pope Makes Love to Lady Mary Wortley Montagu 1861

VAM E.146.1970
A mixed mezzotint (67 × 54·3) by Ferdinand Jean Joubert (1810–84) after the painting of 1852 by William Powell Frith, RA (1819–1909); published by F. Joubert, the engraver, from his address in Porchester Terrace, on 15 July 1861. Another plate, a line engraving by C. W. Sharpe, was published under the title *The Rejected Poet* in small size in *The Art Journal* (1867) p 172.

The love affair here depicted began when Pope met Lady Mary Montagu some time before 1716 when she went East with her husband who was ambassador at Constantinople. Pope's extravagant letters dwindled on her return. The reason for the quarrel may have been that the manuscript of Lady Mary's *Letters during the Embassy to Constantinople*, which included a parody of Pope, was passed around and Pope was offended at the circulation of the satire. Pope is also said to have made Lady Mary a declaration of love which she received with an outburst of mirth. It is this critical moment which is portrayed here. A *Pop upon Pope* is supposed to be hers and it stimulated a virulent counter-attack in couplets. The general theme is that of women's heartlessness.

W. P. Frith I pp 220–24, H. Beraldi VIII p 280, RA (1852) no 336, and the engraving (1861) no 940, AJ (1867) p 172.

99 The Last Sleep of Argyll before his Execution A.D. 1685 1861

VAM E.127.1970
A mixed mezzotint (73 × 79·7) by William Turner Davey (1818–c 1890) after the painting commissioned for the corridors of the House of Commons in 1853 and painted in 1854 by Edward Mathew Ward, RA (1816–79) in the Birmingham City Art Gallery (no p43/60); published by Agnew & Sons in 1861 in an edition of 725 of which 200 were artist's proofs. PA stamp JJR.

Archibald Campbell, 9th Earl of Argyll, was executed for his risings against King Charles on 30 June 1685 on the strength of an earlier sentence passed in 1681. He had on that occasion escaped execution by disguising himself as a

lackey behind the coach of his step-daughter Sophia Lindsay. When he was recaptured four years later, it was long debated whether he should be hanged or beheaded and the less ignominious sentence, beheading, was carried with difficulty. He behaved with great courage and on the morning of his death sat down to write letters to his wife and family. Here he is shown sleeping the sleep of calm resignation, much to the amazement of his jailors.

The engraving was exhibited at the Royal Academy in 1862 and is a good example of Davey's work. This was no 8 in the *Nine Scenes from English History* published by the Art-Union in photogravure in 1881.

PA (1847–75), RA (1854) no 403, (1862) no 934, Macaulay's *History of England.*

100 Last Moments of Mozart 1862

BM 19.13.10.50.83
A mixed mezzotint (82·5 × 67·5) by Samuel Bellin (1799–1894) after the painting of 1849 by Henry Nelson O'Neil, ARA (1817–80); published by R. Turner, 1 November 1862 at Newcastle-upon-Tyne, with his own stamp NC.

At two o'clock on the day of Mozart's death in the year 1791 he was visited by some performers of Schickaneder's theatre who were his intimate friends. He called for the score of the *Requiem*, his last work, and it was sung by his friends around his bed. Mozart died from uraemia. He was 35 years old and had just completed his last opera *The Magic Flute.* He saw in the commission for the *Requiem* an evil omen which was borne out by his death and the distressing circumstances of his funeral which took place in pouring rain so that none of the friends pictured here followed the coffin or marked the spot over the pauper's grave into which it was laid.

RA (1849) no 488.

101 Garibaldi in his Island Home, Caprera 1862

BM 11.2.21.3
Machine engraving and etching (85·1 × 69) by William Holl (1807–71) after Thomas Jones Barker (1815–82), published in 1862. Printed by McQueen.

This print was dedicated to the people of Italy. Guiseppe Garibaldi, Italian patriot and mercenary, was born on the south coast of France in 1807. His swash-buckling career began early, as a sailor and mutineer in the Sardinian Navy, and proceeded apace until 1854 when, having fled to South America with a price on his head, and having been severely tortured, he lost his first wife and gained a small fortune in New York. He bought the island of Caprera and made it his home. He is shown here, in the garb of the Garibaldini, at about the time of his Sicilian campaign.

Slater, p 388.

102 Richard and Saladin 1863

BM 74.7.11.2831
An engraving (76·5 × 86·4) by Henry Lemon (worked mid-century) after

the painting dated 1835 by Solomon Alexander Hart, RA (1806–81). The engraving was exhibited at the Royal Academy in 1863 (no 943) and the painting had been exhibited nearly 30 years earlier under the title *King Richard the First of England, Surnamed Coeur de Lion, and the Soldan Saladin* RA (1835) no 395.

The picture illustrates Walter Scott's *Tales of the Crusades.* Saladin, disguised as an Arabian physician, was introduced to the King by the Knight of the Leopard. 'His blood beats as calm as an infant's,' said the King, taking his pulse as shown above, 'so throb not theirs who poison princes'. The priest on the left is holding out a cross in alarm as though Saladin were a vampire.

RA (1835) no 395, (1863) no 943.

103 Claude Duval 1864

BM 70.8.13.379
An engraving (62·8 × 82) by Lumb Stocks, RA (1812–92) after the painting dated 1859 by William Powell Frith, RA (1819–1909); published by the Art-Union of London 1 July 1864.

Claude Duval was the French page of the Duke of Richmond who went astray and took to the road as a highwayman in spite of the Duke's fatherly attempts at reclamation. Duval's gang stopped Lady Aurora Sydney's coach and took booty worth £400. Duval invited the lady to ransom her possessions by dancing a coranto with him on the heath. Here she is shown nervously complying, while her fellow travellers faint and plead. The driver has a pistol to his head. The coach was copied from one in the possession of Lord Darnley at Cobham Park and the heath was painted in Dorset. The painting and the copyright were bought by Louis Flatow for £1700.

Stocks no 17, AU (Report) 28 (1864), 29 (1865), W. P. Frith I p 307, II p 160, RA (1860) no 162, Slater p 606, Bryan V p 130, DNB XVIII p 1280.

104 The Palace at Westminster 1866

VAM E.357.1970
An engraving (60·3 × 81·3) by William Chapman (born 1817) after the painting dated 1857 by Henry T. Dawson (1811–78). There was a second version dated 1875. This engraving was exhibited at the Royal Academy in 1866 (no 833).

On 16 October 1834 the whole of the original Palace of Westminster except the hall was burnt down. Re-building began on this, the new palace, in 1840 and was completed in 1867 at a cost of about £3,000,000. The architect was Sir Charles Barry and the style is late Perpendicular. Here it is seen from the opposite bank of the Thames, with Big Ben to the right and Westminster Abbey in the background. The building covers eight acres and its main tower was named after Queen Victoria. Big Ben was named after Sir Benjamin Hall, Commissioner of Works at the time, and is 320 feet high. A paddle steamer full of trippers and a rowing four can be seen on the river. The painting, which belonged to the Speaker of the House of Commons, was on a scale suitable to the size of the subject being nine foot by six foot.

BI (1858) no 539, RA (1866) no 833, A. Dawson, *The Life of Henry Dawson, Landscape Painter 1811–78*, (1891) repr p 76.

artist's sketches having been made on the spot expressly for this picture.

AU (1840) p 21, PA (1847–75), Slater p 452, RA (1839) no 583, BI (1840) no 260.

105 Detail from **Grace Darling** **1839, 1872**

VAM E.302.1970

A mezzotint (56 × 69·8) by David Lucas (1802–81) after the painting dated 1838 by Henry Perlee Parker (1795–1873) and James Wilson Carmichael (1800–68); published by Brooks & Sons in an edition of 475 of which 100 were artist's proofs declared to the PA on 11 March 1872. The engraver's name is recorded incorrectly. Another plate of this title by George Zobel after Thomas Brooks was published by the same publishers in 1870 in an edition of 825 of which 500 were artist's proofs. Lucas's plate was originally published by Thomas Boys in September 1839 and again in February 1853 and subsequently as above.

A lettered impression from the first edition (BM 97.4.10.31) was inscribed with a dedication to the Duke of Northumberland, fourteen lines of a song, and this description of the subject:

This historical record of female Heroism inspired by Humanity, as exemplified in the rescue on the 7th September, 1838, on the Fern Islands of the survivors of the Wreck of the Forfarshire steam packet, by Grace Darling and her father. They have sat for their portraits in the dresses worn on the occasion and the

106 Young Puritans **1874**

BM 20.5.8.157

A mixed mezzotint with stipple (86 × 89·5) by James John Chant (c 1820–after 1876) after the painting entitled *Early Puritans of New England Going to Worship* dated 1867, by George Henry Boughton, ARA (1832–1905), published by Henry Graves & Co 1 January 1874. The copyright was also registered in Washington.

This print would have had a large market in America because of the prominence of New England in American colonial history, as the 'land of the Puritans'. The main purpose of its founders was the establishment in the New World of a new Christian Commonwealth. The Puritan government of New England persecuted the Quakers and denied the right of appeal to the Crown. These particular Puritans seem characterised by dumb passivity, unlike their prototypes in reality. There was a later plate engraved by T. G. Appleton in mezzotint, and published by Fishel, Adler and Swartz, 22 November 1884.

RA (1867) no 657, PA (1892).

107 Blind Girl at the Holy Well — 1841

BM 66.12.8.58

A mixed mezzotint with an arched top (70·5×52·7) by Henry Thomas Ryall (1811–67) after Sir Frederick William Burton, RHA, RSA (1816–1900); published by H. T. Ryall for the Royal Irish Art-Union, 4 September 1841, and intended for members of 1839 and 1840 only. The PA records another publication of 26 April 1849 by Lloyd Bros in which this was the companion print to *Sisters at the Holy Well* by Francis Holl after F. W. Topham. This was the first plate published by the *Irish Art-Union*.

The emotional theme of a blind girl hoping for a miracle of faith healing, kneeling by a well with rosary in hand, was very different from the English painter George Smith's blind girl in *Light and Darkness*, **19** being helped by learning to read Braille.

DNB XVII p 522, Slater p 559, *The Art-Union* 1 January 1842 and 1840 pp 72, 101. The drawing was exhibited at the RHA in 1840 (no 257).

108 The Wise and Foolish Virgins — 1846

BM 66.10.13.1062

An engraving (46×66) by Lumb Stocks, RA (1812–92) after the painting by James Eckford Lauder, RSA (1811–69); published by the Association for the Promotion of the Fine Arts in Scotland in 1846.

Matthew 25: 1–6: 'Then shall the kingdom of heaven be likened unto ten virgins, which took their lamps, and went forth to meet the bridegroom. And five of them were wise, and five were foolish. They that were foolish took their lamps, and took no oil with them . . . [Here they are shown on the left in suitable gloom with their empty lamps.] And at midnight there was a cry made, Behold, the bridegroom cometh: go ye out to meet him.' The foolish virgins then tried to borrow oil, as depicted above, and were sent away to buy their own. During their absence the marriage feast commenced and the doors were shut against them. The foolish virgins are shown unprepared, their hair and robes in disarray.

Stocks no 4, RA (1844) no 306, RSA (1855) no 118, Slater p 606, DNB XVIII p 1280, XI p 636, Bryan III p 183.

109 Detail from **Jephthah's Daughter** — 1846

VAM E.139.1970

An engraving with rounded top corners (56·5×71) by Peter Lightfoot (1805–85) after the painting dated 1843 by Henry Nelson O'Neil, ARA (1817–80); published by the Art-Union of London in 1846. Printed by McQueen. The painting, which was no 361 in the Royal Academy Exhibition of 1843, had been selected from the exhibition by Cyrus Legg, a prizeholder of that year. The lettered prints were entitled *Jephthah's Daughter, the Last Day of Mourning* and bore the quotation: 'And when the two months had expired she returned to her father, and he did to her according as he had vowed' Judges 11: 39.

Jephthah became the leader of the idolatrous Gileadites in their struggle to throw off the Ammonitish yoke. He vowed that he would make a burnt offering of the first creature that came from the doors of his house to meet him on his return from the war if he was victorious. He was indeed victorious so the sacrifice became necessary. Unfortunately he was greeted by a procession of dancing maidens led by his daughter, his only child. She retired to the mountains to mourn that she was to die unmarried and is seen here on the last day before her death. The story parallels that of Idomeneus and his son, and also Agamemnon's intention to sacrifice Iphigenia.

AU (Report) 8 (1844), 10 (1846), AU (Almanack) (1862), Slater p 445, RA (1843) no 361.

110 The First Introduction of Christianity into Great Britain — 1847

BM 75.4.10.399

A mixed mezzotint (64·1×88·9) by Charles George Lewis (1808–80) after the painting of 1842 by John Rogers Herbert, RA, HRI (1810–1890); published by E. Gambart & Co 27 May 1847 in an edition including 500 proofs of which 150 were artist's proofs.

Herbert painted this subject soon after his own conversion to Catholicism. The white-robed figure in the centre is a druid discarding his ivy crown. The fighting man on the right is breaking some sort of weapon upon his knee as a gesture that he has accepted the Christian message. The scene takes place at Stonehenge and the evangelist is baptizing his converts. Like Edward Armitage, Herbert's style and subject matter lent themselves to engraving with their Pre-Raphaelite accuracy and authentic detail.

RA (1842) no 11, DNB IV p 654.

111 Christ Blessing Little Children — 1847

VAM E.115.1970

An engraving (76×94·6) by James Henry Watt (1799–1867) after the painting dated 1839 by Sir Charles Lock Eastlake, PRA (1793–1865) in the

Manchester City Art Gallery (no 126); published by F. G. Moon, 1 May 1847. Various Latin inscriptions and marginalia appear dated 1853–4, 29 October 1855 and 16 July 1851. The PA records a publication by Day & Sons in July 1859 of 1525 of which 500 were artist's proofs with remarque. The remarque depicts a monster grasping a small human figure beneath which there are four lines of verse possibly derived from Virgil.

This plate is one of the best examples of pure line engraving on copper before the introduction of steel facing and the demand for large editions, quickly produced, led to the general use of mixed media. The painting was exhibited at the Royal Academy (1839 no 103) with the quotation from Matthew 19: 13, 14, 'And the disciples rebuked them. But Jesus said, Suffer little children, and forbid them not, to come unto me'. Another similar composition with the same title was painted by Benjamin West.

Beck 1, PA (1847–75), Slater p 672, Thieme u. Becker XXXV p 190, AJ (1867) p 171, (1840) p 19, Sandby II p 282, RA (1839) no 103, the engraving (1859) no 1225, BI (1840) no 3, sketch RSA (1852) no 673.

112 Christ and the Woman of Samaria 1850

BM 13.10.15.64
A mixed mezzotint by Samuel Bellin (1799–1894) after the painting by John Rogers Herbert RA, HRI (1810–90), published by Lloyd Bros & Co 28 May 1850 in an edition including 175 proofs of which 50 were artist's proofs. Among biblical themes, this one was popular. Another version was painted by John Graham-Gilbert of the Scottish School (Glasgow no 397).

The Samaritans were said to have done everything in their power to annoy the Jews. They would refuse hospitality to pilgrims on the road to Jerusalem and even went as far as defiling the Temple of Jerusalem with human bones. They would light misguiding rival beacon bonfires to confuse the Jews of Babylon as to the hour and day of the rising of the pascal moon. The bonfire signalling method was the same as that used by Agamemnon. In short, there was no such thing as a good Samaritan. The fact that a Jew and a Samaritan are here seen talking together was unusual. The Jews would not admit any consanguinity, hence the current slang—'Thou art a Samaritan and hast a devil'. This conversation took place by Jacob's well in a suburb of Sychar, a Samaritan village lying between Judea and Galilee. 'How is it that thou, being a Jew, askest drink of me, which am a woman of Samaria?' To which Christ replied 'Whosoever drinketh of this water shall thirst again: But whosoever drinketh of the water that I shall give him shall never thirst; but the water that I shall give him shall be in him a well of water springing up into everlasting life'. 'Sir,' the woman replied 'give me this water, that I thirst not, neither come hither to draw.' John 4: 5–15.

PA (1892), RA (1843) no 339, DNB IX p 654.

113 Cottage Piety 1853

VAM E.241.1970
A mezzotint (60·3×48·3) by George Henry Phillips (worked c 1830–40) after the painting by Thomas Webster, RA (1800–86); first published 1

October 1836 and republished 15 February 1853 by Thomas Boys with the legend 'But, O Thou Bounteous Giver . . . take what Thou wilt away'.

The implication of the legend is that there is precious little to take away. A loaf of bread accompanies a very tiny fowl in the dish. A corn dolly lies on the flagstone floor. The family say grace while the young mother looks at the dish wondering how it will stretch to feed everyone.

Le Blanc III p 490 no 20, Slater p 515.

114 Detail from Cottage Devotion 1854

BM 66.10.13.1073
An engraving (63×73·4) by Henry Lemon (worked mid-century) after Thomas Faed, RA (1826–1900); published by Lloyd Bros in an edition including 425 proofs of which 150 were artist's proofs declared to the PA 6 June 1854. There are two other impressions including a lettered print in the BM (1917.1.8.3 and 1917:1.8.1043).

The detail shows the family listening to the evening bible reading. Bible reading in the evenings was customary in many households. The Victorians cherished the belief that poverty and piety were somehow synonymous, hence the large number of engravings on this theme, for example *Cottage Piety*, **113** by G. H. Phillips after Thomas Webster. The interiors are always full of authentic detail.

PA (1892), DNB XXII p 623.

115 Detail from Young Timothy 1855

BM 13.10.18.75
A mezzotint (55·5×42) by Samuel Cousins, RA (1801–87) after the painting by James Sant, RA (1820–1916), published by Henry Graves & Co 16 April 1855 in an edition of 825 proofs of which 250 were artist's proofs and 25 were presentation proofs. PA stamp BHV.

Timothy was the son of a mixed marriage, his father was a gentile. He was brought up by his mother Eunice and learnt to know the Holy Scriptures. Here he is shown contemplating a scroll. He apparently had a frail constitution, deep piety and a tendency to tears. He practised an ascetic rigour he had not the strength to bear. He had a problem in later life as an uncircumcised disciple—a difficulty settled for him by St Paul, who 'took and circumcised him' (Acts 16: 3).

Whitman no 233, PA (1847–75), *The Crayon* (1855) I no 18, H. Graves p 90.

116 The Last Judgement 1856

A set of three mixed mezzotints by Charles Mottram (1807–76) after the three Judgement pictures by John Martin (1789–1854) of 1851. The prints were published by Thomas McLean, 29 July 1856, in an edition of 1225 sets of which 300 sets were artist's proofs.

(a) Detail from The Plains of Heaven

VAM E.109.1970
This print (71·8×103·8), T.B. Appendix 6a, 56, draws its subject from the *Book of Revelation* xxi. Balston p 407 provides a descriptive key.

(b) The Great Day of His Wrath

VAM E.110.1970

This print (71·8 × 103·5) shows the earth splitting in two in a geological holocaust in which the sinful are swallowed up. The painting is in the Tate Gallery (no 5613). The print is T. B. Appendix 6a, 55.

(c) The Last Judgement

VAM E.111.1970

This print (81 × 111·4), T. B. Appendix 6a, 54, shows the full cast of the human race plus its architecture, its transport in the form of a train and elephant, its wicked clergy, arraigned before the heavenly host. The heavenly domes shown glistening in the background share a common source with the Crystal Palace which was contemporary with Martin's painting.

The three works were also engraved by James Stephenson, ARA and exhibited at the Royal Academy in 1873 (nos 1309, 1310, 1311).

PA (1847–75), Balstone (1934) p 407, Slater p 490, Reynolds (1966) repr p 21, DNB XIII p 1095, Beck 8, 9, 10.

117 Noah's Sacrifice 1857

BM 66.10.13.1119

A mixed mezzotint (76·8 × 92·1) by William Henry Simmons (1811–82) after the painting by Daniel Maclise, RA (1806–1870); published by the Art-Union of Glasgow in 1857. The painting was exhibited at the Royal Academy in 1847 (no 178) with the quotation from Genesis upon which it was based; '. . . the Ark resteth on Ararat . . . the bow is set in the cloud'.

The sacrifice is described in Genesis 8: 20: 'And Noah builded an altar unto the Lord; and took of every clean beast, and of every clean fowl, and offered burnt offerings on the altar. And the Lord smelled the sweet savour; and the Lord said in his heart, I will not again curse the ground anymore for man's sake.' The ark is perched in the clouds under a rainbow and the animals troop out in pairs and the birds fly off to the left. The three men on Noah's right are his sons, Shem, Ham and Japheth; his wife and his three daughters-in-law are also present. Noah lived to 950 years and is shown here as a spritely 600 year old.

Slater p 583, RA (1847) no 178, *The Crayon* (New York 1855) I no 6, DNB XII p 666, Bryan III p 266.

118 St. John Leading the Virgin to his Own Home 1860

BM 66.10.13.1037

A mixed mezzotint (75 × 54·5) by William Henry Simmons (1811–82) after the painting of 1851 by William Charles Thomas Dobson, RA (1817–98); published by Henry Graves & Co 2 July 1860 in an edition including 151 proofs of which 75 were artist's proofs. PA stamp UXT. Artist's proofs on India paper cost five guineas and prints one guinea.

The New Testament was a source of inspiration to painters and publishers alike. Illustrative prints found a ready market during the mid-century. The most widely known were those after Holman Hunt, but there were many others (see the prints after John Rogers Herbert, John Martin, and Phillip Morris). Calvary was the subject of the Art-Union of London's publication of a triptych by William Finden after William Hilton, RA, entitled *The Crucifixion*.

PA (1892), RA (1851) no 513, H. Graves p 17.

119 The Light of the World 1860

VAM E.135.1970

An engraving with stipple and an arched top (74·3 × 42·5) by William Henry Simmons (1811–82) after the painting made between 1851 and 1853 by William Holman Hunt, OM (1827–1910) in Keble College Oxford; published by Ernest Gambart & Co 7 May 1860. The first edition of 1025 proofs included 500 artist's proofs. PA stamp TET. As this is one of the most famous Victorian works of art, largely through the wide circulation of the engraving, the lettered impressions must have run into thousands. Gambart bought the copyright from Holman Hunt in 1856 for £200 and must have recovered his investment several times over. A second smaller plate was made for Gambart by William Ridgway in 1865. The painting was exhibited at the Academy in 1854 with a quotation from Revelation: 'Behold, I stand at the door and knock; if any man hear my voice and open the door, I will come in to him, and will sup with him, and he with me'.

Christ is portrayed knocking on a heavy wooden door which has been closed for so long that creepers have covered it. The light of faith is symbolized by the pierced lantern, which is brilliantly engraved and lights up the robes and features in a theatrical way. Other versions of the painting are in St Paul's Cathedral and Manchester City Art Gallery.

Beck 44, Le Blanc III p 517 no 18, RA (1854) no 508, *Holman Hunt* Exhibition Walker Art Gallery and VAM (1969) no 24, W. Holman Hunt I pp 346–356 repr p 368, J. Ruskin *Notes* (1856) p 31, Mark Roskill, 'Holman Hunt's differing versions of the Light of the World' in *Victorian Studies* (1962–3) VI pp 229–244, *The Pre-Raphaelite Brotherhood* Exhibition Birmingham (1947) no 41, RA *Bicentenary* (1968–9) no 371.

120 The Scapegoat 1861

BM 13.10.15.66

An engraving with machine engraving (62·2 × 92·7) by Charles Mottram (1807–76) after the painting by William Holman Hunt, OM (1827–1910) in the Lady Lever Art Gallery, Port Sunlight; published by Henry Graves & Co 20 August 1861 in an edition including 325 proofs of which 200 were artist's proofs costing ten guineas.

The ceremony behind the traditional idea of the scapegoat took place on the Day of Atonement five days before the Feast of the Tabernacles. It was the day of national humiliation according to Mosaic Law. Upon this day the priest, dressed in white, presented two goats at the Temple, one was to be for Jehovah and one for Azazel. Lots were cast and the one for Azazel had a scarlet cloth tied to its head called the scarlet tongue. The other goat was then sacrificed and its blood sprinkled. The scapegoat was goaded and beaten by the populace as it was led away into the Wilderness. One tradition says the goat was thrown over a precipice and killed and that the place was called Azazel. It was a ceremony in which the sins of the community were transferred to the sacrificial animal which was then punished. Holman Hunt's unfortunate goat, its tongue hanging out with thirst, has been driven to

the banks of the Dead Sea and not killed outright. The subject was painted *in situ*.

W. Holman Hunt, (1905) II frontis. Reynolds (1966) p 62, Ruskin (1865) p 26, RA (1856) no 398, H. Graves p 37.

121 The Parable of the Lost Piece of Money 1863

BM 13.10.15.73

A mixed mezzotint with arched top (73·7 × 43·2) by William Henry Simmons (1811–82) after the painting of 1862 entitled *Parable of the Woman Seeking for a Piece of Money* by Sir John Everett Millais, PRA (1829–96); published by Henry Graves, 1 June 1863, in an edition of 250 proofs of which 100 were artist's proofs and 25 were early state artist's proofs. Millais made a series of drawings *The Parables of Our Lord* and made replicas in water-colour for a window that he later presented to Kinnoull parish church in memory of his son George. Wood engravings of the parables were made by the Dalziel brothers, and published by Bradbury and Evans.

This parable occurs in the Gospel of St. Luke 15: 7–9:

'I say unto you, that likewise joy shall be in Heaven over one sinner that repenteth, more than over ninety and nine just persons which need no repentance. Either what woman having ten pieces of silver, if she lose one piece, doth not light a candle and sweep the house, and seek diligently till she find it? And when she hath found it, she calleth her friends and neighbours together, saying, "Rejoice with me; for I have found the piece which I had lost".'

J. G. Millais I p 360, II p 497, PA (1892), RA (1862) no 309, *Millais* PRB, PRA (1967) nos 170–189. H. Graves p 74.

122 The Bible: That is the Secret of England's Greatness 1864

BM 13.10.15.40

A mixed mezzotint (65·4 × 77·5) by William Henry Simmons (1811–82) after the painting dated 1861 and entitled *Queen Victoria Presenting a Bible in the Audience Chamber at Windsor* by Thomas Jones Barker (1815–82) in the NPG, London. Published by Robert Turner, 30 November 1864 at Newcastle-upon-Tyne in an edition of 620 proofs of which 200 were artist's proofs. PA stamp MXX.

The Queen is seen with Prince Albert in the audience chamber presenting a Bible to a splendidly dressed recent convert from Africa, while Lord John Russell and Lord Palmerston look on. The evangelical aspects of Empire building were regarded as a duty as unquestionably correct as the dispersal of British law. The kneeling potentate wears the exotic dress favoured by French Romantic painters, the turban, leopard skin, dagger and jewels.

PA (1892), Slater p 583, DNB I p 1132.

123 Joseph and Mary 1867

VAM E.137.1970

An engraving (50·8 × 68) by Charles Henry Jeens (1827–79) after the painting entitled *The Parents of Christ Seeking Him*, dated 1866, by Edward Armitage, RA (1817–96); published by the Art-Union of London, on 3 December 1867. The engraving was no 1151 at the Royal Academy in 1876 and finally issued to subscribers in 1877, though it had been commissioned ten years earlier. The painting was offered as a prize, valued at £400, for the year 1877.

Edward Armitage's hard-edge, illustrative style and his biblical subject matter lent themselves to reproductive engraving. This particular subject is based on Luke 2: 43–5. The twelve-year-old Jesus accompanied his parents to Jerusalem for the annual feast of the Passover and stayed behind when the party set off home. His parents searched for three days before they found him in the temple. As Jerusalem was not a large city and strangers would have been spotted, three days was a long time.

And when they had fulfilled the days, as they returned, the child Jesus tarried behind in Jerusalem; and Joseph and his mother knew not of it. But they, supposing him to have been in the company, went a day's journey; and they sought him among their kinsfolk and acquaintance. And when they found him not, they turned back again to Jerusalem, seeking him.

Another of the Art-Union's religious subjects was William Finden's engraving *The Crucifixion* after William Hilton, RA (BM 52.12.11.515).

RA (1876) no 1151, AU (Reports) 31 (1867), 41 (1877), J. P. Richter, *Pictures and Drawings selected from the Works of Edward Armitage* RA (1897) p 8, repr pl xxix.

124 Finding of the Saviour in the Temple 1867

BM 86.12.6.104

An engraving (53·3 × 75) by Auguste Thomas Marie Blanchard (1819–98) after the painting made between 1854 and 1860 by William Holman Hunt, OM (1827–1910) in the Birmingham City Museum and Art Gallery (no 80.96); published by Ernest Gambart & Co 1 August 1867. PA stamp FBI. The plate took several years to complete as Gambart declared his intention of publishing an edition of 3025 proofs including 100 artist's proofs four years earlier, on 2 June 1863.

Holman Hunt copied all the faces and clothes from life and *in situ* in Jerusalem with Pre-Raphaelite dedication to accuracy. The print describes the moment when Joseph and Mary find their twelve-year-old after searching for him for three days. This is a sequel to *Joseph and Mary* by C. H. Jeens after Edward Armitage in which the parents are still making inquiries at the well. Holman Hunt's painting has more vitality and is better engraved than the latter, the face of the Saviour and those of the two elders with the Torah, are particularly compelling.

PA (1847–75), Slater p 160, W. Holman Hunt I pp 168, 174–8, 182–3, 200 and II repr p 177. There is another impression in the VAM (no 23769).

125 Mors Janua Vitae 1868

BM 19.5.2.10

An engraving with stipple and an arched top (78 × 50·8) by William Henry Simmons (1811–82) after the painting by Sir Joseph Noel Paton, RSA (1821–1901); published by Alexander Hill, 1 March 1868. Printed by R. Holdgate. PA stamp. There was an edition of 1375 proofs of which 50 were artist's proofs with remarque. In this case the remarque was something left out and not added. A snail was later engraved on the branch of the tree and remarque proofs are those without it. There were 600 artist's proofs with snail, and 25 presentation proofs.

Latin titles were a fad of the latter half of the century and

tended to be part of the general retreat from modern life. In this print, the heavily armoured knight with winged helmet retreats from life itself and kneels before the prospect of eternity, glowing temptingly behind the curtain. An archangel with jewelled clasp lifts the curtain on the after-life with one hand and lays the other upon the knight's shoulder. This hand withers to a skeleton on contact with the temporal world. In the blasted, rocky crag a St Joseph lily blossoms, which proves that in high Victorian painting anything was possible.

PA (1847–75), RA (1866) no 299, the engraving (1869) no 1122, AJ (1882) p 224.

126 The Mother of Our Lord 1869

BM 86.12.6.93 and 94
A pair of mixed mezzotints both (68·6 × 47·6) by Samuel Cousins, RA (1801–87) after the paintings of 1866 by Frederick Goodall, RA, HRI (1822–1904), published as companion prints in a total edition of 1750 sets of which 750 were proofs and 300 sets were artist's proofs by E. Gambart & Co 1 July 1869. The plates were afterwards destroyed. Both paintings were exhibited at the Royal Academy in 1868 (nos 267, 284). PA stamp KWD and KHO.

(a) Mater Dolorosa (Patient in Tribulation)
The Virgin is portrayed in a dark veil against a severe stone background, wringing her hands. Cousins completed this plate first.

(b) Mater Purissima (Obedient to the Law)
The Virgin is composed as she proceeds into the Temple with two doves for sacrifice. She wears a white veil and is shown against a decorated wall with light playing on her features unlike the deep shadows of the former.
Companion prints of women in different moods seem to have been popular. See the pair entitled *Il Penseroso* and *L'Allegro*, **170** which were published the year before.

Whitman nos 192 and 193, PA (1892), Algernon Graves *Catalogue of the Works of Samuel Cousins* RA (1888) pp 16, 17 nos 266, 268. RA (1868) nos 267, 284.

127 The Mother of Moses 1871

BM 86.12.6.96
A mixed mezzotint (76·2 × 55·3) by Charles Algernon Tomkins (c 1821–after 1897) after Frederick Goodall, RA (1822–1904); published by Pilgeram & Lefèvre, 10 April 1871 in an edition including 175 proofs of which 100 were artist's proofs. The painting entitled *Jochobed* was exhibited at the Royal Academy in 1870 (no 504) with the quotation 'And she laid it in the flags by the river's brink'.

Jochobed, a Hebrew name meaning 'Jehovah is gloriousness', was the name of the mother of Moses and Aaron. She was both the aunt and the wife of Amram, their father. Greater latitude in the laws of marriage was permitted in the pre-Mosaic age. Here Jochobed looks secretive as she prepares to abandon the baby in the basket among the bullrushes. The pyramids can be seen in the distance.

RA (1870) no 504, the engraving (1872) no 1294, PA (1892), R. H. Shepherd, *Notes* (1870) p 24.

128 Rebekah 1873

BM 73.3.8.427
An engraving with stipple (63·5 × 50·2) by William Holl (1807–71) after the painting of 1867 by Frederick Goodall, RA, HRI (1822–1904); published by the Art-Union of London for subscribers of 1873. This was William Holl's last plate and he was working on it at the time of his death. It was completed by his brother.

Rebekah was married to Isaac who was a first cousin of her father. After 19 childless years she produced Jacob and Esau, the former becoming her favourite and the latter the bane of her life. She had a hand in the deceit practised by Jacob on his blind father, and, anticipating Esau's anger, had him sent away. Jacob returned to his father after Rebekah's death. Here she is shown with her son as a baby.

AU (Reports) 36 (1872), 37 (1873), AJ (1871) p 103, RA (1867) no 8 and the engraving (1871) no 849, *The Art-Union*, September 1840 p 144.

129 The Shadow of the Cross 1873

BM 13.10.15.74
A mixed mezzotint (64·8 × 88·9) by Charles Mottram (1807–76) after Phillip Richard Morris, RA (1836–1902); published by Henry Graves & Co 20 February 1873 in an edition including 475 proofs of which 250 were artist's proofs costing eight guineas. PA stamp MYP.

A number of concepts close to the Victorian heart are combined in this print: ideal motherhood, babyhood, Christian faith and death. Another interpretation of this idea was painted by Holman Hunt and given the stronger title *The Shadow of Death*, **130**. In that work Christ is portrayed as a grown man and the poignancy shown here is missing.

PA (1892), H. Graves p 75, RA (1873) no 1317.

130 The Shadow of Death 1878

BM 86.11.27.30
A mezzotint with etching (85 × 66) printed in brown, by Frederick Stacpoole, ARA (1813–1907) after the painting by William Holman Hunt, OM (1827–1910) in the Manchester City Art Gallery; published by Thos. Agnew & Sons, 30 May 1878 in an edition of 4110 proofs of which 1485 were artist's proofs. The publishers were able to anticipate a huge demand for Holman Hunt's religious subjects. This print was distributed in New York by William Schaus. PA stamp GVC.

Unlike Charles Mottram's engraving after Phillip Morris's *The Shadow of the Cross*, **129** Christ is shown as a grown man. He is barefoot among the shavings in the carpenter's shop and stretches up from the saw, thus casting a shadow like a cross. The woman who is kneeling by the trunk has observed the shadow but the look of shock is cleverly concealed by Holman Hunt who shows only the back of her head.

W. Holman Hunt II repr p 306, Slater p 600, PA (1892), Reynolds (1966) p 62, Thos Agnew & Sons, *Catalogue of Publications* (1905) repr p 40, G. Reitlinger *The Economics of Taste* (1961) II pp 346–7.

131 The Night of the Crucifixion 1880

VAM E.129.1970
An engraving (66·7 × 91·7) produced jointly by Herbert Bourne (worked

c 1859–85) and William Ridgway (worked c 1863–85) after the painting of 1872–3 by Gustave Doré entitled *Les Ténèbres*; published by Fairless & Beeforth, 1 March 1880, with the copyright registered in Washington in the same year. The painting was exhibited at the Salon, Paris in 1873 (no 491) and in London at the Doré Gallery in 1904 (no 2). Ridgway was a landscape engraver and would have worked on the background while Bourne did the figure work.

Illustrations from the life and death of Christ were perennial sellers in the print market. This portrayal of Jerusalem thrown into confusion, with lightning striking Calvary, is drawn from Luke 23: 44–8: 'And it was about the sixth hour, and there was a darkness over all the earth until the ninth hour ... And all the people that came together to that site, beholding the things which were done, smote their breasts and returned.'

Beraldi, no 177 refers to the title as *Light of Crucifixion*. H. Le Blanc, *Catalogue de l'Oeuvre Complet de Gustave Doré, Paris* (1931) pp 525, 541, 551.

132 The Queen of Sheba's Visit to King Solomon 1892

VAM E.123.1970

A photogravure (63·8 × 86·7) after Sir Edward John Poynter, PRA (1836–1919); published by Raphael Tuck & Sons in London, Paris and Berlin, also in New York and Montreal. An edition of 725 prints was declared to the PA by Thos. Maclean, 6 July 1892. The painting, dated 1891, is in the Art Gallery of New South Wales, Sydney.

This print represents the apogee of wide-screen scenes from the antique world, accurate in every detail as regards architecture, dress, jewellery and decoration. The queen was of Sheba in Arabia and not of Sheba in the Cushite kingdom of Ethiopia in spite of the later tradition in the Abyssinian church. Sheba 'came to Jerusalem with a very great train, with camels that bear spices, and very much gold, and precious stones ... she gave the King a hundred and twenty talents of gold, and of spices very great store ... there came no more such abundance of spices as these which the Queen of Sheba gave to King Solomon' (I Kings 10: 2, 10). This was typical of the end of the century prints in its disregard of contemporary issues in favour of mythical splendour and extravagance.

RA (1891) no 305, Reynolds (1966) p 140, pl 88, AJ (1897) repr p 21.

133 All Hallows Eve *c* 1840

BM 72.1.13.854*

A mixed mezzotint (55·9 × 81·2 size of image) by James Scott (1809–post 1889) after the painting entitled *Snap-Apple Night, or All Hallows Eve in Ireland* by Daniel Maclise, RA (1806–70).

The painting was exhibited at the Royal Academy in 1833 (no 380) with the following lines of verse:

> There Peggy was dancing with Dan,
> While Maureen the lead was melting,
> To prove how her fortune ran
> With the cards old Nancy dealt in.

Apparently Maclise was inspired to make this painting after a party given for him by the Rev Mathew Horgan at Blarney in Ireland. Maclise's two sisters, and Sir Walter Scott were present and the party was unrestrained, judging from the games, the music making, fortune telling and dancing.

H. Graves p 73, Bryan (1904) III p 265, RA (1833) no 380.

134 Trial of Effie Deans 1845

BM 72.10.12.4827

A mixed mezzotint (64·7 × 98·4) by Frederick Bromley (worked *c* 1840–60) after the painting of 1840 by Robert Scott Lauder, RSA (1803–69); published by Henry Graves & Co, 1 February 1845. Prints cost two guineas and proofs before letters, ten guineas.

Sir Walter Scott's novels had a large circulation and were widely read. It followed that engravings illustrating these favourite books would be popular in the way that the 'film of the book' is popular today. This subject from the *Heart of Midlothian* captures the moment when 'a deep groan passed through the court ... and the venerable old man fell forward senseless on the floor of the court house'.

J. L. Caw, *Scottish Painting* (1980) repr, p 116, H. Graves p 67, DNB II p 262.

135 Village Pastor (The Vicar of Wakefield) 1849

BM 66.12.8.50

An engraving with stipple (71·7 × 91) by William Holl (1807–71) after the painting of 1845 by William Powell Frith, RA (1819–1909), published by Lloyd Bros & Co in an edition including 625 proofs of which 200 were artist's proofs declared to the PA 26 October 1849. The plate subsequently became the property of Henry Graves.

The painting was exhibited at the Royal Academy in 1845 (no 498) with the following quotation from Oliver Goldsmith:

> The service past, around the pious man,
> With steady zeal, each honest rustic ran;
> E'en children followed with endearing wile,
> And plucked his gown to share the good man's smile.

Thackeray, writing as Michael Angelo Titmarsh in *Fraser's Magazine* had this to say:

Now I won't say that Mr Frith's sentiment is like garlic, or provoke any other savoury comparison regarding it; but say, in a word, this is one of the pictures I would like to have sent abroad to be exhibited at a European congress of painters to shew what an English artist can do ... An ass will go and take the grand historic walk, while, with lowly wisdom, Mr Frith prefers the lowly path where there are plenty of flowers growing and children prattling along the walks.

The impact of *The Vicar of Wakefield* and its many pictorial forms, despite the Regency dress, demonstrates the important role of the clergy in Victorian social life.

RA (1845) no 498, PA (1847–75), H. Graves p 113, *Fraser's Magazine* June 1845.

136 The Scoffers 1853

VAM E. 309.1970

A mezzotint with stipple engraving (57·8 × 77·5) by Henry Thomas Ryall (1811–67) after the painting entitled *The Village Church* (RA 1847 no 284) by Alfred Rankley (1819–72), published by Hering & Remington, 1 March 1853 in an edition of 725 of which 300 were artist's proofs.

The informal atmosphere with the congregation gathered casually about the pulpit suggests the social role of the village church in Victorian England, though here the figures are in Regency dress. Atheism, like nudity, was more acceptable if set in the past. The playing card in the scoffer's pocket indicates his past devotion to a life of self-indulgence. A verse from Oliver Goldsmith's *The Deserted Village* accompanies the print:

> At Church with meek and unaffected grace,
> His looks adorn'd the venerable place;
> Truth from his lips prevail'd with double sway,
> And fools who came to scoff, remained to pray.

Beck 25 RA (1847) no 284.

137 The Departure (Second Class)　　　1857

VAM E.148.1970

A mixed mezzotint (58·7 × 75·6) by William Henry Simmons (1811–82) after the painting by Abraham Solomon (1824–62) in the collection of the Marquess of Lansdowne; published with the companion print *The Return (First Class)* by the same artists, by Ernest Gambart & Co 4 April 1857 in an edition including 225 pairs of proofs of which 100 pairs were artist's proofs. The original pair of paintings was exhibited at the Royal Academy in 1854, this one with the quotation 'Thus part we, rich in sorrow, parting poor'. Subsequent versions are in the Southampton Art Gallery, the Museum of British Transport and the collection of Sir Arthur Elton.

Poverty at home and the gold rush in Australia led to increased emigration in the 1850s which in turn caused the break up of families such as this one. The young boy is travelling to the coast in a railway carriage plastered with advertisements for work in Australia. His mother and tearful sister accompany him. The masts of the ships can be seen through the carriage window. The seats are of bare wood in the second class. Other prints about the effects of emigration are *The Emigrant's Letter*, **147** and *The Last of the Clan*, **150**.

PA (1847–75), Slater p 584, DNB XVIII p 624, Reynolds (1953) p 65, *Victorian Paintings*, Mappin Art Gallery Sheffield (1968) no 93, *Punch* (1854) vol 26, p 247, Beck 38.

138 Life at the Sea-side　　　1859

VAM E.401.1968

An engraving (64 × 115) by Charles William Sharpe (c 1830–70) after the painting of 1854 by William Powell Frith, RA (1819–1909) in the collection of Her Majesty The Queen; published by the Art-Union of London in 1859.

This is the third of Frith's great pictures of contemporary life. Rich in detail, it recreates a day on the beach at Ramsgate in the mid-19th century, the dark umbrellas, the shawls and heavy coats, the bathing machines in the background right, the modern man with his newspaper, the peddlar trying to sell a souvenir doll to an intractable woman in black, and the upright chairs.

The engraving was exhibited at the Royal Academy in 1858 (no 1155), and the painting was bought from the exhibition of 1854 (no 59) for the Royal Collection.

Beck 36, W. P. Frith I p 243, RA (1854) no 59, (1858) no 1155, *Victorian Paintings*, Mappin Art Gallery Sheffield (1968) no 80, Reynolds (1953) p 58, fig 18. There is another impression in the BM (70.8.13.379). AJ (1859) advertisement.

139 The Derby Day　　　1858

VAM E.560.1970 and BM 86.12.6.90

A line engraving (49·6 × 110·5) by Auguste Thomas Marie Blanchard (1819–98) after the painting of 1858 by William Powell Frith, RA (1819–1909) in the Tate Gallery (no 615), published by E. Gambart.

Ruskin described the Derby Day as 'this English carnival' and Frith's interpretation of it as having 'a dash of daguerrotype here and there and some pretty seasoning with Dickens' sentiment'. He referred, no doubt, to the hungry little acrobat with ravenous eyes fixed on the picnic hamper. Despite Ruskin's disparaging remarks, the picture was an overwhelming public success, so much so

that a policeman had to be called in to prevent the crowd rubbing against the canvas. Jacob Bell who had commissioned the work and held the engraving rights feared for the safety of his potential money-spinner and prevailed upon the Royal Academy to install posts and rails around the picture. Servants were most unlikely visitors to the Academy, yet liveried grooms were seen amongst the crowd on this occasion. The picture was sent to Paris to be engraved by Blanchard before being sent on a world tour to Vienna, America and 'the Antipodes'.

Though the subject is a race meeting, this picture is about people not horses. In fact the indistinct miniscule size of the thoroughbreds is an indication that this work, unlike sporting prints of the 18th century, was not designed for the Equestrian classes. The 18th-century horse frequently dwarfed his groom but here the roles are reversed. Another particularly modern touch is the sense of crowding, the growth and mobility of the population. There was a total edition of 55,025 impressions after which the plate was destroyed.

Beck 34, W. P. Frith II pp 268–303, Ruskin (1858) p 20, Reynolds (1953) pp 59, 60; (1966) pp 37, 49, 57, BN: Fonds p 487, RA (1858) no 218, PA (1847–75).

140 A Listener Never Hears Gude o Himsel'　　　1861

BM 93.11.15.63

A preparatory etching for the engraving (68·6 × 88·3) by Alfred Smith after the painting of 1858 by Thomas Faed, RA (1826–1900); published by Henry Graves & Co in an edition of 375 proofs of which 250 were artist's proofs declared to the PA, 9 December 1861.

Faed's illustration is of an old adage in which the listener at the door arrives just as a letter about him is being read with some amusement inside the house. The letter might have been found in the small casket on the floor.

PA (1892), RA (1858) no 272, AJ (1871) p 2, H. Graves p 24, repr p 32/1.

141 My Ain Fireside　　　1861

BN 1866.10.13.1034

A mixed mezzotint (76·2 × 58·4) by James Stephenson, ARA (1808–86) after the painting of 1859 by Thomas Faed, RA (1826–1900); published by Henry Graves & Co in an edition of 300 proofs of which 175 were artist's proofs, declared to the PA on 9 May 1861. PA stamp ZUC.

Another print about family life; the young couple enjoy the meagre comforts of their own home and own fireside. The man watches his wife and small baby with a proprietorial air. The newspaper conveys an umistakeably modern impression as in *Many Happy Returns of the Day*, **9**.

PA (1892), RA (1859) no 595, the mezzotint (1861) no 954, AJ (1871) p 2, H. Graves p 24, DNB XVIII p 1075.

142 Raising the May Pole　　　1862

BM 86.12.6.93

An engraving with stipple (73·7 × 106) by Charles William Sharpe

(c 1830–70) after the painting of 1851 by Frederick Goodall, RA, HRI (1822–1904); published by the Art-Union of London in 1862. The engraving was completed and exhibited in 1860 at the Royal Academy (no 928). Another small plate of the subject was made for *The Art Journal* by Edward Goodall.

The scene, like that of *An English Merry-making in the Olden Time*, **34**, is set in the past, but its sense of national identity is very Victorian. The young cavalier has ridden out on his pony from the distant manor house, to observe the villagers raising the maypole. The windows of the Tudor public house stand open, and the old oak is in leaf, daisy chains are being made and a huge sirloin is about to be carved. The ale has been flowing for some time and the warmth of summer is in the air. The blacksmith takes the weight of the pole. The Art-Union (1861) published these lines from Pasquil's *Palinodia* (1634):

> Happy the age, and harmless were the dayes
> (For then true love and amity were found)
> When every village did a Maypole raise,
> And Whitsun-ales and May-games did abound.

AU (Report) 25 (1861), 26 (1862), Slater p 578, DNB XXII p 116, RA (1851) no 552, (1860) no 928. Another impression is BM 92.4.11.28.

143 Detail from **The Birthplace of the Locomotive 1862**

BM 13.10.15.68
An engraving with stipple (79·4 × 64·1) by Francis Holl, ARA (1815–84) after the painting by John Lucas (worked c 1828–post 1874); published by Henry Graves & Co 30 August 1862 in an edition including 200 proofs of which 75 were artist's proofs costing ten guineas.

This engraving was published the same year as Frith exhibited his *Railway Station*, **149**. The public interest in trains equalled mid-20th century interest in space travel. Here the steam locomotive is shown approaching an anachronistic group including the stock 18th-century figure of a milkmaid, a Welshman with a miner's lamp, and a woman reading a copy of the *London Journal*.
It was near Merthyr Tydfil in Wales, in 1804, that Richard Trevithick tried a high pressure steam locomotive with smooth wheels, but found it more expensive to run than horses. In 1811 an engine with cogged wheels was patented by John Blenkinsop and used to carry coal from the Middleton Colliery to Leeds. It was the opening of the Liverpool & Manchester Railway in 1830 that really fired the public imagination and began the revolution in transport.

PA (1847–75), H. Graves p 71.

144 Sunday in the Backwoods of Canada 1863

VAM E.198.1970
A mixed mezzotint (68·3 × 88) by William Henry Simmons (1811–82) after the painting dated 1859 by Thomas Faed, RA (1826–1900); published by Henry Graves & Co 29 April 1863, in an edition including 625 proofs of which 350 were artist's proofs. PA stamp EHJ.

Although this subject was painted before *The Last of the Clan*, **150**, it is in a sense the sequel. Here the emigrant family gather around to listen to the words of the Bible, on a Sunday in the backwoods of Canada. The girl on the left is ill and has been brought out to sit in the sun. The family is Scottish and the boy on the left still wears his kilt. Ruskin described the painting as having much gentle pathos.

Beck 16, PA (1847–75), RA (1864) no 840 and (1859) no 310, Sandby II p 349, J. Ruskin *Notes* (1859), H. Graves p 25.

145 From Dawn to Sunset 1864

BM 72.1.13.1248
A mixed mezzotint (68 × 88) by Samuel Cousins, RA (1801–87) after the painting of 1861 by Thomas Faed, RA (1826–1900) published by Henry Graves & Co 1 February 1864 in an edition including 900 proofs of which 575 were artist's proofs. PA stamp PRW. The preparatory etching, by Alfred Smith, is in the BM (93.11.1561).

Thomas Faed concentrated on detailed and humourless portrayals of the Scottish crofters in their moments of domestic emotion. Here the full range of generations from the baby in the mother's arms to the grandparent dying in the bed alcove are shown. Stoic acceptance, the hallmark of a Faed character, is exemplified in the figure of the head of the family. The title is drawn from Tennyson 'From Dawn to Sunset, So runs the round of life from hour to hour'. The engraving was exhibited at the Royal Academy in 1864 (no 824) and was one of two plates Samuel Cousins undertook after Faed. The other was *The Mitherless Bairn*.

Whitman no 190, Slater p 243, PA (1892), RA (1861) no 247, (1864) no 824, RSA (1873) no 234, J. Dafforne in AJ (1871) p 2, H. Graves p 23, repr p 25.

146 The Hunted Slaves 1864

VAM E.132.1970
An engraving (50·2 × 80·3) by Charles George Lewis (1808–80) after the painting dated 1861 by Richard Ansdell, RA (1815–85) in the Walker Art Gallery, Liverpool; published by Ernest Gambart & Co 11 February 1864 in an edition of 2385 of which 960 were artist's proofs.

H. W. Longfellow wrote his *Poems on Slavery* in 1842 and their emotional morality stirred up the youth of New England and prepared them for the struggle to wipe out slavery. This particular print illustrates *The Slave in the Dismal Swamp*—'In dark fens of the dismal swamp ... Like a wild beast in his lair'. The nobility of the negro in the face of his degradation was also the message of an engraving by W. Hulland after a painting by W. Simpson (RA 1845) printed by G. Virtue for *The Art Journal*, March 1853.

Beck 24, E. Rimbault Dibdin in AJ (1904) repr p 218, PA (1847–75) lists a publication by B. Brooks in 1865. RA (1861) no 59, *Historical Exhibition of Liverpool Art* (1908) no 1.

147 The Emigrant's Letter 1865

BM 93.11.15.66
A preparatory etching (76·2 × 54·4) by Alfred Smith after the painting by James Clarke Hook, RA (1819–1907); the final engraving was made by Thomas Lewis Atkinson and was published by Henry Graves & Co in 1865 in an edition of 200 proofs of which 125 were artist's proofs costing three guineas.

This picture of rustic peace might have been conjured in the mind of the emigrant as he addressed his letter home from some remote and foreign landscape. Here the trout stream winds between verdant trees past a small cottage which could be the home of William Dibble and family. He leans on his hoe and listens to his wife reading the letter from the one who went away. Thomas Faed's *The First Letter from the Emigrants* was engraved by William Howison for the Association for the Promotion of the Fine Arts in Scotland.

The envelope is addressed 'William Dibble, Ongar Hatch, Surrey' and this is the sequel to Hook's *The Shipboy's Letter*.

PA (1847–75), H. Graves p 32.

148 (a) Waiting for the Verdict 1866

BM 13.10.15.76

One of a pair of mixed mezzotints (67 × 78·8) by William Henry Simmons (1811–82) after the paintings of 1857 and 1859 by Abraham Solomon; published as a pair by Henry Graves & Co 1 January 1866 in an edition including 425 pairs of proofs of which 200 were artist's proofs. PA stamp LUH and LHG. There is a small version of this subject in the Tunbridge Wells Museum (Ashton Bequest).

Solomon's interest in the crises of the working class here dwelt on the plight of the families of those who stand trial. In the first print, the defending barrister is about to enter the court to defend the husband of the young wife. She sits on the step wringing her hands while the eldest child sleeps and the grandparents wait anxiously. Ruskin remarked that this was '. . . rather the subject for engraving than painting. It is too painful to be invested with the charm of colour'.

148 (b) The Acquittal

BM 13.10.15.77

This print (67 × 76·5), the sequel to the above, captures the joyful moment when the barrister and the defendant emerge triumphant. The old father expresses his thanks, while his son is re-united with wife, baby, mother and dog. The door on the left through which he will leave a free man is open and sunshine floods in.

PA (1847–75), RA (1857) no 562 and (1859) no 557, the mezzotints (1866) nos 831 and 832, H. Graves p 91, Ruskin *Notes* (1857) p 32, Reynolds (1966) pp 113, 115, 179, pl 66, C. Wood (1971) p 156, DNB XVIII p 625, Bryan V p 83.

149 The Railway Station 1866

VAM 23770 and BM 13.10.15.59

An engraving (64·5 × 122) by Francis Holl, ARA (1815–84) after the painting by William Powell Frith, RA (1819–1909) in The Royal Holloway College, Egham, published by Henry Graves on 1 October 1866. PA stamp PDW.

This is one of Frith's three great pictures of modern life, along with *The Derby Day*, **139** and *Ramsgate Sands*, **138** which gave the Victorian public the mirror they so enjoyed. It had a huge circulation as an engraving, a fact anticipated by the perspicacious Louis Victor Flatow, Jewish print publisher, who offered Frith the sum of £4500 for the painting and the engraving rights. This, no doubt, erased Frith's uncertainty as to the suitability of so mundane a subject as a railway station which was 'in no sense pictorial'. Locomotives, railways and the excitement of travel in the steam age provide the key to the picture's success. The scene is set on a platform at Paddington station. The train has got up steam, the whistle is blowing and departure is imminent. The boy with the cricket bat is returning to school. The cabbie is haggling with the foreign gentleman in the fur collar over his fare. For the felon on the right, escape is forestalled by two plain clothes detectives, in real life Messrs Haydon and Brett, well-known police officers. Apparently livestock was allowed on British Rail as the family on the left are taking their pet bird. The model for the foreigner was an Italian prince, house guest of the Friths, who was annoyed by the likeness as he was in England incognito and the picture blew his cover. Every detail was painted from life. Over 21,000 people paid for admission to Flatow's gallery to see the picture in 1862 and many paid again to ensure they got a copy of the forthcoming engraving. The proofs were over-priced at between eight and 15 guineas, especially as there were over 3000 of them.

Beck 35, H. Graves p 27; W. P. Frith I pp 327–35; Reynolds (1953) p 59 (1966) pp 33, 173; PA (1847–1875).

150 The Last of the Clan 1868

VAM E.199.1970

A mixed mezzotint (73 × 87·7) by William Henry Simmons (1811–82) after the painting dated 1865 by Thomas Faed, RA (1826–1900); published by Henry Graves & Co 14 July 1868 in an edition including 200 proofs of which 175 were artist's proofs. PA stamp OGE.

The Highlanders were the subject of many heart-rending prints as they were an oppressed class forced, as in this engraving, to an unknown future in Canada by the policy of Highland clearance. The old clansman is left behind with the women as they watch a ship slip her moorings.

Beck 17, PA (1847–75), DNB XVIII p 261, H. Graves p 24, repr pp 32/2. The painting was sold at Christie's, 5 March 1971. RA (1865) no 150.

151 The Poor: the Poor Man's Friend 1871

BM 13.10.15.57

A mixed mezzotint (67·1 × 87·7) by William Henry Simmons (1811–82) after the painting by Thomas Faed, RA (1826–1900) in the Jones Bequest, VAM (no 504–1882); published by Henry Graves & Co 4 April 1871 in an edition including 300 proofs of which 175 were artist's proofs. PA stamp KSP.

The implication here is that the poor are more likely to be charitable than the rich. A poor blind man begs alms from a fisherman and his family. The fisherman pauses in his net mending to find a coin for the little girl who is the poor man's guide. A turnip lies in the foreground. This vegetable appears in other prints about poverty (for

example, *Charity*, **12** by Simmons after Brooks) and was evidently part of the staple diet.

PA (1892), RA (1867) no 107, the mezzotint (1871) no 856, Royal Jubilee Exhibition Manchester (1887) no 395, H. Graves p 25, AJ (1871) p 3, DNB XVIII p 260.

152 Prayer in Spain 1873

BM 20.4.20.198. and VAM E.5121.1910
A mixed mezzotint (66·7 × 53·3) by Thomas Oldham Barlow, RA (1824–89) after the painting of 1860 by John Phillip, RA (1817–67); published by Edward Samuel Palmer, 15 November 1873, in an edition including 500 artist's proofs and 25 presentation proofs. PA stamp EXU.

This example of female piety, set in Spain, was Phillip's diploma picture. The mood is paralleled in *The Soul's Awakening* by H. S. Bridgwater, after James Sant, RA—a beautiful woman full of divine love.

RA (1860) no 168, (1873) no 1265, PA (1892).

153 The Silken Gown 1874

VAM E.102.1970
An engraving (56·2 × 44·5) by Lumb Stocks, RA (1812–92) after the painting dated 1863 by Thomas Faed, RA (1826–1900) in the Tate Gallery (no 1525). The engraving bore the quotation 'And ye shall walk in silk attire' from an old Scottish folk song.

The bride-to-be looks pensive as her old mother consoles her with the thought of the silk wedding dress. The groom can be seen discussing his future with her father.

RA (1863) no 377, (1875) no 1103, DNB XVIII p 1280. Stocks no 20.

154 Salon d'Or, Homburg 1876

VAM E.117.1970
A mixed mezzotint (61·5 × 120·5) by Charles George Lewis after the painting dated 1871 by William Powell Frith, RA (1819–1909) in the Rhode Island School of Design; published by Henry Graves & Co 6 November 1876 in an edition including 475 proofs of which 300 were artist's proofs.

Frith's interest in people and their activities here switched to the glamorous world of the casino. This was as close as he got to the women of the demi-monde. The woman in the foreground has apparently lost everything except her looks. The wife on the extreme left is restraining her husband from parting with the notes in his hand. The respectable couple arm in arm behind the table are portraits of Frith and his wife, looking as if they are out for a stroll on the pier.

Beck 37, PA (1892), W. P. Frith II p 16, Reynolds (1966) repr pl 25, RA (1871) no 158, H. Graves p 29, C. Wood *Victorian Panorama* (1976).

155 Detail from 'La Gloria'—a Spanish Wake 1877

BM 21.6.1.9. Leggatt Gift
A mixed mezzotint (66·7 × 92·5) by Thomas Oldham Barlow, RA (1824–89) after the painting dated 1864 by John Phillip, RA (1817–67) in the National Gallery, Edinburgh (no 836), published by T. O. Barlow, 1 May 1877 in an edition limited to 312 artist's proofs and 25 presentation proofs. There were no other states and the plate was destroyed. PA stamp WKH. This is one of the rather rare examples of an engraver publishing his own work rather than putting it with one of the large publishing houses. He exhibited the mezzotint at the Royal Academy in 1864 (no 1276) the same year as the painting (no 51). There was a gap of 13 years between the production of the plate and publication.

In this detail a group of Spanish women play tambourines for the dancers at a Spanish wake, apparently insensitive to the grief which isolates the mother and her dead child to the left of this group. The broad striped dresses are effective in the black and white medium of engraving.

PA (1847–75), RA (1864) nos 51, 1276.

156 Devonshire House 1878

VAM E.144.1970
A stipple engraving (78·8 × 54) by Charles Knight after the painting by Valentine Cameron Princep, RA (1836–1904); published by G. P. McQueen on 1 May 1878 in London and Stiefbold & Co in Berlin. PA stamp. There was an edition of 350 including 175 artist's proofs declared on 24 February 1875.

Fashions did not change as rapidly as they do now. This was little more than a portrait of clothing. The two women look like fantail pigeons with their elaborate silk bustles at the back and their feathery hems.

PA (1847–75), RA (1873) no 896.

157 The Road to Ruin 1882

VAM E.95–98.1970
A series of four etchings by Leopold Joseph Flameng (1831–1911) after four of the five pictures painted in 1877 by William Powell Frith, RA (1819–1909); published by the Art-Union of London in 1882.

This Victorian series based on the Hogarthian model tells a story of moral decline due to gambling.

(a) College (45 × 53·6)

VAM E.95.1970

The young man gets the gambling bug at Cambridge. Here he is seen after a night of cards, keeping bad company in the form of his dissolute friend across the table. The candle is blown out and the morning light streams in through the window on to a mess of empty bottles.

(b) The Royal Enclosure at Ascot (44·8 × 52·7)

VAM E.96.1970

Cards lead to horses and the spendthrift gets through a fortune in bets and smart clothes. Here an older man tries to restrain him from making bets across the fence with disreputable bookies. The seated woman may be his wife.

(c) Arrest (44·8 × 53·6)

VAM E.97.1970

The bailiff can no longer be fobbed off with promises and he arrives with a warrant for arrest. In spite of the late hour,

the gambler is not dressed properly. His wife and two children look on in alarm.

(d) Struggles (44·8 × 53·4)

VAM E.98.1970

Soon the family find themselves living in France. Our hero is trying to write a bestseller while his wife makes water-colour sketches to sell. The bed alcove indicates that they are living in one room. The crucifix suggests a return to religion. The landlady is at the door with a demand which has not been met. The fifth painting which was not engraved, shows the man shutting the door of a squalid attic and making for a gun with which to end his life.

In spite of the success of the paintings when exhibited at the Royal Academy in 1878 (nos 291–295) when the iron rail and policeman were again necessary, the engravings were not a great success. Frith's other series *The Race for Wealth*, about the demise of a fraudulent financier, was published in photogravure in an edition of 15,000 in the same year 1882.

Beck 39, 40, 41, 42, W. P. Frith II pp 121–130, Slater p 321, AU (Reports) 46, 47, PA (1892), Blackburn's *Academy Notes* (1878) repr p 33, C. Wood, *Victorian Panorama* (1976).

158 My Lady's Garden　　　　1904

VAM E.201.1970
An etching (47·6 × 73·7) printed in brown, by Charles Oliver Murray (1842–1923) after the painting dated 1899 by John Young Hunter (born 1874) in the Tate Gallery (no 1698); published by C. E. Clifford & Co in 1904 in an edition of 425 of which 400 were artist's proofs on vellum. The etching was exhibited at the Royal Academy in 1901 (no 1431).

A typical example of the mannered style of the Aesthetic Movement. A pointless subject bears out the 'art for art's sake' principle of the movement. Mediaevalism was still rife and here the woman poses in mediaeval dress before an Elizabethan knot garden. Art Nouveau swirls appear in the trees and the peacock's tails.

Beck 59, *The Printseller* (1903) p 233, PA (1912), RA (1899) no 997, (1901) no 1431.

159 After Dinner Rest Awhile　　　　1905

VAM E.286.1970
An etching (43·8 × 56·5) by James Dobie (born 1849) after the painting of 1904 by Walter Dendy Sadler (1854–1923); published by Raphael Tuck & Sons in London, Paris and New York and first registered with the PA by L. R. Lefèvre & Son, 2 August 1905.

Walter Dendy Sadler portrays the material ease of the urban rich here seen enjoying a post-prandial exchange of views before the dining room fire. Sadler was particularly fond of this all-male moment, also portrayed in *Old and Crusted*, a title which applies as much to the diners as to the port itself. Although Sadler frequently put his figures into Regency dress, the mood is that of the end of the century, one of relaxed prosperity. Here are all the essential items of the well-to-do, the silver salvers, candlesticks and clock, the furniture, rugs and framed engravings. Everything except a moral point of view.

Beck 60, PA (1912), RA (1904) no 841.

LITERATURE, LEGEND AND THE ANTIQUE

160 The Appointed Hour 1836

VAM E.101.1970
A mixed mezzotint (65·4 × 45·5) by John Charles Bromley (1795–1839) after the painting of 1835 (BI no 418) by John Rogers Herbert, RA (1810–90).

This was Herbert's first success and like much of his early work, it has a fashionably Byronic flavour, typical of the early romantic annuals (see Introduction, p 13). A small engraving of this work was made by Charles Rolls for *The Keepsake* of 1836.

A Venetian lover lies assassinated at the foot of the stone stairs, his lute silenced, while his killer makes a dash for a waiting gondola. His mistress trips down the stairs unaware of the gruesome surprise. Eight lines from a Venetian manuscript accompanied the print:

> Away! Away! She's on the stair
> The breath of Zephyr lifts her hair
> The glow of love lights up her cheek
> Her eyes his own mute language speak!
>
> No sound? no signal?—Why thus mute
> The silver strings of that sweet lute,
> Which his loved hand beneath her bower,
> Struck soft at 'The Appointed Hour'.

Beck 3, Sandby II p 179, DNB IX p 654, *The Keepsake* 1836.

161 Sadak in Search of the Waters of Oblivion 1841

VAM E.350.1970
A mezzotint (49·9 × 37·4) attributed to Alfred Martin (T. Balston Appendix 8 (b) no 6) after his brother John Martin (1789–1854). The first version of the painting, exhibited in 1812, is in the Southampton Art Gallery, and the second (T. Balston Appendix 6 no 82), from which this mezzotint was made, is in the Boston Museum of Fine Arts. Another impression is in the VAM (E.2859.1913). The plate was published by Alfred Martin on 1 December 1841 in London. The subject was also engraved by Edward John Roberts (1797–1865) for *The Keepsake* of 1828. An impression was bequeathed by T. Balston to the VAM (E.707.1968). The subjects illustrates the *Tales of the Genii* by James Ridley.

Man, the plaything of the elements, clings to a ledge over a fierce waterfall while lightning flashes overhead. He is the survivor who appears frequently in 19th-century French painting. This was one of Martin's first successes.

Beck 7, T. Balston (see above), RA (1812) no 363, *Charles Dickens Exhibition* VAM (1970) no A20, *The Keepsake* (1828).

162 The Alarm Bell 1849

VAM E.250.1970
A mezzotint with etching (80·6 × 59) by Frederick Bromley (worked c 1840–60) after the painting of 1846 by John Rogers Herbert, RA (1810–90), published by Robert Jenning, 6 June 1849 for the proprietor, W. G. Herbert, in an edition of 250 of which 75 were artist's proofs.

Although this print was published mid-century, the mood is that of the picturesque annuals of the 1830s. The exact story is not known but it clearly involves female heroism in the face of an attack on the community. The young woman, mindless of her own safety, has climbed up to the bell tower and in spite of the enemy arrows is sounding the alarm on the church bell. Her loose hair, the stiletto at her waist and above all, her bare feet, indicate a non-suburban wildness of spirit. Another print on the theme of courage in women is *Grace Darling*, **105**.

PA (1847–75).

163 Sabrina 1849

VAM E.100.1970
An engraving with an arched top (47·3 × 68) by Peter Lightfoot (1805–85) after the painting by William Edward Frost, ARA (1810–77); published by the Art-Union of London in 1849. Another small plate was engraved by J. & G. P. Nicholls for *The Art Journal* in 1857.

The lettered prints bear three lines of verse from Milton's *Comus*:

> The water-Nymphs that in the bottom play'd
> Held up their pearled wrists and took her in,
> Bearing her straight to aged Nereus' Hall.

Sabrina was goddess of the River Severn whose job it was 'To help ensnared chastity'. Here she is shown being wafted under water accompanied by her hand-maidens in similar Greek dress.

Beck 13, AU (Report) 12 (1848) pp 10, 13 (1849) p 9, Slater p 445, AJ (1857) repr pp 6, 7, Sandby II p 220, RA (1845) no 325, DNB VII p 729.

164 Detail from **The Combat** 1849

VAM E.94.1970
A line engraving (41·6 × 49·5) by George Thomas Doo, RA (1800–86) after the painting entitled *The Combat—Woman Pleading for the Vanquished* dated 1825 by William Etty, RA (1787–1849) in the NG: Edinburgh (no 189);

published by J. Hogarth, 1 June 1849. G. T. Doo was one of the engravers who petitioned Parliament on behalf of the declining art of engraving.

This is an example of pure line engraving used on a classical subject to express the rounded forms of the figures which descend from Hellenistic sculpture. The problem of male nudity has been solved by the victor treading on the loin cloth of the vanquished. John Martin bought the painting in spite of its size and later sold it to the Scottish Academy. Although the print was not typical of mid-19th century prints, it was well reviewed and well known.

Beck 11, Slater p 280, PA (1847–75), RA (1825) no 1, BI (1826) no 343, AJ (1903) repr p 375, RSA (1831) no 4, (1844) no 341. A. Gilchrist, *Life of William Etty* (1855) I pp 227–9.

165 The Origin of Music 1852

VAM E.251.1970

A mixed mezzotint with an arched top (78·6 × 51·5) by Christopher Wentworth Wass (born 1817) after a painting by Henry Courtney Selous (1811–90); published by Lloyd Bros & Co 17 January 1852 in black and white and in colour.

In this allegory an Arcadian figure blows tentative notes on his pan's pipe recently made from the rushes at the side of the brook. The figure of his companion is rigidly demure and semi-naked under the spreading oak. In this English Arcadian scene a dog appears as if modelling for 'His Master's Voice'.

PA (1847–75), Slater p 668, RA (1850) no 1190.

166 Lady Godiva 1860

VAM E.303.1970

A mixed mezzotint (71·5 × 53·4) by James John Chant (c 1820—after 1876) after a water-colour by Edward Henry Corbould, RI (1815–1905) in the National Art Gallery of New South Wales, Sydney (no 384), published by Henry Graves & Co 11 October 1860, in an edition of 110 of which 25 were artist's proofs on India paper costing four guineas.

Lady Godiva made her legendary ride through the streets of Coventry clothed in nothing but her hair in order to shame her husband into lifting the oppressive toll he imposed on his tenants. She is said to have been the wife of Leofric, Earl of Mercia and Lord of Coventry. An historical person, a Saxon called Godiva or Godgifu, did exist in the early 11th century. She was a widow when she married Leofric in 1040. She founded and endowed a number of monastries and died a few years before the Doomsday Survey.
Here she is shown, waiting in the wings, exposed to an extremely lecherous stone monster. Her palfrey, not naked, is standing by. The proclamation that shutters should be barred and eyes averted is about to be defied by 'peeping Tom'. The protest was successful and the taxes were lifted. This is a polite form of Victorian pin-up.

Beck 12, PA (1847–75), Slater p 216, RA (1871) no 230, H. Graves p 13.

167 The Play-scene in Hamlet 1863

BM 70.8.13.381

An engraving with arched top (67·2 × 100·7) by Charles William Sharpe (c 1830–70) after the painting of 1842 by Daniel Maclise, RA (1806–70); first published by the Art-Union of London in 1863 and re-published by them, 1 May 1866.

Maclise was a keen illustrator of Shakespeare and this subject was drawn from *Hamlet* III. ii, in which Hamlet observes the effect of his players' re-enactment of the murder of a king and seduction of a queen upon his treacherous uncle and mother. They sit on the right striken with remorse while Hamlet lies at the foot of the stage intent upon their reactions. Ophelia is given prominence on the left. She gazes down at Hamlet, oblivious of all else.

RA (1842) no 62, the engraving (1867) no 947, AU (Report) 32 (1863), DNB XII p 666, Bryan III p 266.

168 Details from **The Pursuit of Pleasure: a Vision of Human Life** 1864

VAM E.113.1970

An engraving with stipple (80·7 × 116·8) by Henry Thomas Ryall (1811–67) after the painting by Sir Joseph Noel Paton, RSA (1821–1901) in the Durban City Art Gallery; published by Alexander Hill, 24 March 1864. The PA records an edition of 1325 impressions of which 550 were artist's proofs declared by Alexander Hill on 10 May 1859.

Details from this High Victorian allegory show Pleasure personified by the floating nude on the left with long flower-decked hair and accompanying cherubs blowing bubbles which symbolize the fragility of moments of pleasure. She is winged as pleasure is a fleeting thing. The human race full of vices, drunken and bacchanalian, making music and love, follow in pursuit, regardless of torn banners and trampled hopes. Above both these details the avenging Angel of the Lord lifts his sword. The work is a compendium of classical styles and influences, especially that of Poussin.

Beck 33, PA (1847–75), Slater p 559, RSA (1855) no 294; (1850) no 499 and (1860) no 646, (1863) no 319—preliminary sketches, DNB XVII p 552.

169 Ophelia 1866

BM 93.11.15.59

A mezzotint with engraving by James Stephenson, ARA (1808–86) after the painting of 1852 by Sir John Everett Millais, PRA (1829–96) in the Tate Gallery (no 1506), published by Henry Graves & Co 1 March 1866 in an edition including 325 proofs of which 200 were artist's proofs costing ten guineas. PA stamp JSE.

The subject illustrates *Hamlet* IV, vii:

> There, on the pendant boughs her coronet weeds
> Clamb'ring to hang, an envious sliver broke;
> When down her weedy trophies and herself
> Fell in the weeping brook. Her clothes spread wide
> And, mermaid-like, awhile they bore her up;
> Which time she chanted snatches of old lauds,
> As one incapable of her own distress,

Or like a creature native and indued
Unto that element; but long it could not be
Till that her garments, heavy with their drink,
Pull'd the poor wretch from her melodious lay
To muddy death.

Elizabeth Siddal, a milliner's assistant and the future Mrs D. G. Rossetti, posed in a large bath kept warm by lamps placed beneath it. This precarious arrangement did not prevent her getting ill and her father threatened Millais with an action for £50 damages. The picture was a Pre-Raphaelite triumph and the national devotion to Shakespeare, plus the heart-rending sight of a drowning girl, made it a successful print. The little robin singing on the left contrasts with the dirge of Ophelia.

J. G. Millais I pp 144–7, repr 117, II p 496, Reynolds (1966) pp 63–4, *Millais* PRA, PRB (1967) no 34, PA (1892), H. Graves p 74, Ironside & Gere (1948) p 41 repr 155.

170 (a) L'allegro 1868

VAM E.140.1970
An engraving with arched top (74 × 41·5) by Francis Holl, ARA (1815–84) after the painting by George Elgar Hicks (born 1824); published by Messrs Fores 18 January 1868 with its companion print *Il Penseroso* in an edition of 525 pairs of which 300 were artist's proofs. The prints were also sold separately. PA stamp FPV.

The pair illustrate the poems by John Milton and they have been interpreted as two women in the contrasting moods of gaiety and pensiveness.
In this print, *L'Allegro*, the idea of lightness is conveyed by the open landscape with light sky, the movement of the figure and her flying hair and the swirling of her summer skirt.

170 (b) Il Penseroso

VAM E.141.1970
In this, the companion print (74 × 41·5), the atmosphere of thoughtfulness and repose is created by the heavy folds of the long-sleeved gown, and the static background of ecclesiastical stone. The painting was exhibited at the Royal Academy in 1865 with the quotation 'There let the pealing organ blow . . . And bring all heaven before mine eyes' from the poem. Both engravings show the Gothic influence in the shape of the plates with pointed arches. This was a popular shape in the 1860s.

PA (1847–75), Slater p 388, RA (1870) nos 855 and 849, the engravings; one painting RA (1865) no 352, AJ (1872) p 99.

171 Isabella: or the Pot of Basil 1869

BM 86.12.6.105
A mixed mezzotint (75 × 49) by Auguste Thomas Marie Blanchard (1819–98) after the painting by William Holman Hunt, OM (1827–1919); published by E. Gambart & Co 1 May 1869 in an edition including 187 proofs of which 100 were artist's proofs. PA stamp OJD.

Isabella has arisen from her bed alcove in the background and embraces the pot of basil. The exotic watering-can on the floor, the embroidered cloth over the inlaid wood, the curious chased metal pot with death's heads and the temple lamp are typical of Hunt's Palestinian, Melbury Road style.

Keats' poem, *Isabella or the Pot of Basil*, derived from Boccaccio, tells the story of the murder in Messina of Isabella's lover, Lorenzo, by her three brothers. Lorenzo appeared in a dream telling her where his body lay in the forest, and she exhumed the head, kept it in a pot of Basil, watering it daily with her tears. She died of grief when her brothers took it away; hence the song, composed at the time, which began 'O cruelty, To steal my Basil-pot away from me'.

W. Holman Hunt II repr p 254 illus PA (1847–75).

172 Rosalind and Celia 1870

VAM E.301.1970
A mixed mezzotint (65·8 × 83·8) by William Henry Simmons (1811–82) after the painting dated 1868 by Sir John Everett Millais, PRA (1829–96) in the Walker Art Gallery, Liverpool; published by Henry Graves & Co in an edition of 400 proofs of which 275 were artist's proofs declared to the PA on 8 April 1870.

The subject is drawn from *As You Like It* II. iv, in which Rosalind dressed as Ganymede in male clothes and Celia as Aliena rest under a tree in the forest of Arden with Touchstone listening behind the tree trunk.
Rosalind Oh Jupiter, how weary are my spirits!
Touchstone I care not for my spirits, if my legs were not weary . . .

PA (1847–75), Slater p 583, Le Blanc III p 517 no 3, J. G. Millais II repr p 3, RA (1868) no 70, Winter (1898) no 102, DNB XVIII p 260, H. Graves p 75, A. L. Baldry, *Sir J. E. Millais: His Art and Influence* (1899) p 30.

173 The Eve of St. Agnes 1871

BM 86.12.6.123
A line engraving (69·5 × 55·2) by Auguste Thomas Marie Blanchard (1819–98) after the painting of 1868 by Daniel Maclise, RA (1806–70), published by Pilgeram & Lefèvre, 1 July 1871 in an edition including 100 artist's proofs, 25 presentation proofs, 25 proofs before letters and 25 lettered proofs, making 175 in all. PA stamp VED. Pilgeram & Lefèvre took over Ernest Gambart's premises at 1, King Street, St James's.

The engraving derives from Keats's poem *The Eve of St. Agnes*, where Madeline prepares to follow the advice of 'old dames':

> They told her how, upon St. Agnes' Eve,
> Young virgins might have visions of delight,
> And soft adorings from their loves receive
> Upon the honey'd middle of the night,
> If ceremonies due they did aright;
> As, supperless to bed they must retire,
> And, couch supine their beauties, lily white;
> Nor look behind, nor sideways, but require
> Of Heaven with upward eyes for all that they desire.

The engraving faithfully reproduces details of the poem: the triple-arched casement with its 'shielded scutcheon', the moonbeams falling on Madeline's breast, the pearls

she is removing from her hair and her lute in the foreground.

Next to the casement in the background is a statue of St Agnes with her emblem, a lamb (which led her to become the patron saint of wool merchants). The simplicity and innocence of her posture contrast with the dreamy sensuousness of Madeline in the foreground and the rich textures of her dress. The contemporary taste for Gothic can be seen in the stained glass and the stone tracery.

PA (1847–75), *Royal Jubilee Exhibition*, Manchester (1887) no 803.

174 The Legend of the Briar Rose 1892

VAM E.270–3.1970

Photogravures of the series of four paintings of 1890, by Sir Edward Coley Burne-Jones, Bart, RWS (1833–98) in Buscot Park, Berkshire; published by Thos Agnew & Sons, 15 April 1892, in London, Liverpool and Manchester, in an edition of 525 sets of which 400 sets were termed 'artist's proofs'. As the technique of proofing hardly applied to photogravure, this mis-nomer simply meant certain prints were signed by Burne-Jones. The photogravures were printed in Paris. PA stamp HNA, HPY, IPA and HZV. Messrs Agnew, who reserved the copyright, exhibited the paintings in 1890.

The four were accompanied by verses written by William Morris and were entitled as follows:

(a) The Briar Wood (55·2 × 94)

VAM E.270.1970

> The fateful slumber floats and flows
> About the tangle of the Rose,
> But lo, the fated hand and heart
> To rend the slumberous curse apart.

(b) The Council Chamber (55·5 × 94·6)

VAM E.271.1970

> The threat of war, the hope of peace,
> The kingdom's peril and increase.
> Sleep on, and bide the latter day
> When Fate shall take her chains away.

(c) The Garden Court (55 × 88)

VAM E.272.1970

> The maiden pleasaunce of the land
> Knoweth no stir of voice or hand,
> No cup the sleeping waters fill,
> The restless shuttle lieth still.

(d) The Rose Bower (55·5 × 88·7)

VAM E.273.1970

> Here lies the hoarded love, the key
> To all the treasure that shall be.
> Come, fated hand, the gift to take
> And smite the sleeping world awake.

Lady G. Burne-Jones, *Memorials of Sir Edward Burne-Jones* London (1904) II pp 204–5. Thos Agnew, *Catalogue of Publications* (1905) repr pp 32–3 PA (1892), *The Year's Art* (1891) p 227, Beck 48, 49, 50, 51.

175 The Garden of the Hesperides 1893

VAM E.183.1970

A circular photogravure (plate mark 73 × 69·2) after the painting dated 1892 by Frederic Leighton, Baron Leighton of Stretton, PRA (1830–96) in the Lady Lever Art Gallery, Port Sunlight; published by Arthur Tooth & Sons, 1 February 1893 with the American copyright registered by The British Art Publishers' Union. Published in Berlin by Stiefbold & Co and printed in Berlin, probably by The Berlin Photographic Company. The edition included 425 artist's proofs.

The Hesperides, in Greek myth, were the maidens who guarded the golden apples given to Hera by Earth, on her marriage to Zeus. Daughters of Erebus and Night, the Hesperides lived on the westerly border of the ocean by the setting sun, hence the golden glow and flame-coloured robes in Leighton's painting. Ladon, the watchful dragon whose envious power kept the golden apples—or the light of knowledge—back from mankind, here appears more python-like than dragon-like. It was Heracles's job to slay Ladon and restore the apples to Athena, though what became of the Hesperides afterwards is not known. The apples were symbols of love and fruitfulness, both promised by Leighton's lovelies.

PA (1912), RA (1892) no 204, Winter (1897) no 29, Bicentenary (1968–9) no 350, J. Maas, *Victorian Painters* (1969) repr p 179, Q. Bell, *Victorian Artists* (1967) pl 56.

176 He Loves Me—He Loves Me Not! 1893

VAM E.181–1970.

An etching (30·8 × 43·2) with a remarque depicting a marguerite, by Leopold Lowenstam (1842–98) after the painting by Sir Lawrence Alma-Tadema, RA (1836–1912); published by Stephen T. Gooden, 13 January 1893 in an edition of 375 of which 350 were artist's proofs. The copyright was registered in New York by The British Art Publishers' Union. PA stamp ZT.

Acres of marble were *de rigueur* in these late pseudo-Roman subjects (see also *The Baths of Caraculla* and *The Greek Dance*, 180). Photogravure made exact reproduction possible and many of these late prints were produced that way. However, Leopold Lowenstam did etch several plates after Alma-Tadema, and others. Here two girls dismember a daisy in order to get an answer to the question of love. Boredom is the predominant mood.

Beck 57, PA (1912), RA (1893) no 1453.

177 Invocation 1893

VAM E.292.1970

A mezzotint (69 × 42·5) by John Douglas Miller (worked *c* 1872–1903) after the painting dated 1889 by Frederic Leighton, Baron Leighton of Stretton, PRA (1830–96); published by Arthur Tooth & Sons 10 January 1893 in London, M. Knoedler in New York and Stiefbold & Co in Berlin. PA stamp. There was an edition of 925 of which 400 were artist's proofs, after which the plate was to be destroyed. The mezzotint was exhibited at the Royal Academy in 1893 (no 1475).

The face and arms of the woman invoking her household gods are as marble-like as the Ionic column and her offering of grapes, as glassy as those normally found in glass domes on Victorian whatnots. This rigid formality

would have lent itself to line engraving if that art had still flourished in the 1890s.

Beck 53, PA (1912), RA (1889) no 31, (1893) no 1475, Winter (1897) no 9, *The Year's Art* (1890) p 46, E. Staley, *Lord Leighton of Stretton* PRA London (1906) Appendix III p 246.

178 Richard, Duke of Gloucester and the Lady Anne
1897

VAM E.354.1970

An etching (45·7 × 81·5) by Leopold Joseph Flameng (1831–1911) after the painting dated 1896 by Edwin Austin Abbey, RA (1852–1911) in a private collection. The print was issued by the Art-Union of London on 1 October 1897.

Subjects drawn from Shakespeare were perennial sellers. This one illustrates *Richard III*, I. ii, the wooing of Anne by Richard at the funeral of her husband Edward, Prince of Wales, murdered by Richard. An element of art for art's sake is evident in the elaborate treatment of the dress and train. This also enabled the etcher to show off his skill.

Beck 61.

179 Dreamers
1898

VAM E.274.1970

A mezzotint printed in brown (55 × 78·1) by Thomas Gooch Appleton (1854–1924) after the painting of 1882 by Albert Joseph Moore (1841–93) in the Birmingham City Museum and Art Gallery (no 676); published by Henry Graves, 14 September 1898 in an edition of 525 of which 250 were artist's proofs. PA stamp UMM.

By this time mezzotint in its pure form had regained some of its lost status and was not simply used to provide tonal background for other engraving and etching techniques. This is reflected in the small size of the edition. Large editions could be produced more cheaply by photogravure. Albert Moore's fondness for soporific subject matter suited the slack folds of antique dress and the idleness and warmth of patrician life convey a sense of relaxed luxury prevalent at the end of the 19th century.

Beck 54, R. Ormond in *Apollo* (1968) p 244, fig 3, RA (1882) no 407, RA *Bicentenary Exhibition* (1968–69) no 359. PA (1912).

180 The Greek Dance
1900

VAM W.182.1970

A photogravure (66 × 83·8) by the Berlin Photographic Co after Sir Edward John Poynter, PRA (1836–1919); published by Messrs Arthur Tooth & Sons, in 1900 and distributed in Paris, New York and Berlin. The plate was also published by P. & D. Colnaghi & Co. PA stamp ZXV. The edition included 300 of which 250 were artist's proofs. A small engraving of the subject appeared in *The Art Journal* of 1895.

The interior and its occupants appear to be Roman, the atmosphere is one of relaxed decadence. The performer is meant to be Greek. She dances shamelessly in a diaphanous robe. The free movement seems to herald Isadora Duncan.

Beck 55, PA (1912), AJ (1895) p 174, *The Art Annual* (1897) repr p 27.

181 Sea Melodies
1901

BM 24.5.10.115

A mezzotint in an oval (68·5 × 50·8) by Norman Hirst (born 1862) after Herbert James Draper (1864–1920); published by Frost & Reed in Bristol, 1 November 1901, and in Berlin by Stiefbold & Co. In 1904 the copyright was registered in America. PA stamp FRI. The edition included 275 artist's proofs and 25 presentation proofs.

This picture shows just how far the Victorian woman had come, from the trim bonneted creatures of the *Book of Beauty* (Introduction, p 13) to these maidens. This picture conveys Wagnerian elements and was published in the cultural wake of the first productions of his operas in London and New York in the 1880s. There is the river, a cave, a couple of Rhinemaidens and part of the Walküre rock. The painting was exhibited at the Royal Academy in 1904 (no 302) with the line: 'And rippling through the plash of waves the merman's pipe shall sound', which indicates that the Wagnerian inclusions were coincidental.

Slater p 383, PA (1912), RA (1904) no 302.

Glossary

Aquatint
A means of producing tones on a metal plate by the action of acid through resin dust. The resin is applied in two ways, either as a *dust ground* or a *spirit ground*. When the plate is heated the particles stick to it and resist the acid. The areas of the plate which are to remain white are stopped out with varnish before the plate is laid in the acid bath. Successive tones are achieved by repeating the process of stopping-out and etching, until the darkest tones are achieved. Then all the varnish is removed and the plate is inked, cleaned and printed in an etching press. The timing in relation to the strength of the acid is an important factor in making an aquatint. An aquatint tone differs from a mezzotint. It is a shallow rather transparent tone laid on the plate and not cut deeply into it.

Artist's proofs
A small number of impressions or proofs taken before the edition is printed. These are signed in pencil by the artist and usually numbered. In the case of reproductive engravings, *signed artist's proofs* were often signed by both the painter (on the left) and the engraver (on the right). Prints bearing facsimile signatures are not artist's proofs.

Burr
The rough edge of metal left by the cutting action of the burin, mezzotint rocker or dry-point needle, and the name given to the rich furry quality on a print, which results from the ink catching in it. It is the essential feature of a good mezzotint.

Copper-plate engraving
An intaglio process in which a polished copper-plate is cut with a *burin* or *graver*. The burr left by the graver is removed with a *scraper* to achieve brilliant incised lines. The plate rests on a pad to facilitate turning. Ink is worked into the engraved lines with a *dabber*, the surface of the plate is wiped clean and the impression obtained from the ink remaining in the furrows. The plate is printed under considerable pressure in a double-roller press.

Copper-plate press
A sliding board which passes between two rollers. The pressure is controlled by raising or lowering the upper roller.

Dotted manner
A method of engraving a tone. Dots are punched on to a copper-plate with a *dotting-punch* and *hammer*. Under magnification a dotted print differs from a stippled print in that the dots are perfectly round and not irregular as in the latter.

Dry-point
A direct method whereby the design is scratched into the metal plate with a strong metal point known as a *dry-point needle*. The line is not fluid as in etching, or deep and clean as in engraving, and it is characterized by the quality of the burr which is not scraped off.

Electro-etching
Etching by means of an electric battery instead of the usual acid. If the plate was connected to a negative pole instead of a positive one, copper was deposited on the bare lines instead of being removed and a relief plate could be built up.

Etching
An intaglio process by which lines are bitten into a metal plate by means of acid. The polished plate is grounded with a wax *etching ground*, which is then blackened with smoke from a taper. The design is drawn through the ground with an *etching needle*. The back and edges of the plate are protected with stopping-out varnish before it is placed in a bath of dilute hydrochloric or nitric acid. Bubbles form on the surface of the plate which hamper the action of the acid and have to be brushed away with a feather. The plate is cleaned, heated and inked with a dabber. The ink is cleaned off with muslin and the palm of the hand. This is sometimes intentionally uneven, leaving a tone. Proofs are pulled during the surface working of a plate, and these are known as *states*. The plate is thoroughly cleaned with turpentine and then ammonia and French chalk before a new ground is applied for further work on the plate. An etched line is free and light and always has a blunt end, unlike an engraved line which is firm, regular and pointed at the end.

Impression
The name given to a print from a plate, block or stone. Impressions vary greatly depending on the condition of

the plate and the skill of the printer. Early impressions are usually the best.

India proof
A proof printed on a fine tissue which is stuck to the sheet of paper. The plate mark extends beyond the fine paper.

Intaglio
The term applied to all processes where the design is cut or etched below the surface of the plate, and the impression is taken from the ink in the furrows.

Lettering
Lettering usually appears in the lower margin, though the publisher's name and address sometimes appear above the image. The painter's name usually appears on the lower left, and the engraver's name on the lower right. The Latin abbreviations *pinx.*, *delin.*, *inv.*, mean painted, drew, designed; *sculp.*, *sculpt.*, and *incid.*, mean engraved; *fecit* means etched, and *excudit* or *imp.* means printed or published. If the painter's name or monogram appears on the image of a reproductive engraving, it has been copied from the painting by the engraver.

Lithography
A process whereby a print is obtained from the flat, porous surface of a stone or zinc plate, through the antipathy of grease and water. The image is drawn on the stone with a greasy litho crayon or litho ink. The stone is then gummed up with a mixture of gum arabic containing acid which slightly etches the areas not touched by the crayon. Turpentine is used to remove the original drawing while the gum protects the non-greasy areas. The stone is washed completely clean and kept damp while the ink roller is applied. Only the parts of the stone which absorbed the greasy drawing take up the ink. The impression is taken by passing the stone through the scrapper press. The image can deteriorate quickly and the grain of the drawing becomes dense and black if the stone is not kept moist while it is being inked up.

Machine ruling
Engraving machines for ruling lines were used since the end of the eighteenth century largely by commercial, reproductive engravers for skies and other regular areas.

Mezzotint
A tonal method carried out on a metal plate by roughening it with a tool known as a *mezzotint rocker*, so that it would print black, and then scraping it smooth to get lighter tones. The plate is rocked at many angles, and this gives a distinctive texture which can be seen under magnification. The burr, which gives a mezzotint its deep rich tone, becomes worn down in the press, thus limiting the number of good impressions to about 200. The whitest areas of a mezzotint have the least texture. This was one of the factors leading to the use of line and stipple-engraving on mezzotint plates in order to strengthen otherwise empty light areas.

Mixed Mezzotint
A mezzotint over which other methods including line-engraving, stipple and etching have been used. It combined the benefits of a quick tonal method with the clarity of line. Under magnification the mezzotint ground is visible beneath the engraving, stipple or etching. Some engravings may look like mixed mezzotints until it is seen that aquatint and not mezzotint was used as the tonal basis for engraving.

Photogravure
A method of reproduction which looks similar to a photograph. It is a process involving the transfer of a reversed positive half-tone photograph on to a light sensitive layer of carbon tissue which is backed with gelatine which has also been rendered sensitive to light. A polished metal plate is prepared with an aquatint ground, and the exposed sheet of tissue and gelatine is pressed on to it. The tissue and the exposed gelatine are washed off the plate leaving a half-tone gelatine relief which is the negative of the original image. When the plate is laid in a solution of ferric chloride, the mordant only penetrates the metal in proportion to the thickness of the gelatine relief, reproducing exactly the tones of the original. In modern machine photogravure the grain is provided by a screen instead of the aquatint ground.

Planographic
The term applied to methods of printing from a flat surface, as in lithography.

Plate mark
The mark made by the impress of the plate in the paper. Measurements are taken from this mark, height before width. If the print has been cut down within the mark, it is known as a *clipped print*.

Platen press
A press in which both the printing surface and the impression surface are flat.

Proofs
The impressions taken from a plate before the final edition of prints is run. Strictly, proofs are trial prints pulled during the process of completing and printing a plate. During the nineteenth century commercial motives led to the publishing of various grades of proof editions. There was the signed artist's proof on vellum or on india paper; the presentation proof; the proof before letters (with nothing apart from the image); the lettered proof (with only the names of the painter and engraver); the proof with title in open letters, and the remarque proof.

Relief printing

A method of printing where the impression is taken from the surface of the block or plate. Vertical pressure is applied, and the ink is thicker than for intaglio printing, so that it does not flow into the recessed areas. The same method is used for printing from type.

Remarque

The name given to the same design engraved or etched in the margin by the engraver. There was a fashion for remarque proofs towards the latter half of the nineteenth century. It was an affectation probably originating from the practice of taking proofs before the engraver's trial marginal scratches were polished off and replaced by the final lettering.

Remarque on Christ blessing Little Children. *J. H. Watt after Sir C. L. Eastlake, Engraving (VAM E.115.1970)*

Reproductive engraving

Any engraving or etching which is carried out after the work of another artist which may be a painting, drawing or water-colour.

States

Separate stages through which a print passes when new work is added to the plate. Proofs which vary because of the printing are not states, unless the plate has been worked on.

Steel engraving

The practice of engraving on steel plates in order to print larger editions. The hardness of steel gave rise to finer, lighter engraving and favoured small plates rather than large ones. The process of steel-facing copper-plates removed the necessity of actually engraving on steel. Mezzotints were made directly on to steel because the process of steel-facing copper-plate mezzotints was not perfected until the 1870s.

Steel-facing

A method of facing a copper-plate with steel by means of electrolysis.

Stereotyping

The means of obtaining duplicates of wood blocks or relief metal plates by taking a negative mould and casting lead positives from it.

Stipple-engraving

A method of engraving tones on to a metal plate. An etching ground was laid on the plate which was pierced by numerous dots or *flicks* made with an etching needle or a bundle of needles. The dots were etched in and the final stippling carried out straight on to the plate with a stipple-engraver and various roulettes. The dots on a stippled plate are irregular unlike those on a dotted plate which are round.

Bibliography

GENERAL SOURCES

Beraldi, H., *Les Graveurs du XIX siècle*, Paris 1885

Bibliothèque Nationale, *Inventaire du fonds français après 1800*, Paris 1930–65

Blackburn, H., *Academy Notes*, London 1875–82, 1885–1903

——, *Academy Sketches*, London 1884–94, 'The Comparative Merits of Line-engraving and Mezzotinto', *The Art-Union*, 1839, p 57

Davenport, C., *Mezzotints*, London 1904

Delteil, L., *Manuel de l'amateur d'estampes des 19ᵉ et 20ᵉ siècles 1801–1924*, Paris 1925

Fielding, T. H., *The Art of Engraving*, London 1841

Graves, H. & Co, *Catalogue of the publications of Henry Graves & Co.*, London 1899. Another edition 1900. Catalogue Supplement 1905. Catalogue of Publications 1907–8

Hind, A. M., *A Guide to the Processes and Schools of Engraving . . . etc.*, British Museum, Department of Prints and Drawings, 1952

Landseer, J., *Lectures on the Art of Engraving*, London 1807

Le Blanc, C., *Manuel de l'amateur d'estampes*, Paris 1854–89

Levis, H. C., *Descriptive Bibliography of the Most Important Books in the English Language Relating to the Art and History of Engraving and the Collecting of Prints*, London 1912

Linton, W. J., *Specimens of New Processes of Engraving for Surface Printing*, London 1861

Maas, J., *Gambart, Prince of the Victorian Art World*, London 1975

Mann, Maybelle, 'The American Art-Union, Missionaries of the Art World', *American Art and Antiques*, July/August 1978

Moon, Boys, & H. Graves, *A Catalogue of Engravings*, London 1829

The Printsellers' Association List of Engravings, London 1847–75, 1892, 1894, 1912

'Proposed National Gallery of Engravings', *The Art Journal*, 1856, p 258

Reynolds, G., *Painters of the Victorian Scene*, London 1953

——, *Victorian Painting*, London 1966

Rodee, H. D., *Scenes of Rural and Urban Poverty in Victorian Painting and their Development*, PhD thesis, Columbia University 1975

Ruskin, J. *Notes on Some of the Principal Pictures Exhibited in the Royal Academy and the Society of Painters in Water-Colours*, London 1855, 1856, 1857 and 1875

Slater, H., *Engravings and their Value*, London 1929

'The State and Prospects of Lithography', *The Art Union*, 1839, p 97

Stauffer, D. M., *American Engravings upon Copper and Steel*, 2 vols, New York 1907

Thackeray, W. M., *Critical Papers in Art*, London 1904

Whitman, A., *The Print Collector's Handbook*, London 1901

Wood, C., *Dictionary of Victorian Painters*, London 1971

——, *Victorian Panorama: Paintings of Victorian Life*, London 1976

INDIVIDUAL PAINTERS AND ENGRAVERS

Lawrence Alma-Tadema

Exhibition of Works by the Late Sir Lawrence Alma-Tadema RA, OM, Royal Academy Winter Exhibition, 1913

Richard Ansdell

Dafforne, J., 'British Artists, their Style and Character: Richard Ansdell', *The Art Journal*, 1860, pp 233–5

Charles Baxter

Dafforne, J., 'British Artists, their Style and Character: Charles Baxter', *The Art Journal*, 1864, pp 145–7

George Baxter

Lewis, C. T. C., *George Baxter, Colour Printer: his Life and Work*, London 1903

John Bagnold Burgess

'The Works of John Bagnold Burgess, ARA', *The Art Journal*, 1880, pp 297–300

Edward Burne-Jones

Burne-Jones, Lady G., *Memorials of Sir Edward Burne-Jones*, 2 vols, London 1904

Sizeranne, R., 'La "Briar Rose" de E. Burne-Jones', *La Grand Revue*, no 22, Paris 1890

John Burnet

Burnet, J., 'Autobiography: John Burnet FRS', *The Art Journal*, 1850, p 275

——, *The Progress of a Painter in the 19th Century, Containing Conversations and Remarks upon Art*, London 1854

Théophile Chauvel

Delteil, L., *Théophile Chauvel: Catalogue Raisonné*, Paris 1900

Samuel Cousins

Graves, A., *Catalogue of the Works of Samuel Cousins RA*, London 1888

Whitman, A., *19th Century Mezzotinters: Samuel Cousins RA*, London 1904

Thomas Faed
Dafforne, J., 'British Artists, their Style and Character: Thomas Faed RA', *The Art Journal*, 1871, pp 1–3
Graves & Co, *The Engraved Works of Thomas Faed*, ND

William Powell Frith
Exhibition of Works by Five Deceased British Artists (including William Powell Frith, RA), Royal Academy Winter Exhibition, 1911
Frith, Exhibition at Harrogate and Whitechapel, 1951. Introduction by Jonathan Mayne
Frith, W. P., *My Autobiography and Reminiscences*, London 1887–8

James Duffield Harding
James Duffield Harding, *The Art Journal*, 1864, p 39 and 1850, p 181 and *The Portfolio*, 1880, p 29

George Elgar Hicks
Dafforne, J., 'British Artists, their Style and Character: George Elgar Hicks', *The Art Journal*, 1872, pp 97–99

William Hilton
'British Artists, their Style and Character: William Hilton RA', *The Art Journal*, 1855, pp 253–5

William Holman Hunt
Holman Hunt, W., *Pre-Raphaelitism and the Pre-Raphaelite Brotherhood*, London 1905
Roskill, M., 'Holman Hunt's Differing Versions of "The Light of the World"', *Victorian Studies*, vol. VI, 1962/3, pp 229–44
William Holman Hunt, exhibition organised by the Walker Art Gallery Liverpool and the Victoria and Albert Museum, 1969

Edwin Landseer
Graves, A., *Catalogue of the Works of the Late Sir Edwin Landseer RA*, London 1874
Landseer, E., Correspondence and Annotations, with index and typewritten transcriptions by R. E. Mitchell, 4 vols, MSS c 1820–1919
Landseer, E., Letter Relating to the Engraving of his Pictures in a collection of letters to H. M. Cundall, MSS c 1850–1912
Mann, C. S., *The Works of Sir Edwin Landseer: Catalogue Raisonné with Photographs of All Works. The Exhibition catalogue of 1874 annotated and with references to A. Graves catalogue raisonné*, 4 vols, MSS 1874–7
Sir Edwin Landseer, RA, Royal Academy 1961
The Works of the Late Sir Edwin Landseer RA, Royal Academy Winter Exhibition 1874

Thomas Landseer
Graves, A., 'Engravers that I have known: Thomas Landseer ARA', in *The Printseller*, 1903

Lord Leighton
Exhibition of the Works of the Late Lord Leighton of Stretton, PRA, Royal Academy Winter Exhibition 1897

Charles George Lewis
Graves, A., 'Engravers that I have known: Charles George Lewis', *The Printseller*, 1903, pp 201–7

Daniel Maclise
Daniel Maclise RA, Royal Academy Winter Exhibition, 1875

John Martin
Balston, T., *John Martin 1789–1854, his Life and Works*, London 1947

John Martin, Exhibition at Whitechapel Art Gallery, 1953. Introduction by T. Balston and E. Newton

John Everett Millais
The Late Sir John Everett Millais, PRA, Royal Academy Winter Exhibition, 1898
Millais, J. G., *The Life and Letters of Sir John Everett Millais*, London 1899
Millais PRB, PRA, Exhibition at the Royal Academy of Arts, 1967, organised by the Walker Art Gallery, Liverpool
Ruskin, J., *Notes on Some of the Principal Pictures of Sir John Everett Millais*, London 1886

Albert Moore
Ormond, R., 'Albert Moore', *Apollo*, 1968, p 244

William Mulready
Dafforne, J., 'British Artists, their Style and Character: William Mulready RA', *The Art Journal*, 1864
Mulready, Exhibition at City Art Gallery, Bristol, 1964. Introduction by Arnold Wilson

William Orchardson
Little, J. S., 'William Quiller Orchardson: his Life and Works', *The Art Annual (The Art Journal)* 1897

Joseph Noel Paton
Story, A. T., 'Sir Noel Paton: his Life and Work', *The Art Journal*, 1895, pp 97–128

Samuel Reynolds
Whitman, A., *19th Century Mezzotinters: Samuel William Reynolds*, London 1903

James Tissot
Laver, J., *Vulgar Society: The Romantic Career of James Tissot, 1836–1902*, London 1936

Charles Turner
Whitman, A., *19th Century Mezzotinters: Charles Turner RA*, London 1907

J. M. W. Turner
Rawlinson, W. G., *The Engraved Works of J. M. W. Turner*, 2 vols, London 1908

Queen Victoria
Graves, A., 'Queen Victoria as an Engraver', *The Printseller*, 1903

Thomas Webster
'British Artists, their Style and Character: Thomas Webster RA', *The Art Journal*, 1855, pp 293–6

David Wilkie
Catalogue Raisonné of Pictures by Sir David Wilkie, probably compiled by Messrs Hogarth, Print & Picture Dealers, London MSS c 1842
'The Engraved Work of Sir David Wilkie', *The Art Union*, 1840, pp 10–11

William Woollett
Cecil, L., 'William Woollett, Engraver', *The Printseller*, 1903, p 241

GENERAL EXHIBITIONS AND MUSEUM CATALOGUES

The Bicentenary Exhibition, Royal Academy, 1968–9
Catalogue of Oil Paintings in the Gallery, Bristol 1957
Great Victorian Pictures, The Arts Council, Royal Academy 1978
Guide to the Manchester Art Gallery, Manchester 1956

Illustrations of 100 Oil Paintings in the Collection, Birmingham 1952

Tatlock, R. R., *Catalogue of the English Paintings in the Lady Lever Art Gallery*, Port Sunlight, Liverpool 1928

Victorian Paintings, Mappin Art Gallery, Sheffield 1968

Walker Art Gallery, Liverpool 1927

ART-UNIONS, JOURNALS AND ALBUMS

The Art Journal, London 1849–1912

The Art-Union, London 1839–48

The Art-Union of London Album, London c 1890

The Art-Union of London Almanacks, London to c 1885

The Art-Union Scrap Book, A selection of proofs from *The Penny Magazine*, London 1843

Finden, E. F. and W., *Finden's Tableaux of the Affections: a Series of Picturesque Illustrations of the Womanly Virtues*, London 1839

Heath's Book of Beauty, 1833–49

Heath's Picturesque Annuals, 1832–45

The Keepsake, London 1828–57

Magazine of Art, London 1878–1902

The Picturesque Keepsake and Continental Tourist, London 1836

The Year's Art, London 1879–1946

The Yellow Book, 1894–97

List of Printsellers

It was possible for non-members to have their plates stamped with the stamp of the Printsellers Association for a fee. Between 1866 and 1894 only 45 such plates were stamped.

Index

1 Numbers in italic refer to illustrations.
2 Engravings are referred to under their titles (as a main entry) and again under the names both of the painter and the engraver (as a sub-entry). Where the original painting has a different title from the engraving, the alternative title is given in brackets. Titles of engravings have been abbreviated where necessary.
3 Techniques of engraving are given in the glossary which is self-indexing. Only further discussion of techniques elsewhere in the book has been indexed here.